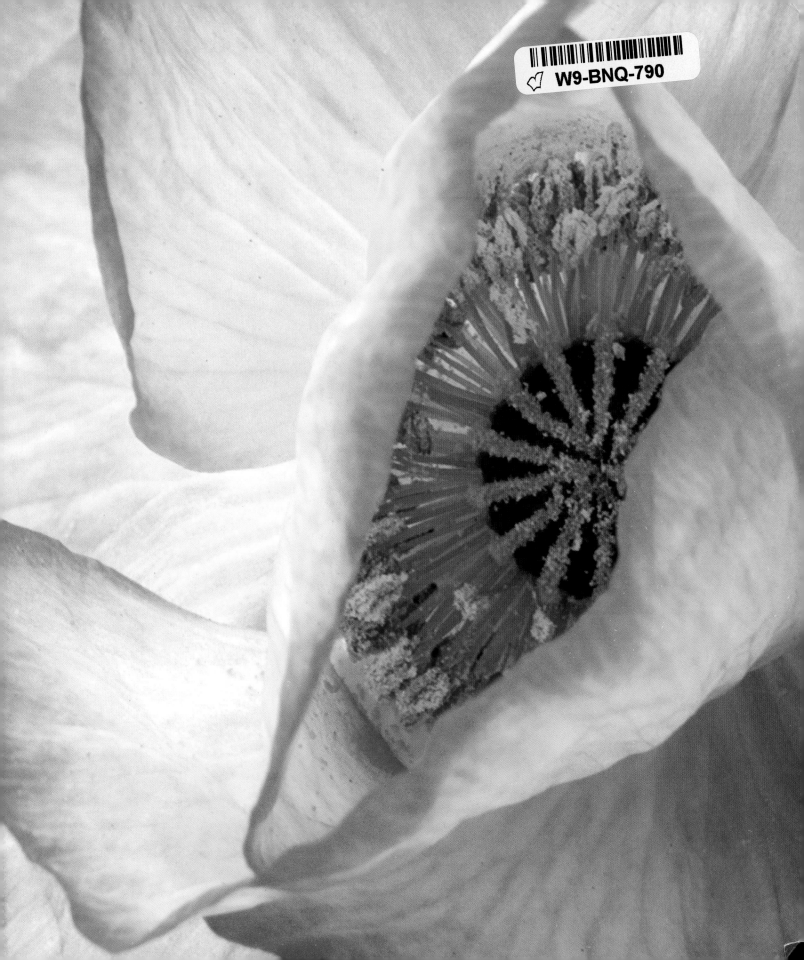

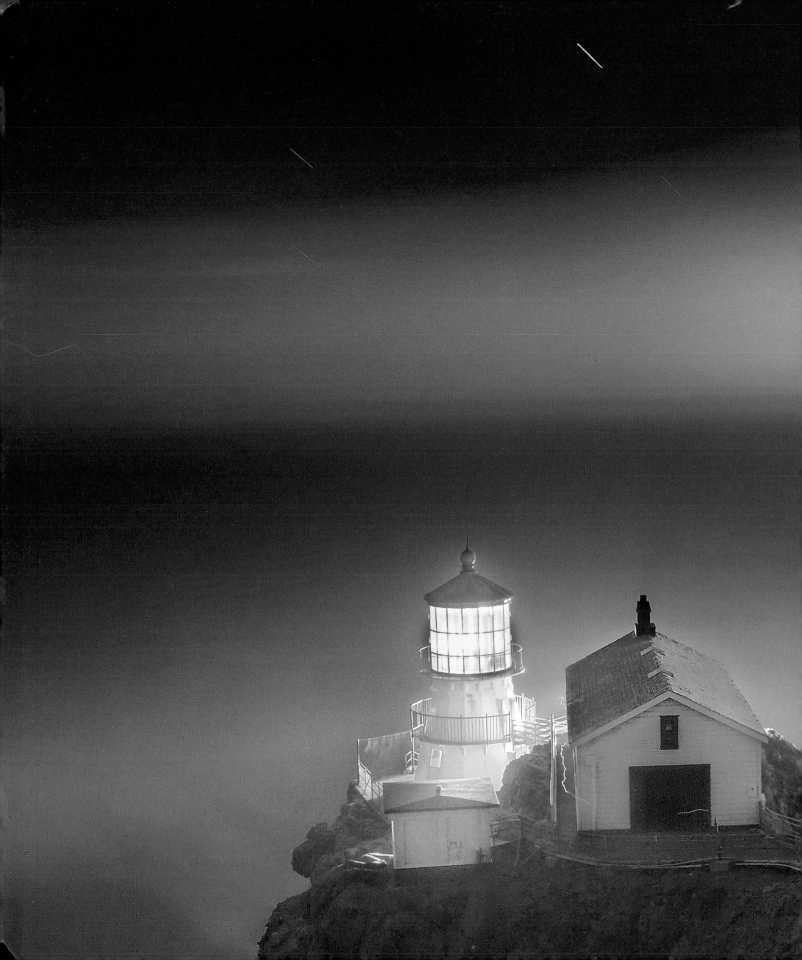

PRACTICAL ARTISTRY

Light & Exposure

for Digital Photographers

Harold Davis

O'REILLY®

Beijing · Cambridge · Farnham · Köln · Paris · Sebastopol · Taipei · Tokyo

Acknowledgments

Special thanks to Nancy Bell, Ron Bilodeau, Dan Brodnitz, Mark Brokering, Martin Davis, Steve Fehler, Josh Fisher, Dennis Fitzgerald, Tim O'Reilly, Mark Paglietti, Derrick Story, Matt Wagner, Steve Weiss, and Colleen Wheeler.

Practical Artistry: Light & Exposure for Digital Photographers
by Harold Davis

Published by O'Reilly Media, Inc., 1005 Gravenstein Highway North, Sebastopol, CA 95472

O'Reilly books may be purchased for educational, business, or sales promotional use. Online editions are also available for most titles (safari.oreilly.com). For more information, contact our corporate/institutional sales department: 800.998.9938 or corporate@oreilly.com.

Executive Editor: Steve Weiss
Editor: Colleen Wheeler
Managing Editor: Dennis Fitzgerald
Copy Editor: Nancy Bell
Technical Editor: James Duncan Davidson
Cover Design: Mark Paglietti
Interior Design: Ron Bilodeau
Layout: Phyllis Davis

Print History:
January 2008 First Edition Printed in Italy.

ISBN-10: 0-59652-988-0
ISBN-13: 978-0-59652-988-8
[L]

▲ **Cover:** Spring Starflower

18–200mm VR zoom lens at 95mm, 1/160 second at f/5.3 and ISO 100, tripod mounted.

▲ **Page 1:** Dawn Chorus Poppy

105mm f/2.8 macro lens, 1.3 seconds at f/36 and ISO 100, tripod mounted.

▲ **Pages 2–3:** Night at Point Reyes Lighthouse

12–24mm zoom lens at 24mm, 5 minutes at f/9 and ISO 100, tripod mounted.

▶ **Page 4:** Popping

200mm f/4 macro lens, 1 second at f/36 and ISO 100, tripod mounted.

▼ **Pages 6–7:** Stained glass window, Santa Fe

18–200mm VR zoom lens at 200mm, 1/40 second at f/5.6 and ISO 200, tripod mounted.

For Julian, Nicky, and Mathew,
our three wonderful sons

Contents

Introduction

This book treats the techniques of classical photography and the tools of the digital artist holistically: they are both integral to the best practices of modern digital photography.

In recent years, the art and craft of photography has changed beyond recognition. Today's photographer is one part digital artist and one part photographer.

This book aims is to present the best practices of the craft of photography in the context of the digital era. A great photograph starts with the photographer's understanding of light, and proceeds with a good (and sometimes creative) exposure.

While there are some books that treat light and exposure in the context of analog photography, the subject has yet to be thoroughly explained for the digital photographer.

It is fundamentally flawed to assume that incorrect exposures can be "fixed in Photoshop." Photoshop, and other digital darkroom programs, can do great things, but are best used as creative tools for further enhancing photos that are already good.

Understanding exactly what can be done in post-processing should help to inform your decisions as a digital photographer at the moment of exposure. And a good understanding of the concepts of photography will help you make better use of digital tools. For example, if you want to adjust exposures in the Adobe Camera RAW plug-in, it is essential to understand how apertures and f-stops work.

Light & Exposure for Digital Photographers is a practical book for digital photographers who want to understand light and exposure and to use photography to explore their worlds. It is a substitute for neither your camera manual nor a good Photoshop book. My philosophy is that if you understand the principles behind a concept, it's easy to look up the details.

Even if I wanted to, I couldn't possibly explain the controls on each digital camera model. There are just too many different camera models, and they all implement their exposure controls in slightly different ways.

But I can tell you what makes up an exposure—aperture, shutter speed, and sensitivity—and explain when to change each of these settings, and the likely impact of the change. Your camera manual will tell you the rest.

That said, this book *is* rich in pragmatic details. For example, you can find the exact lens and exposure settings I used for every photo in this book.

Speaking of the photos, I do believe that a picture is worth a thousand words. This cliché is certainly true when it comes to learning photography. It's very reasonable to start with this book by finding a few photos that interest you, and discovering how they were made.

In fact, I designed this book to work for you on a number of different levels. If all you want to do is browse my photos, read the captions that discuss how each photo was made, and consider some of the light and exposure issues that went into making them, that's fine. You can use the photos as a springboard, or an idea book, for taking photos of your own.

The photos are strategically placed in the text, so you can learn a bit more about the techniques I used by dipping into the text near each photo. Most of the topics in the book can be read on their own, if they interest you.

In other words, you don't have to start at the beginning and end at the end. But, of course, I hope that eventually you do so—and that your journey with this book and making photos is as joyous and magical as mine has been.

Harold Davis

Berkeley, California

▶ Lobelia

105mm f/2.8 macro lens, extension bellows, 4/5 of a second at f/36 and ISO 100, tripod mounted.

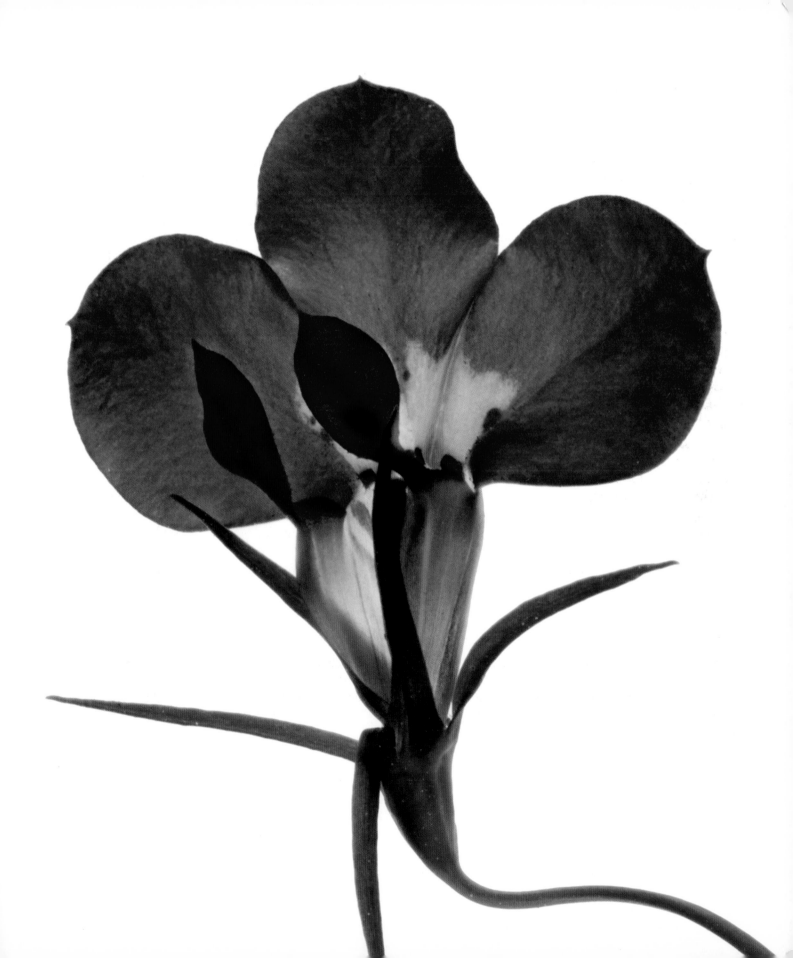

A Note about Equipment

With a few exceptions (each is noted), I've used Nikon digital Single Lens Reflex ("dSLR") cameras and lenses to capture the photographs that appear in this book.

I want to be very, very clear that this by no means constitutes an explicit or implicit endorsement of Nikon hardware as better or worse than any other cameras or lenses. I'm an agnostic when it comes to camera brands, and I have no opinion about which brand is best. The camera you have when you want to take a photo is the best camera to use.

In the technical caption information, I refer to some lenses as *VR*. VR is short for "vibration reduction," a computerized technology designed to stabilize images that are hand-held. Many manufacturers call the technology "image stabilization" rather than vibration reduction, and sometimes this facility is built into the camera rather than into a specific lens. (For more about image stabilization, see the sidebar on page 91.)

By whatever name, image stabilization should be turned off when the camera is used on a tripod. (The exception to this rule is that some cameras and lenses have a special image stabilization mode for when the camera is on a tripod to reduce the vibration from mirror slap, so check your equipment documentation.)

Therefore, when a VR lens is mentioned in the technical caption, you can safely assume that I used this image stabilization feature if the capture is designated as handheld, and turned off the image stabilization feature when I used a tripod.

The photographs that appear in *Light & Exposure for Digital Photographers* have been post-processed in Adobe Photoshop from digital RAW originals as I describe in Chapter 6.

Understanding Focal-Length Equivalency

You don't have to understand focal-length equivalency to learn from *Light & Exposure for Digital Photographers*. I included this note to be technically accurate and consistent, but if you want, you can skip it. Focal length is an extremely important topic having to do with lens choices and photographic composition and framing, but it's not really germane to the subjects of light and exposure.

The *focal length* of a lens is the distance from the end of the lens to the sensor. In each technical caption, I have designated the actual focal length of the lens I used when I made the capture (as well as the focal length range of the lens in the case of zoom lenses). This information tells you exactly what lens I used to take each photo.

Besides telling you what lens I used, focal length also provides data about the magnification involved in each photo. To make sense of this information, you need to understand that focal length of a lens in and of itself doesn't tell you how close or far away a subject will appear from the camera (the "magnification"). To understand the magnification that is provided by a given focal-length lens, you also need to know the size of the image capture device (film or sensor) because the magnification is the result of the ratio of the lens focal length to the sensor size.

In order to be able to make apples-to-apples magnification comparisons across different brands of cameras with differing sensor sizes, it is customary to speak of *35mm focal-length equivalency*, the focal length that a lens would have if mounted on a 35mm film camera to give it equivalent magnification to the lens mounted on a particular digital camera.

As I've noted, I mostly use Nikon cameras. To determine the 35mm focal-length equivalency of a lens mounted on the Nikon dSLRs I've used, you need to multiply the lens length by 1.5. This corresponds to the 1.5:1 ratio of a frame of 35mm film to the size of my Nikon digital sensor.

In practice, calculating focal-length equivalency isn't very complicated. For example, my 200mm Nikon macro lens on my digital camera has a 35mm focal-length equivalency of 300mm, calculated as (200mm)(1.5) = 300mm.

To convert the focal lengths designated in each of my captions to their 35mm equivalents, you'll need to multiply each by 1.5.

Different cameras have different sensor sizes, and therefore use different conversion factors to convert to 35mm equivalency. For example, depending on the model of Canon dSLR you use, your 35mm equivalence ratio may be 1.6:1 or simply 1:1. Your camera manual will tell you the conversion factor that applies to your sensor.

In the 35mm world, a 50mm to 55mm lens is considered a "normal" lens with approximately the field of view of a normal person, which (excluding peripheral vision) is about 53 degrees. Any focal length less than 50mm is a wide angle lens with a wider field of view, and any focal length greater than 55mm is a telephoto lens with a narrower field of view.

Generally, having to multiply the lens focal length by a factor like 1.5 (Nikon) or 1.6 (the less expensive Canon dSLR models) is good news for telephoto lenses (long lenses get longer) and bad news for wide angle lenses (even the widest of wide angle lenses gets less wide).

It's also worth remembering that all other things being equal, the smaller the sensor the more digital noise you'll get (see Chapter 4, starting on page 106). From the viewpoint of noise, the bigger the sensor the better.

If focal-length equivalency seems confusing right now, my suggestion is to file a mental note that this explanation is here, forget about the subject for now, and carry on.

It's worth remembering that cameras, lenses, and software don't take photos. People do. Your eye, your heart, and your spirit will have far more impact on the photos you take than the hardware or software you use.

Understanding the Technical Info about the Photos

I've provided full technical information about each photograph reproduced in this book. For example, take a look at the caption below that goes with the photograph on this page.

The technical capture data that accompanies each photograph is the italicized gray type and includes:

- Lens and focal length (see the note on page 10)
- Shutter speed
- f-stop (the lens aperture used)
- ISO (the light-sensitivity setting used)

You can use the technical data to learn more about how each photo was made. More importantly, the point of providing this information is to help you use the photos in this book as a starting place for your own photography, if you wish to do so.

▼ Dawn reflections in the Merced River, Yosemite
18–200mm VR zoom lens at 18mm, 1/160 of a second at f/6.3 and ISO 100, tripod mounted.

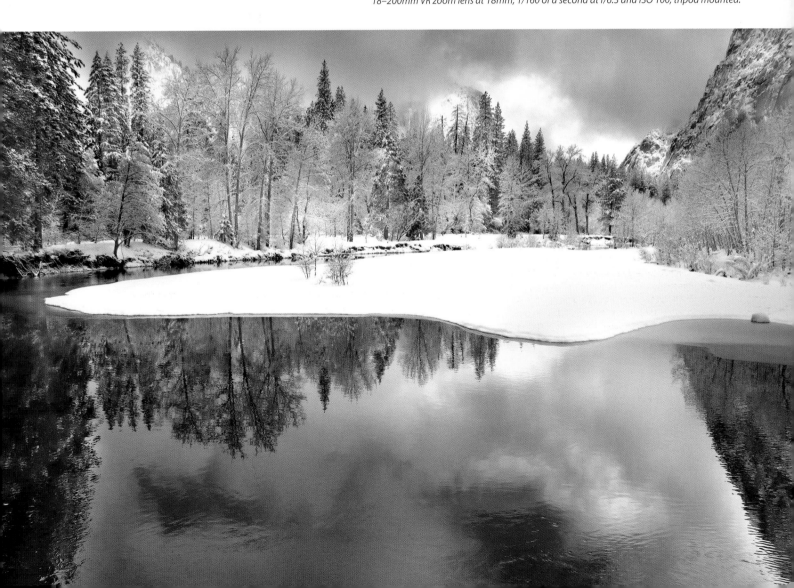

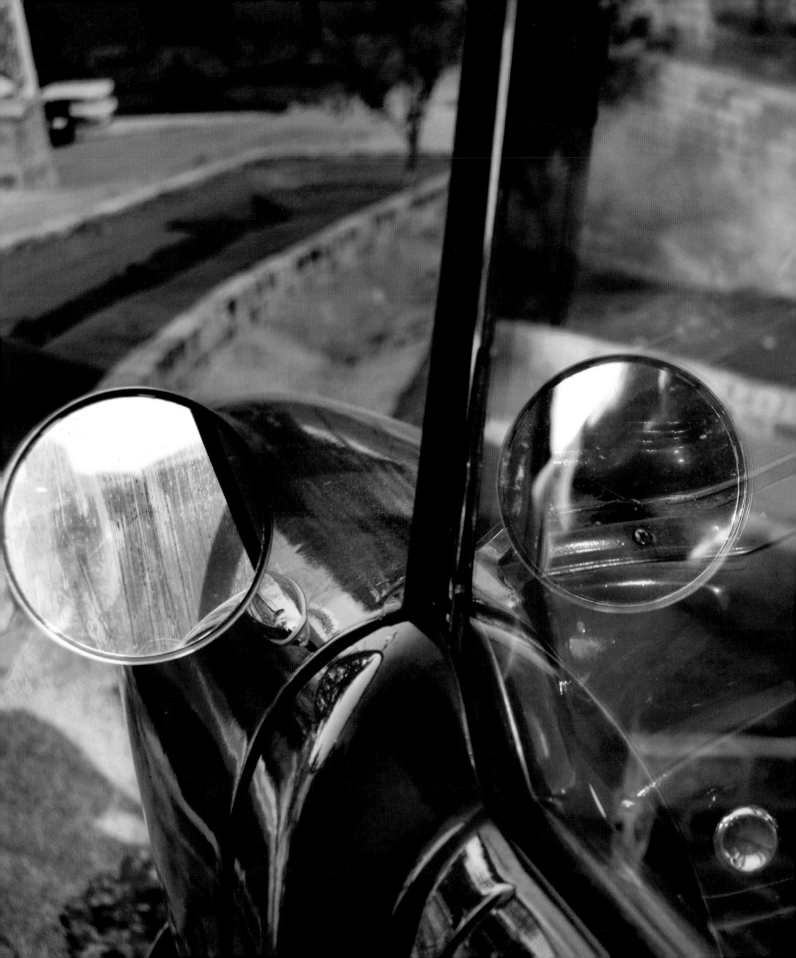

What Is an Exposure?

The word *exposure* can be used to mean a number of different things. It's important to be clear about these meanings. After all, exposure is part of the title of this book.

An exposure can mean a photograph, as in "I've got 100 exposures on my memory card." The word can also be used to refer to a finished photographic print or image on the Web: "Wow! That's a nice exposure."

More relevant to the content of this book, an exposure can also mean the amount, or the act, of light hitting a sensor. Finally, and most importantly, an exposure can also mean the camera settings used to record this incoming light.

With exposure used in the last sense, and given a particular camera and lens, there are three settings (and only three settings) that can be used to make an exposure: shutter speed, lens aperture, and light sensitivity (also called ISO).

Consider that a camera is a light-proof box with a lens attached to an opening in the box, and a mechanism for recording exposures inside the box. This is fundamentally unchanged since the early days of analog photography. So are two of the three settings that make an exposure: shutter speed and aperture.

Shutter speed means the duration of time the camera is open to receive incoming light, and, as a result, the

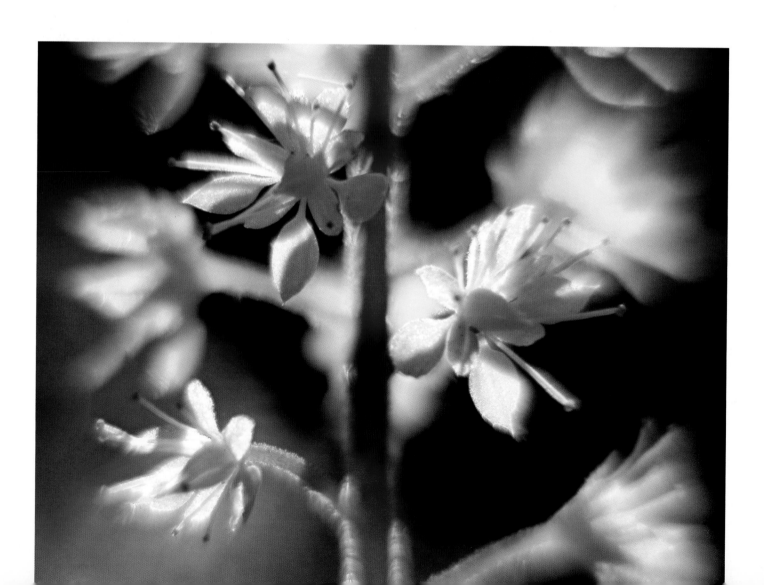

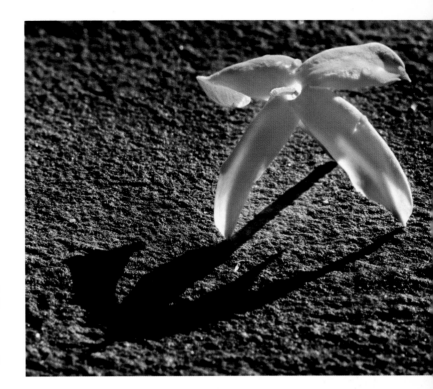

▶ For me, the dramatic aspect of this Jasmine flower on the ground was the long shadow the bud cast, so I wanted to set the exposure controls to render the shadow areas almost, but not entirely, deep black.

200mm f/4 macro lens, 1/40 of a second at f/32 and ISO 100, tripod mounted.

◀ Lying flat on my belly, I photographed the sunlight streaming through this small Tiarella flower (left) with a handheld telephoto, exposing for the dramatic highlights. I knew I wanted to capture the details in the extremely bright flowers, and didn't really care about the background, so I measured the light at its brightest point and set the exposure manually to render these highlights, allowing the background to go black.

18–200 VR zoom lens at 200mm, 12mm extension tube, +4 diopter close-up filter, 1/400 of a second at f/8 and ISO 200, hand-held.

▲ **Chapter opener:** Looking up the hill I saw the sunlight streaming through the vintage Nash Metropolitan. I hurried up and aimed my camera through the driver-side window. My primary concern was the overall exposure, which didn't vary too much from lights to darks. So I was happy to use settings that corresponded to an average light meter reading of the scene as a whole.

18–200 VR zoom lens at 40mm, 1/125 of a second at f/6.3 and ISO 100, hand-held.

amount of time the sensor is exposed to the light coming through the lens. This setting, controlled electronically, can range from a small fraction of a second to minutes (and, in unusual cases, hours). If you think of the shutter covering a window, you get a good mental picture of what is going on. When you set the camera's shutter speed, you are telling the camera how long to leave the shutters on its internal "window" open. I'll cover shutter speed in more depth in Chapter 3, starting on page 84.

The *aperture* means the size of the opening in the camera's lens. Obviously, the size of the aperture will impact the amount of lighting making it through to hit the sensor. The size of the aperture of a lens is designated using an *f-stop* setting, written f/*n*, where *n* is also called the *f-number*. Counterintuitively, the larger the f-number, the smaller the opening in the lens—and the smaller the f-number the larger the opening. (I know, and yes this does seem confusing!)

It's conventional to think of a progression of "full" f-stops, each of which lets in roughly half the light of the previous f-stop: f/1.0, f/1.4, f/2.0, f/2.8, f/4, f/5.6, f/8, f/11, f/16, f/22, f/32, f/45, f/64. When setting the aperture onboard a digital camera, you are not limited to these full f-stop settings, but it is helpful to keep them in mind to get a feeling for how your aperture changes impact the amount of light reaching the sensor.

The maximum and minimum aperture are hardware dependent, meaning that a given lens will have smallest and largest possible openings. Between this minimum and maximum aperture, the lens mechanism called the *diaphragm* creates the polygonal (many-sided) opening that is the aperture. The smaller the opening, the closer to circular it will appear. Chapter 2, starting on page 54, explains more about aperture.

The third component that makes up the settings for an exposure, *sensitivity*, or ISO, determines how sensitive the sensor is to light. With analog photography, the ISO was determined by your choice of film, and a matter of film chemistry. In contrast, with a digital camera you can dial in an ISO setting at any point prior to your exposure (or allow your camera to automatically choose and vary the ISO for you).

With digital photography, ISO has joined shutter speed and aperture as a real-time configurable component of exposure. Of course, there are consequences, digital rather than chemical, to ISO changes (besides changing the sensitivity to light). Just as higher speed films have more grain, boosting the ISO increases the amount of *noise*, or random changes in pixel values, in a photo. (I'll explain ISO and noise more in Chapter 4, starting on page 106.)

It's extremely important to understand something else about the meaning of exposure: a correct exposure cannot be set merely as the response to the average amount of light from a scene falling onto the camera's sensor. This light is easy to measure, but it's only one piece of data. In some cases, you may be able to expose for overall light. But more often you'll care more about specific light or dark areas. Intentionally under or overexposing may also work well. In addition to these significant creative exposure variations, as you read further in this book, you'll see that changing either shutter speed, aperture, or sensitivity has a specific effect (along with a need to adjust other exposure components to compensate for the change).

◄ Looking at the water flying from the sprinklers in a garden, I felt that the most interesting part of the story was the way the sunlight isolated individual water drops. I realized that to capture the play of the sunlight on moving water I needed to use a fast shutter speed.

At the same time, I couldn't use the largest possible aperture because I needed some sense of focus on the flowers and the dark background as well as on the water drops in the foreground. Fortunately, in the bright sunlight I was able to have it all: a fast shutter speed, a moderate aperture, and the lowest possible ISO.

200mm f/4 macro lens, 1/350 of a second at f/10 and ISO 100, tripod mounted.

▲ This is an extreme close-up showing the anthers of a Poppy coated with pollen. I lit the yellow Poppy pod in the rear of the photo so that it would seem like a sun.

With the lighting in place, I knew I needed to be careful to select the aperture that provided just the right amount of focus on the central anther, and blurred the rest of the photo. So I dialed the aperture—using the depth-of-field preview control on my camera to pre-visualize the impact of the aperture changes—until I found the effect I liked best (at f/16), and adjusted the aperture accordingly.

105mm f/2.8 macro lens, lens reversal ring, 1/40 of a second at f/16 and ISO 200, tripod mounted.

▼ After a rain storm, I saw this tiny heliotropic (sun sensitive) Succulent flower reflected in a water drop. It's unusual to catch this flower open following rain, because the flower is usually closed unless the sun is shining.

I was concerned about the dynamic range between the reflected sunburst, and the flower and reflection in the water drop. I realized that an average exposure of the scene would render everything (except the sunburst) too dark, and I wanted to maintain the delicate pink tones of the flower (and particularly the flower in the reflection). So I ignored the exposure readings, and intentionally set my camera to "overexpose" the entire scene. This preserved the tonal values of the flowers, although the color in the sunburst was lost.

200mm f/4 macro lens, extension bellows, 1/8 of a second at f/40 and ISO 100, tripod mounted.

▲ I lit this Iris as evenly as I could using tungsten lights. I wanted to make sure the finished image would have moderate tonal qualities, without deep shadows or blown-out highlights.

Even with my supplemental lighting, the flower showed some variations in dynamic range (the contrast between the lightest and darkest tonal values in a scene). I wanted to make sure that I was right in the middle of the exposure range, so I checked the camera's histogram before capturing the image. (Some cameras will only display an exposure histogram after a photo has been captured, in which case you can adjust your exposure on the next capture.)

A histogram is a bar graph that shows the distribution of values. If the bars are clumped over to the left side in an exposure histogram, then a great deal of the photo will be dark; if the bars are grouped on the right side of a histogram it indicates the possibility of a overexposure. With this image, I adjusted the exposure to let in less light when I saw the heavy clumps of bars on the right side of the graph.

105mm f/2.8 macro lens, 36mm extension tube, 10 seconds at f/40 and ISO 200, tripod mounted.

The Exposure Equation

The exposure equation is another way of saying that the light reflected by a scene towards a camera is captured at a given dynamic intensity by shutter speed combined with aperture and sensitivity.

The phrase "at a given dynamic intensity" means the average overall level of brightness of a scene, and implies that this overall brightness is kept constant. If the overall brightness changes, then of course so must the related exposure settings.

As I've already mentioned, shutter speed is a unit of time, often a fraction of a second, for example 1/125 of a second, or 4 seconds.

Sensitivity is measured by an ISO number. ISO is the acronym for the International Organization for Standardization. ISO numbers, used to describe the light sensitivity of film and digital capture devices, is defined in ISO standard 5800 (1987). A low ISO, such as 100, means relatively lower sensitivity to light than a higher ISO of 1000, which captures ten times the light of ISO 100 (but may produce unwanted side effects, such as too much noise).

Remember, aperture is denoted in f-stops. The larger the f-number, the smaller the physical opening creating the aperture. For example, f/1.4 represents a lens almost fully open (the lens is sometimes said to be "wide open"), whereas f/32 means that the lens is only open slightly (the lens is sometimes said to be "stopped down").

There's a fundamental difference in the numerical scales used to represent aperture compared to shutter speed or sensitivity. Shutter speed is simply an amount of time, and sensitivity is a measurement on a linear scale. You can use these numbers in arithmetic calculations. While the numbers used to represent aperture do relate to the area of the lens opening (actually, to the ratio of the focal length of the lens to the diameter of the lens opening), you cannot get usable results by using aperture numbers directly (that is, without further conversion) in a calculation with shutter speed and sensitivity.

With the definitions in mind (and the reservation regarding aperture), here's how the exposure equation for light at a specific dynamic intensity can be written:

$$\text{Captured Light} = \text{Shutter Speed} \cdot \text{Aperture} \cdot \text{Sensitivity}$$

There are some important practical consequences of the exposure equation. To make the photograph that results from an exposure lighter, you'll need to use a longer shutter speed, a more open lens aperture, or increase the ISO setting. You can use a combination of these setting changes.

The exposure equation also tells one that to make an exposure darker, a shorter shutter speed, or a smaller lens opening, or a lower ISO setting (or a combination of these setting changes) must be used.

As you'll see in later chapters of this book, there are times when for good creative and pragmatic reasons you need to select a specific shutter speed, aperture, or ISO. With one component of the exposure "triangle" set, you can only use the other two components to adjust the exposure for a given dynamic intensity (brightness). With two of the components set, you only have one component left to adjust up or down. (Obviously, with all three components preselected, you already have an exposure without any additional room to wiggle.)

▶ I shot the original photo used in this composite sandwich of endless doors in the officer's quarters in historic Fort Point in San Francisco.

I knew that for the photocomposite to work, I needed to preserve as much detail as possible, as well as get as much of the image as possible in focus. The need for preserving detail meant I needed to use the lowest available ISO (100). The need to keep as much of the photo in focus (high depth of field) meant using the smallest available aperture (f/22). With two of the three components of the exposure equation preselected, I chose the shutter speed (10 seconds) to match the average light on the scene.

Photocomposite, 18–200 VR zoom lens at 95mm, 10 seconds at f/22 and ISO 100, tripod mounted.

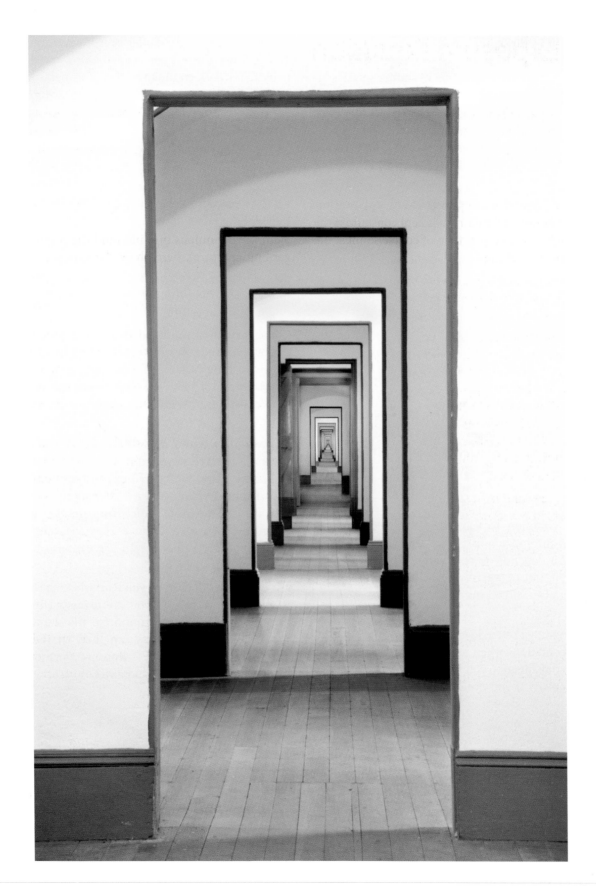

In other words, to change the amount of light your exposure captures, you can change your exposure by raising or lowering any combination of shutter speed, sensitivity, and aperture however much you want. If you go too far towards limiting the light you let into your camera, your capture will be completely dark (black), and if you let way too much light into your camera, the capture will be blown out (entirely transparent); but the choice is yours.

Given a specific dynamic intensity of capture, these relationships are shown as follows:

Preset	Available for Adjustment
Shutter speed	Aperture, ISO
Aperture	Shutter speed, ISO
ISO	Shutter speed, aperture
Shutter speed, aperture	ISO
Shutter speed, ISO	Aperture
Aperture, ISO	Shutter speed

While all the possibilities shown in this table do come into play, the most common sequence is to preset the shutter speed and ISO, and then use the aperture as the variable to match with the exposure or to preset the aperture and ISO, and come up with a shutter speed to complete the exposure.

It's pretty common to leave the ISO set as low as possible to minimize noise. This is a camera-specific setting, so it depends on your camera, but a low ISO setting of 50, 100, or 200 is typical. The higher the ISO, the more noise, so you may want to leave the ISO at this low setting.

One situation that often does call for boosting ISO is in low-light conditions when you are hand-holding your camera. In this situation you might well try boosting the ISO, particularly if you need to stop motion. Freezing motion implies a fast shutter speed, which means that you can't use a tripod and a slow shutter speed to compensate for dark conditions. Digital cameras keep getting better at processing high ISO photos without offensive levels of noise, but if there is too much noise in your image you can likely fix this in the digital darkroom.

The fact that ISO is not commonly thought of as a variable that can be changed on-the-fly like shutter speed and aperture probably has to do with photography's analog heritage. In the old days, you *couldn't* change ISO without changing your roll of film.

So with ISO held constant, for example, at 100, your only variables are shutter speed and f-stop. If you know the shutter speed you need to use, for example, to capture motion, then the only exposure setting you can change is the aperture.

Conversely, with the fixed ISO, if you know the aperture you need to use to get the right depth-of-field, then your only variable that can be changed is shutter speed. Depth of field, the back-to-front distance that is in focus, is explained more in Chapter 2, starting on page 54.

As I've said, assuming the ISO is constant, the exposure equations leads to a spectrum of possible shutter speed and f-stop pairs, each pair representing the same exposure value. When neither shutter speed nor depth of field are an issue, your choice from among these pairs doesn't make much difference. However, the choice of which exposure value pair to use can also be highly significant.

If you need depth of field, you'll be selecting the smallest possible aperture. If you are using a tripod with a subject that is not in motion (so the shutter speed doesn't really matter), you can then let the shutter speed be determined by the exposure equation. As an example, an exposure-value pair of this sort might be 1/4 of second at f/32.

Understanding Exposure Value

Exposure value, or EV, is sometimes used to describe the shutter speed and aperture components of an exposure. In other words, with ISO held constant, for a capture of a given light intensity, EV is represented by sets of shutter speed and aperture pairs, all of comparable total exposure value. To make comparable exposure values clearer, as an example, 1/125 of a second at f/5.6 represents the same exposure value as 1/250 of a second at f/4. The f/4 aperture lets in twice as much light as f/5.6, balancing the 1/250 shutter speed, which lets in half the light of the 1/125 shutter speed.

▶ Sunset cast strong shadows of an old fence on a barn along the northern California coast. I knew that I want to capture detail, so I picked the lowest available ISO (100).

I knew I needed the entire image to be in focus, because I wanted the right part of the image (this part of the image is actually along the fence, running towards the camera) to appear to be part of the same plane as the part of the shadow projected on the barn. To get as much as the image as possible to be in focus (high depth of field) I selected the smallest available aperture (f/32).

With ISO and aperture selected, I used the exposure equation to choose the shutter speed that matched the average light from the scene falling on the sensor. However, when I checked the results of the exposure using my LCD, the exposure seemed too dark. The details of the shadows had gone black.

So I used manual controls to intentionally "overexpose" the photo by lengthening the shutter speed from 1/10 of a second to 1/4 of a second, arriving at what I thought was the best exposure for the situation. When an exposure that intentionally does not match the exposure suggested by the light meter in your camera turns out well, it is sometimes called a good "creative exposure."

105mm 2.8 macro lens, 1/4 of a second at f/32 and ISO 100, tripod mounted.

On the other hand, if you are hand-holding your camera, or photographing a moving subject, you may want to preselect as fast a shutter speed as possible, for example 1/500 of a second.

For a moment, assume that both exposure-value pairs represent an exposure of the same scene. In this case, an excellent use of the exposure equation is to compare two different possible exposures of the scene.

Here's how the exposure equation looks when it is used to compare two different possible exposures of a given scene that capture the same amount of light:

$$\text{Shutter Speed}_{\text{Exp 1}} \cdot \text{Aperture}_{\text{Exp 1}} \cdot \text{ISO}_{\text{Exp 1}} \cong$$
$$\text{Shutter Speed}_{\text{Exp 2}} \cdot \text{Aperture}_{\text{Exp 2}} \cdot \text{ISO}_{\text{Exp 2}}$$

Plugging the example of the exposure of 1/4 of a second at f/32 and ISO 100 into this comparative version of the exposure equation, you can solve the equation to find the aperture that corresponds to a shutter speed of 1/500 of a second:

$$1/4 \text{ of a second} \cdot \text{f/32} \cdot \text{ISO 100} \cong 1/500 \text{ of a second} \cdot \text{f/X} \cdot \text{ISO 100}$$

Dropping the ISO out because it is the same on both sides of the equation above, makes it look like this:

$$1/4 \text{ of a second} \cdot \text{f/32} \cong 1/500 \text{ of a second} \cdot \text{f/X}$$

Each full f-stop lets in half the light of the next larger aperture. So f/32 lets in 1/2 of the light of f/22, 1/4 the light of f/16, 1/8 the light of f/11, 1/16 the light of f/8, 1/32 the light of f/5.6, 1/64 the light of f/4, and 1/128 of the light of f/2.8.

The aperture f/2.8 is the solution for X in the example of the comparable version of the exposure equation because 1/4 of a second • 1/125 = 1/500 of a second (and 1/125 is close enough to 1/128 for these purposes).

Note, as I mentioned earlier, that shutter speed and ISO can be adjusted using straightforward arithmetic. Aperture, on the other hand, is usually manipulated using full f-stop differences. And yes, it is definitely more painful to calculate aperture adjustments in the field than the relatively simple adjustments to shutter speed and ISO. As the film heritage of photography fades into the past, it's certainly possible that aperture will come to be designated using linear numbers that are easier to calculate with. But for now, we are stuck with f-stops.

As time goes by and you get used to the idea of the comparison version of the exposure equation, it will be valuable in the real world to help you determine possible exposure values. I often find myself gauging the impact of different settings, and using the back of an envelope (or more likely, working through the arith-

Don't Sweat the Equations

As a practical matter, if equations give you a headache, don't worry. When your goal is to find the fastest shutter speed possible for a given exposure, the easiest way to quickly do so is to select the widest aperture (smallest f-number) possible for your lens, and then use the exposure equation (or aperture-preferred semi-automatic exposure mode) to determine the shutter speed that correlates for a given exposure.

Things get even easier because, in fact, the maximum aperture for a lens is not an unknown. It is hardware determined. Given a constant ISO, and this hardware-determined maximum aperture, the exposure equation (or aperture-preferred mode, explained on page 32) can easily be used to find the fastest possible shutter speed without cumbersome comparisons. In field conditions, it is surely easiest to use aperture-preferred metering to find the fastest shutter speed you can use.

Since it's easy to review digital captures immediately after they've been made, you'll often want to tweak an exposure to make the final photograph lighter or darker.

Working with Exposure

A good way to start working with exposure is to use your camera to automatically make an exposure. (Alternatively, after a while you may be able to come up with your initial exposure simply based on your own experience and visual assessment of a scene.) Review the exposure. Next:

- Determine whether you want to adjust shutter speed, ISO, or aperture leaving the overall amount of light captured by the camera the same (see Chapters 2–4 for more information about the effects of changing these settings).

- Decide whether you want to intentionally under or overexpose your photo by changing one or more of the shutter speed, ISO, or aperture settings to capture less or more overall light.

metic in my head) for comparative exposure equation calculations so I can understand my options. The comparative exposure equation is a fundamental tool for anyone who wants to understand exposures, how they compare, and when they represent comparable exposure values. This is a tool of practical value for all photographers, even those who largely rely on in-camera exposure automation (because you'll know how to dial in the right amount of exposure compensation to make up for the failings of an automatic exposure).

Your choice of the exposure values that make up the exposure equation for a given photo is one of the biggest creative choices you have available as a photographer. Probably the only more important creative choice is where you decide to point your camera. Realizing the spectrum of exposure values that are available to you—when they are comparable, and also when they are not—is an important step in becoming a technically proficient creative photographer.

If you take matters a couple of steps further, by learning how exposure modes relate to the exposure equation, the consequences of over and underexposure, and pre-visualizing the impact of choice of shutter speed, aperture, and sensitivity, then you will have mastered the basics of exposure.

Using Auto Exposure as a Starting Place

A good place to start finding the right exposure settings is to see what your camera comes up with in automatic mode. You can then move from the shutter speed and f-stop combination the camera suggests using manual mode by trial and error, checking your results as you go by looking in your LCD viewer.

▶ The American West is full of long, empty stretches of road like this portion of US 6 in Nevada near the California border. Fortunately, there's little traffic so you can stand in the middle of the road to take a photo without worrying too much about being run over.

For this photo, I wanted to be sure to expose properly for the road in the foreground, since it is the most important element in the composition, and much darker than the surrounding landscape. Using Programmed Automatic, I aimed the camera at the road, partially depressed the shutter release to hold the exposure settings for the road, and then raised the camera to compose my photo including the landscape with the settings from the road.

18–70mm zoom lens at 70mm, 1/160 of a second at f/8 and ISO 200, hand-held.

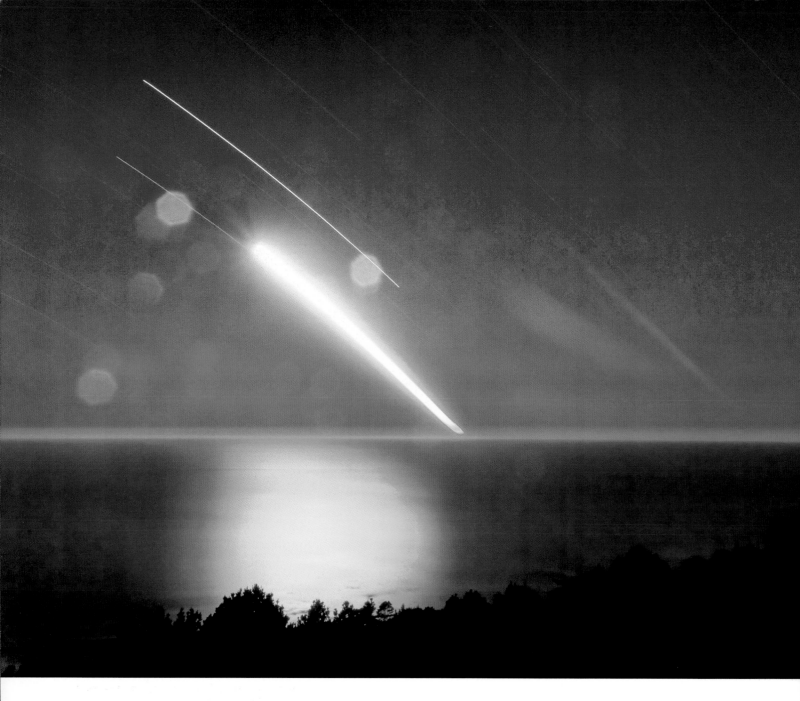

▲ With a long night exposure, it can be hard to find the right exposure components because there's little opportunity for taking more than one photo per night. I wanted my photo to show star trails that were as long as possible, and as much of the moon's descent as it could. I decided to create a 90-minute exposure, roughly the time until the moonset. I took a number of test shots (see photo to the right) and got roughly the right exposure at 30 seconds, f/4 and ISO 640. Since digital photography allowed me to dial in the ISO, it was an easy matter for me to create a test shot this way.

To go from 30 seconds to 90 minutes meant I would be letting in 180 times as much light (without other adjustments). Then, to go down in sensitivity from ISO 640 to ISO 100 meant reducing the amount of light by 6.4. To make the math easier, I rounded 6.4 down to 6. Dividing 180 by 6 , I saw that the aperture I needed should let in roughly 1/30 of the light as f/4.

Going up the sequence of f-stops starting with f/4, each of these apertures lets in roughly half the light of the preceding aperture: f/4, f/5.6, f/8, f/11, f/16, f/22. So, $1/2 \cdot 1/2 \cdot 1/2 \cdot 1/2 \cdot 1/2 = 1/32$, which is why I chose f/22 for my exposure.

Clearly, the transition from test exposure to longer exposure involves some estimation—I divided by 6 rather than 6.4, and cut the aperture by 1/32 rather than my estimated 1/30—but the estimate proved to be close enough.

12–24mm zoom lens at 18mm, 5393 seconds (approximately 90 minutes) at f/22 and ISO 100, tripod mounted.

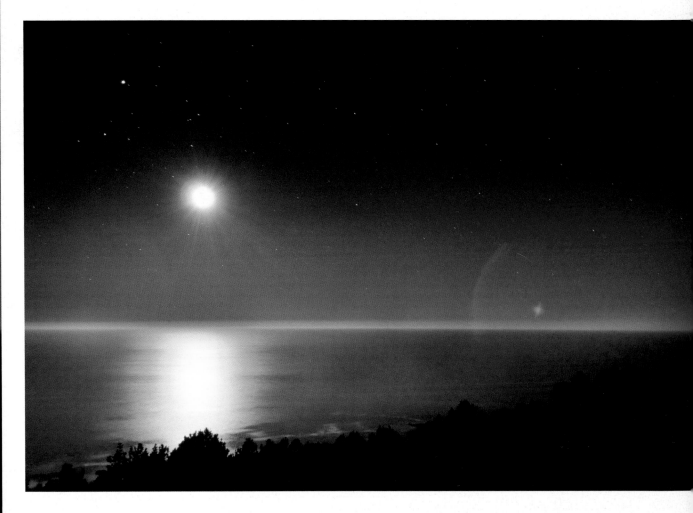

▲ To create this test photo of the moon low over the Pacific Ocean, I snapped the image at 30 seconds and f/4 and tried a variety of ISO settings. This exposure worked best at ISO 640, so I knew I could use the values of 30 seconds, f/4, and ISO 640 for one side of the comparison version of the exposure equation (see the text for an explanation of the equation, and the photo to the left for an exposure of roughly equivalent value).

When I saw this photo on my computer, I realized that the "test" photo may be just as attractive in its own way as the longer "final" version.

12–24mm zoom lens at 18mm, 30 seconds at f/4 and ISO 640, tripod mounted.

▼ When I saw this water drop on a Dahlia petal, I knew there was (relatively speaking) a huge focus difference between the flower in the reflection and the petal.

I knew I had to choose as small a lens aperture as possible (f/45), and after taking a light reading I used the exposure equation to find the corresponding shutter speed (1.5 seconds).

With the camera on a tripod anyhow, the precise duration of the exposure simply didn't matter to me (although even a slight gust of wind would have spoiled the photo).

It's interesting that even with the maximum possible depth of field, the foreground portions of the petal are slightly out of focus.

200mm f/4 macro lens, 1.5 seconds at f/45 and ISO 100, tripod mounted.

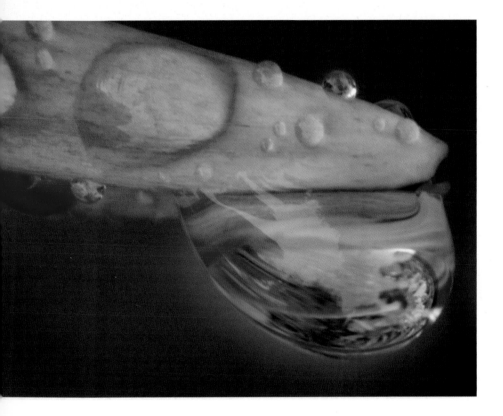

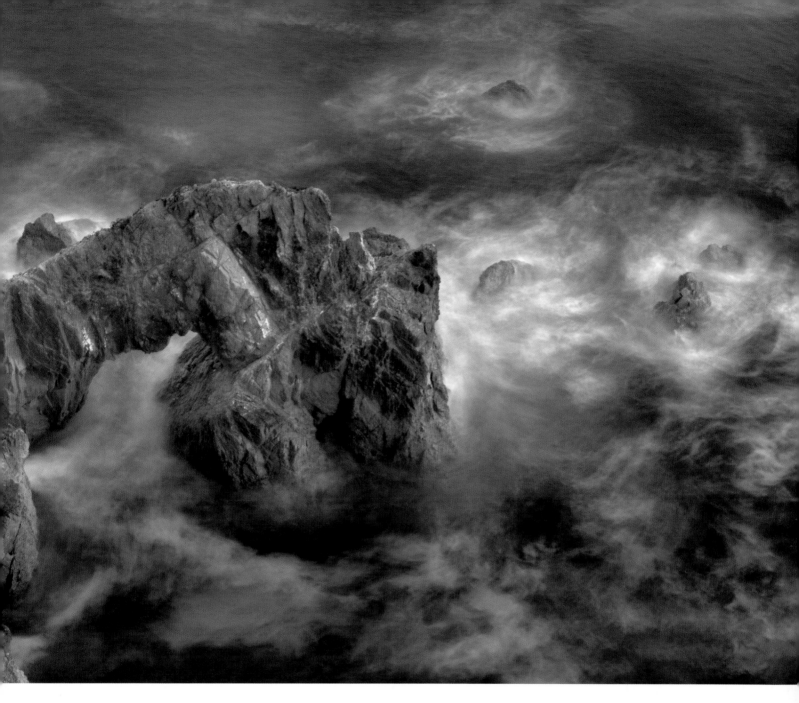

▲ Looking down from a cliff edge along California's rugged Point Reyes peninsula, I saw this rock arch surrounded by white surf. I decided to create a photo that showed the rock as vivid and unmovable. To create this effect, I needed to use an exposure of at least several seconds so that the water would appear blurred by the motion.

With my camera mounted on a tripod, I used shutter-preferred metering and made a number of different captures, each with a different shutter speed. For each shutter speed I chose, my camera's semi-automatic, shutter-preferred metering system used the exposure equation to select the corresponding value for the aperture.

This exposure, at 3.6 seconds, worked better than either shorter or longer exposures because the medium length of time showed some form of the waves and also displayed attractive motion blur. At longer shutter speeds the waves were not recognizable, and at shorter shutter speeds the waves looked out of focus without motion blur.

18–200mm VR zoom lens at 50mm, 3.6 seconds at f/36 and ISO 100, tripod mounted.

Working with Exposure Modes

Sure, you can sometimes get perfectly good results using your camera set on automatic exposure mode. But, of course, using auto exposure substitutes a calculation made by the processor inside your camera for your own creative judgement. Sometimes there's no substitute for manually choosing your exposure components.

Purists will say that if you want to take those great photos you see in your mind's eye, you've got to get your camera off automatic exposure. In part, this is because getting your camera off auto does mean understanding exposure. Great photos start with good exposures (even if these exposures are later enhanced in the digital darkroom). These purists (and I) *do* want you to understand exposure.

Even the purists know that it sometimes makes sense to use one of the semi-automatic exposure modes that I've already mentioned in passing.

As opposed to a fully automatic exposure mode, in a semi-automatic mode you choose one of the components of the exposure equation (such as shutter speed or aperture), and the camera makes the rest of the settings.

If you understand how the different exposure modes work, along with the basics of exposures themselves, you'll know when you can effectively use automatic exposure or a semi-automatic exposure mode. All reasonably sophisticated digital cameras provide four exposure modes (one of which is fully manual exposure), although these modes may go by different names. The

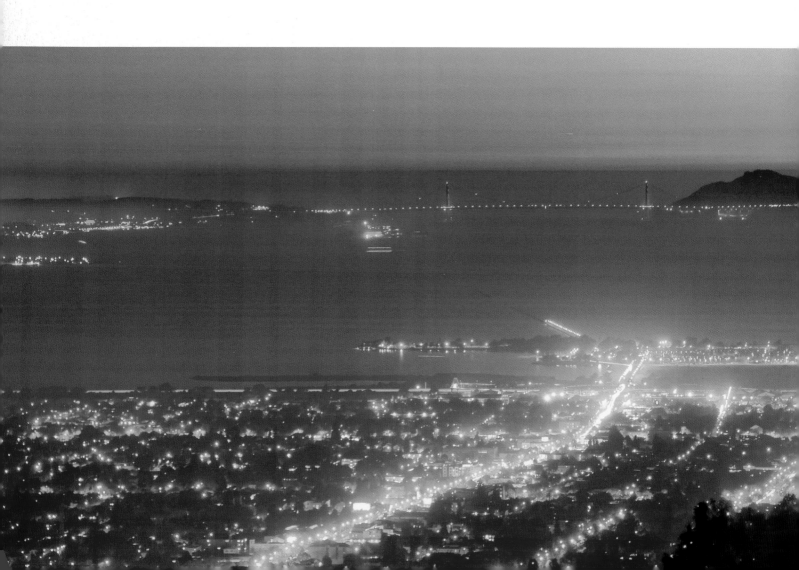

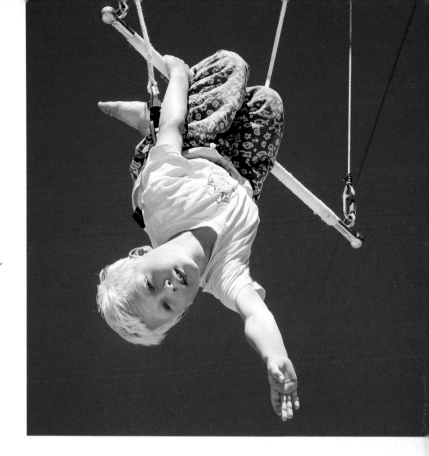

My son Julian was on the high trapeze in the bright mountain sun near Lake Tahoe. To capture him crisply, I knew I needed to use as fast a shutter speed as possible.

My first thought was to use shutter-preferred metering with a fast shutter value. But I realized that shutter-preferred mode wouldn't necessarily give me the *fastest* shutter speed—just the shutter speed I had pre-selected. So I switched to aperture-preferred metering, and pre-selected f/4.5, the largest aperture available. The camera's aperture-preferred mode metering then selected the fastest possible shutter speed, 1/1250 of a second, that combined with the aperture to properly expose the image.

18–70 zoom lens at 70mm, 1/1250 of a second at f/4.5 and ISO 200, handheld.

◄ Looking out at the Golden Gate Bridge, I knew that I wanted to use a long enough exposure time to exaggerate the motion of headlights, and to allow the slight atmospheric fog to soften the photo. I used shutter-preferred metering to set the shutter speed to 25 seconds, and allowed the camera to select the aperture.

18–200 VR zoom lens at 40mm, 25 seconds at f/7.1 and ISO 100, tripod mounted.

important modes are: fully automatic exposure mode, aperture-preferred mode, shutter-preferred mode, and manual mode. Experienced photographers know how to take advantage of each of these modes.

In automatic mode, the camera makes the decisions about exposure settings, and you are (as it were) a by-stander. This mode is good for situations that are moving too quickly for you to fuss with camera controls or to think about camera controls. It's also useful for getting an idea about the proper exposure settings, which you can then modify by switching to manual mode.

In aperture-preferred mode, you set the aperture and the camera selects the corresponding shutter speed. This is the mode to use when the key issue is setting the aperture to select the depth-of-field, and the lighting in a scene is uniform enough so that you expect the camera to get the shutter speed right. In aperture-preferred mode, you pick an aperture and the camera is solving the exposure equation for you, and providing a shutter speed.

In shutter-preferred mode, you set the shutter speed and the camera picks the corresponding aperture. Use this mode when setting the shutter speed is the key issue, for example an extremely fast shutter speed (maybe 1/1000 of second) to capture a moving sports scene, or the landscape from a moving car. In shutter-preferred mode, you pick a shutter speed and the camera chooses the aperture for you using the exposure equation.

In manual mode, the photographer sets both aperture and shutter speed. You'd be surprised at how often you'll end up using manual mode as you learn more about exposure and lighting.

When Should You Use Auto Exposure?

So when should you use fully programmed automatic exposure and let your camera do the thinking for you?

A photograph with generally low dynamic range (meaning no great differences between light tones and dark tones) is a good candidate for auto exposure.

If you don't have time to think out an exposure (perhaps because the lighting conditions are changing quickly), automatic exposure makes sense. At least you'll get something.

Finally, automatic exposure often works as a quick way to get exposure settings. You can use the exposure settings the camera comes up with and adjust them from there to come up with your own exposure settings.

This table shows the relationship between the two semi-automatic exposure modes and solving the exposure equation.

Mode	You Pick	Camera Solves Equation For
Aperture-preferred	f-stop	Shutter speed
Shutter-preferred	Shutter speed	f-stop

For reasons having more to do with history than logical consistency, sensitivity, the third component of the exposure equation, often doesn't have its own semi-automatic mode. Most likely, you'll need to go into your camera's menu system to change the ISO with accuracy.

With many cameras, the menu that lets you change the ISO also lets you select auto sensitivity. Effectively, this setting operates in conjunction with every other automatic and semi-automatic mode. For example,

Scene Modes

Many consumer-oriented cameras also have modes such as "Flowers," "Macro," "Sports," and so on. Under the hood, these modes are all variants of the basic exposure modes.

For example, Sports mode will be shutter-preferred metering with a fast shutter speed selected. And Macro mode will probably be aperture-preferred metering with a small aperture selected.

Some specific cameras have a great many of these derivative modes ("Candlelight mode," "Pet mode," and so on). But there's no

magic here; these are just variants of the basic exposure modes with some additional assumptions about consumer use of the camera figured into the derivative mode.

If you can tell what these modes are actually doing, then you can use them as a shorthand way to achieve specific results. For example, it's often a little quicker to select Sports mode if it is available than shutter-preferred, followed by your choice of a fast shutter speed.

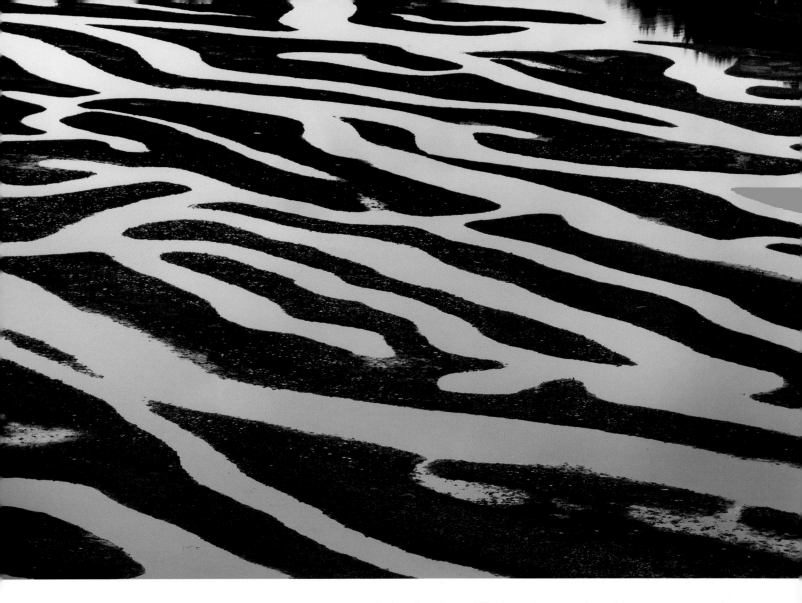

▲ Looking down from a cliff's edge on these water channels in an estuary at sunset, I saw an interesting pattern. But the last light of the sunset reflected on the water was about to disappear. There was no time to be lost.

I also noted that the entire landscape was lit fairly uniformly. This meant I didn't have to expose for one area of highlights or shadows, or adjust for bright or dark lighting. I could use an overall exposure without fear of blown-out highlights or impossibly dark, shadowed areas.

I took the photo on fully programmed automatic, and an instant later the sunset light vanished from the water channels and the world was dark.

18–200mm VR zoom lens at 90 mm, 1/6 of a second at f/10 and ISO 100, tripod mounted.

with aperture-preferred or shutter-preferred metering, the camera is selecting two of the three exposure value components.

However, you should know that the auto ISO setting is potentially dangerous. As I mentioned earlier, in response to low light, the automatic ISO setting will likely choose a high ISO. High ISO settings can produce images that are noisy and unattractive (see Chapter 4, starting on page 106, for more information).

The problem with the auto ISO is not that a relatively high ISO might be selected (as I explain in Chapter 4, choosing a high ISO is sometimes a good idea). The issue is that you probably won't be very aware of the ISO the camera selects when auto ISO is chosen, and may not know the consequences until it is too late because you generally can't see noise issues on the camera's LCD.

If setting the ISO automatically isn't such a good idea, how should you proceed? One good approach is to first pick the ISO. Most often, this will be the lowest possible setting, but sometimes you'll want to boost the sensitivity.

In any case, with the ISO set, the exposure equation will give you a range of exposure-value pairs. You can then pick from these pairs to set your exposure values.

▼ Looking up in Yosemite Valley in the spring, I saw this beautiful Dogwood lit by the sun. I figured that a general overall exposure would work fine for this photo. The only things I really cared about were getting enough depth of field to have the flowers and background in focus, and using a fast enough shutter speed to stop any motion of the flowers from the wind.

Using aperture-preferred metering, I set the aperture to f/8, and then used my depth-of-field preview to check the focus (see page 54 for more about depth of field). I noted that at f/8, I would be exposing at 1/400 of a second, plenty fast enough to stop the slight motion, so I snapped the photo.

18–70mm zoom lens at 50mm, 1/400 of a second at f/8 and ISO 200, hand-held.

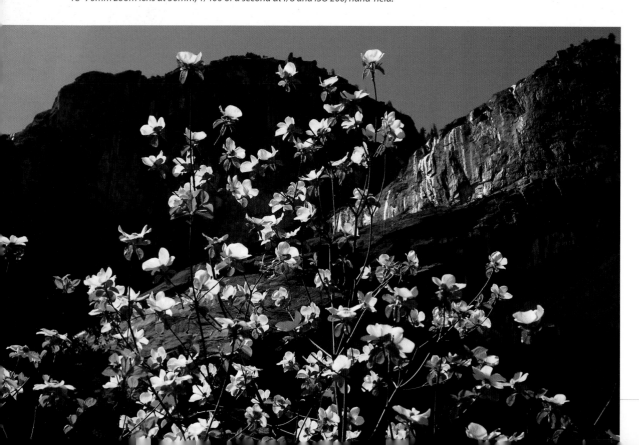

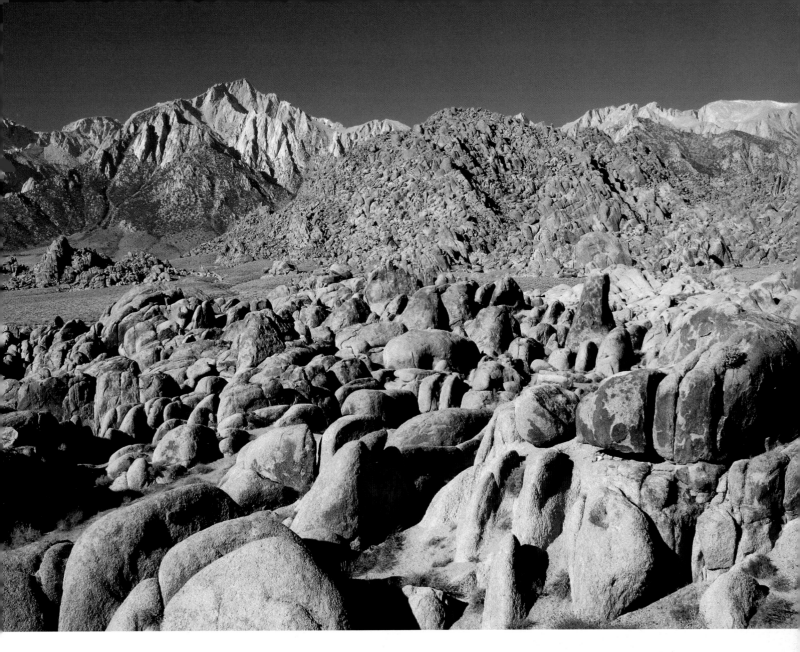

▲ The Alabama Hills lie east of the Sierra Nevada Mountains in Owens Valley, California. This beautiful formation of jumbled rocks is a photographer's delight.

For this photo of the Alabama Hills, with Mount Whitney in the background, I knew that my exposure really didn't matter because nothing was in motion (meaning I didn't care about shutter speed), and everything was in focus at infinity (so I didn't care about aperture), so I used Landscape mode (essentially, a version of Programmed Automatic with the flash disabled that tends to select middle-of-the-road aperture and shutter speed settings).

18–700mm zoom lens at 27mm, 1/200 of a second at f/10 and ISO 200, tripod mounted.

▽ Who could wish for a better, or more poetic, floral subject than Cherry blossoms in a light rain on an overcast day? And yet, this is a technically and aesthetically challenging subject: wind can make long exposures problematic, and precision of focus and depth of field is critical.

With this image, I decided that I was looking for a little bit of depth of field, but not a great deal of depth of field.

I wanted the anthers of the Cherry blossom to be in focus, and the flower to be slightly out of focus. I used the depth of field preview button to gauge the effect of various apertures, and determined I liked the effect at f/10. I then used aperture-preferred metering to find the shutter speed that correlated with f/10.

105mm f/2.8 macro lens, 1/100 of a second at f/10 and ISO 200, tripod mounted.

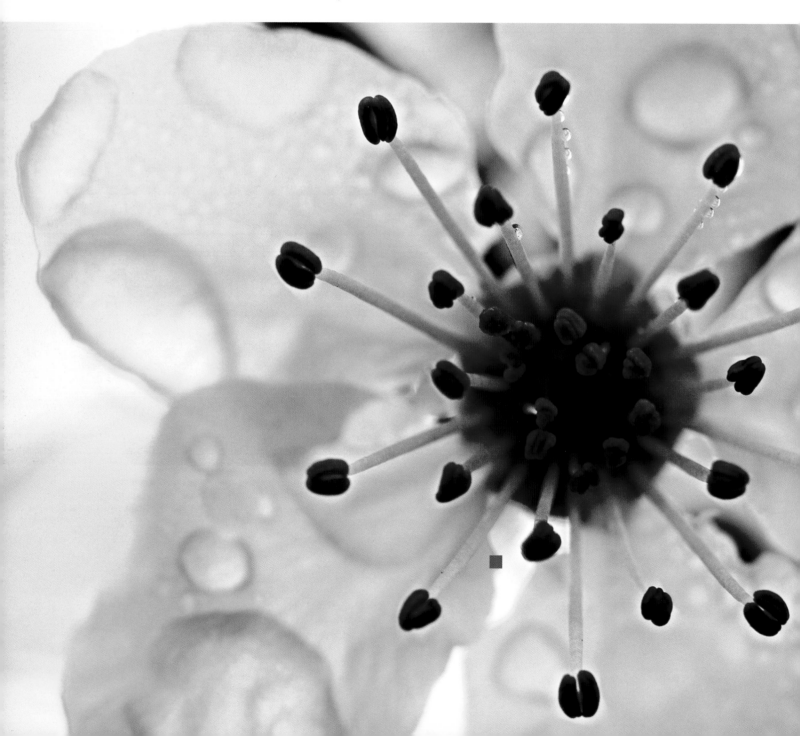

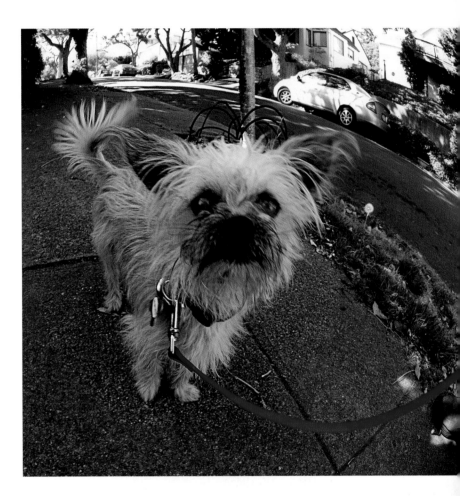

▲ I was fooling around with my digital fisheye lens, when this dog and her human came walking up the street. It's always a good idea to photograph children and small animals on their own level. I got low to the ground so I could capture the dog face-to-face rather than from above.

Choosing f/8 for the aperture gave me moderate depth of field, so the primary subject of the photo, the dog, was isolated from the slightly out-of-focus background while the entirety of the dog was in focus. If I had used a smaller aperture, the street would have been entirely in focus and the dog would have been less clearly the important subject of the photo. I used aperture-preferred metering to find the right shutter speed to expose the image.

10.5mm digital fisheye, 1/60 of a second at f/8 and ISO 200, hand-held.

Measuring Light

The art and craft of measuring light is used to establish a base reading for setting your exposure. This "reading" is a sample exposure given the amount of light available for you to capture.

Once you have a sample light reading, you can use the components in the exposure equation to choose your exposure settings to set shutter speed, aperture, and sensitivity.

The most commonly used tool for measuring light is your camera's light meter. If you choose an ISO and set the camera on auto exposure, you can get an initial light reading, with a supplied shutter speed and f-stop.

You can get initial light readings in shutter-preferred mode by pre-selecting the shutter speed. The camera will supply the f-stop.

Using aperture-preferred mode allows you to obtain a light reading by pre-selecting the aperture. The camera gives the shutter speed.

Aperture or shutter preferred modes are often more convenient than fully automatic for getting exposure readings because you may have some idea already of where you need one of the exposure components to be set.

Depending on your camera model, you can get a light reading simply by turning the camera on and pointing it at your subject, or you may have to partially depress the shutter release button. Check your camera manual for specifics.

A big issue is what you point the camera at to get your light meter reading. Most photographic subjects are not lit uniformly. A brightly lit person will give you a very different light reading than the dark background behind the person. The sky at sunset is a great deal brighter than the dark earth below the sky. The moon is usually much brighter than the earth or sky at twilight. So it's very important to be mindful of what you are pointing the camera at when you get a light meter reading.

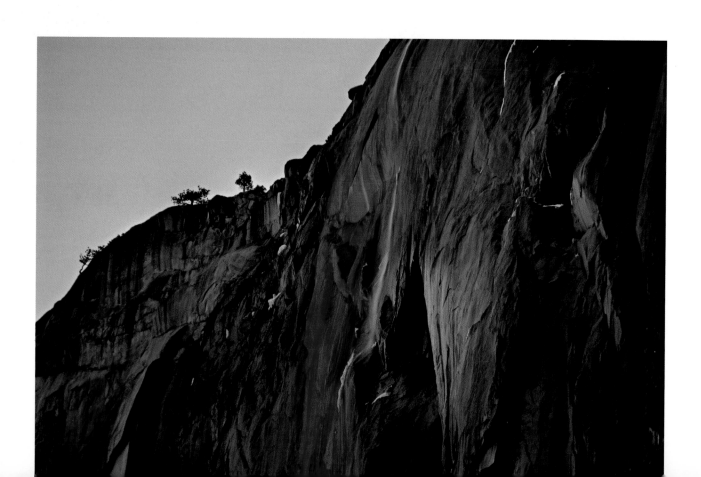

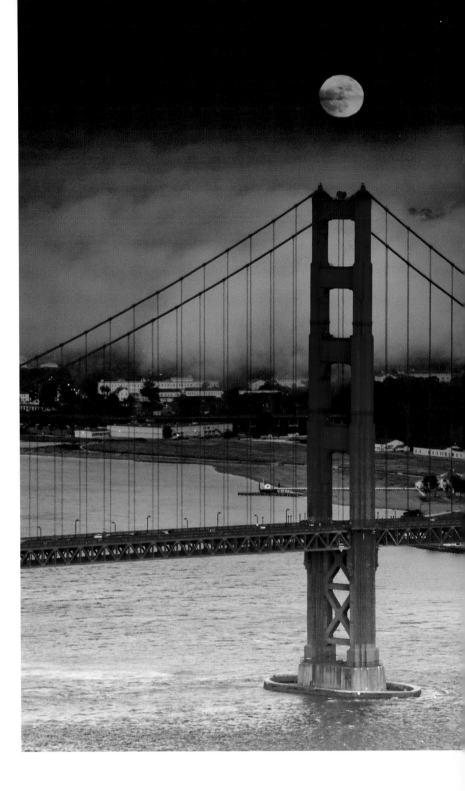

▶ I knew a full moon was rising over the Golden Gate Bridge, and I wanted to capture this moon in alignment with the southern tower of the bridge.

The danger with this photo was that any averaged overall exposure would not take into account the brightness of the moon, and would make the moon look washed out and pale. So I used the spot-metering mode on my camera to take a light reading off the moon, set the data in manually, and got this photo of a wonderfully saturated moon over the bridge against a dark might sky.

18–200mm VR zoom lens at 200mm, 1/13 of second at f/8 and ISO 100, tripod mounted.

◀ Horsetail Falls in Yosemite Valley, Yosemite National Park, is lit by the setting sun during the last week in February, if you are lucky enough to be there when conditions are right.

I captured this phenomenon during the few seconds it lasted, intentionally underexposing to make the colors seem more intense by using a light reading from the dark areas of the cliff to establish the exposure values. Using the darker meter reading from the cliff rather than the lighter waterfall caused the colors of the water and the sunset to turn deep red.

18–200mm VR zoom lens at 200mm, 1/13 of a second at f/5.6 and ISO 100, tripod mounted.

For example, if you are photographing buildings dramatically silhouetted against the sunset sky, and are primarily interested in photographing the sunset, an effective strategy might be to point your camera at the sky, obtain a light reading, and then reframe your photo to include the buildings. This will give you a light reading for the sky, and if the buildings go black because they are underexposed, the effect will merely add to the drama.

If you rely on your camera's metering system in its default mode, you will probably get some kind of average exposure for the scene you are photographing.

More advanced digital cameras also provide the ability to make a *spot* light meter reading. This gives you a light reading for a specific, small area shown in your viewfinder, for example a circular area making up the central 10% of an image. You'll need to check your manual for the details of your spot metering coverage, and how to switch into spot metering. Be sure to point the spot area at the portion of your subject that you want to measure.

If there is no great range of tonal values in your photo, average metering works well. For example, if the light areas of a photo are not very bright while the dark areas are not very dark, then the light meter in your camera will do a good job. If necessary, you can point your camera at the significant parts of your image for your light measurement, and then restore your composition for the actual photo.

For many photos, there is in fact a considerable range of tonal values and it is up to the photographer to take a light reading of the areas of the photo that are most important. Spot metering is a great tool for getting a light reading off the most important areas of your photo, and ignoring portions of the photo that are both very different in light intensity from your important area and also unimportant to your final results.

Using Your Eye To Measure Light

It turns out that one of the most effective tools for measuring light is the human eye. You should make a point of keeping track of your exposure readings in a variety of conditions.

Over time you may learn to be your own light meter. It's likely that eventually you may do a better job than your camera, particularly in extremely low and very high light conditions (when camera light meters tend not to work very well).

▼ As I was wandering along a headland near the end of Point Reyes, California (the westernmost point of land in the continental United States), I saw the sun setting below the cliff. I knew it was hopeless to expect to capture the sun and the cliffs in one exposure, so I decided to ignore the sun and let it blow out.

I used my camera's light meter in spot-meter mode to take a reading from an average area of the cliffs, and took the exposure values I used for this capture from that reading.

12–24mm zoom lens at 24mm, 1/200 of a second at f/7.1 and ISO 100, hand-held.

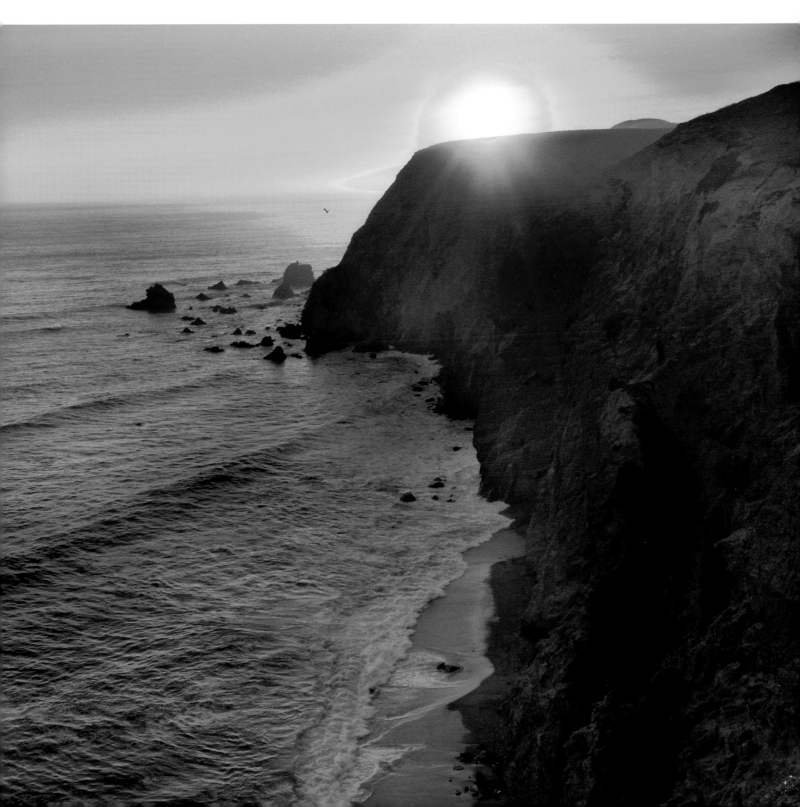

▼ I saw this tiny Cactus flower in my garden. The flower is about 1/4" across. Looking inside the blossom, I discovered a tiny, glowing, red world that I wanted to capture. The natural light outside was shining through the red wall at the back of the flower, creating a luminescent effect. However, the motion of the wind made it impossible to photograph the flower outside because of motion blur.

After snipping the flower and bringing it inside to my studio, I placed the flower on a mirror and sprayed it with water. My job was to recreate the red glow that I had seen inside the flower.

To accomplish this job, I rigged a small household light bulb as a spotlight behind the flower. When I'd taped the flower in place, I could use the luminescent red of the flower core for lighting. I used my light meter in spot mode to expose specifically for this red area, allowing the parts of the flower (other than the red core) to overexpose.

105mm f/2.8 macro lens, extension bellows, 2.5 seconds at f/40 and ISO 200, tripod mounted.

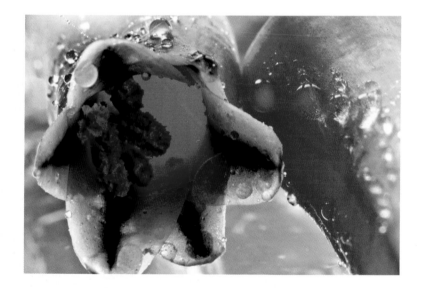

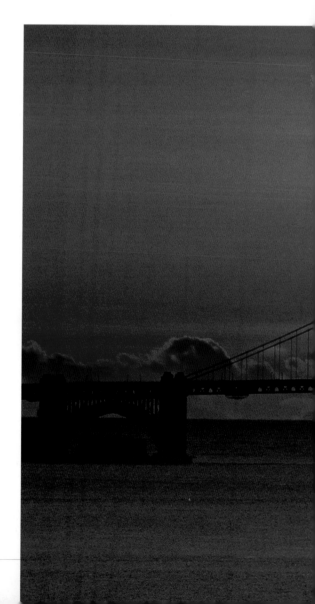

▼ I stood on a high rock in Berkeley, California, across the Bay from the Golden Gate Bridge. With my camera on my tripod, I trained a long lens (600mm in 35mm equivalency terms) on the setting sun behind the bridge. I'd been coming back to this spot every day for almost a month, hoping to capture the setting sun in exactly the right position behind the bridge, and now the moment was at hand.

In taking this photo, I was careful not to look directly through my telephoto lens at the sun to avoid damaging my eyes. I held a welding shade filter (a very dark piece of glass) in front of my eyes as I composed photos in the viewfinder. I also reviewed captures in the camera's LCD screen, and modified settings depending on what I saw in the LCD.

After all the waiting, patience paid off. As the sun started to sink below the horizon, I got this shot. The sailboat in the foreground was an added bonus. The trick in measuring the light so I could find the exposure for this photo was to ignore the disk of the setting sun, and to ignore any overall average light readings of the scene (because the overall readings would be biased by the brilliant sunlight).

I expected the highlights to blow out in any case, so I needed to ignore the sun and expose for the generally less bright areas. I used spot metering on the sailboat in the foreground to get the exposure I ended up using.

70–200mm VR zoom lens with 2X teleconverter at 400mm, 1/400 of a second at f/10 and ISO 200, tripod mounted.

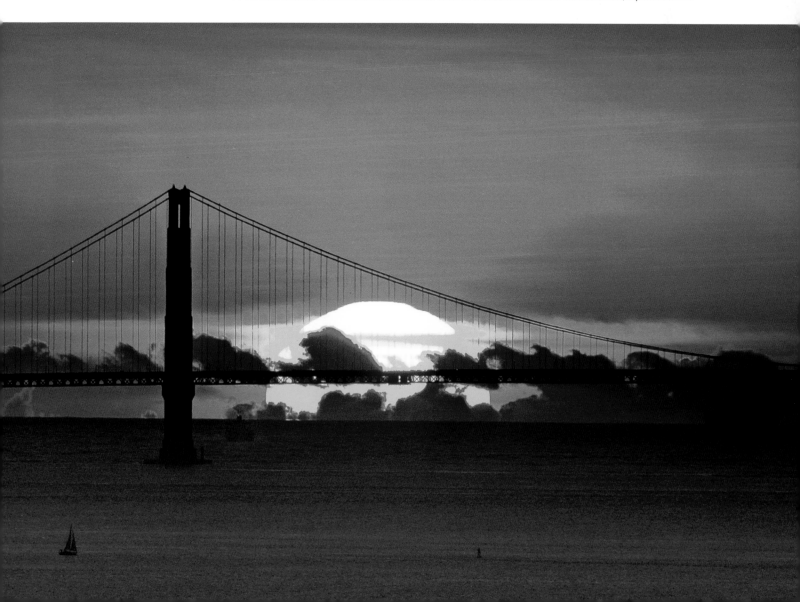

Intentional Over and Underexposure

What is meant by *overexposure* and *underexposure*? Intuitively, overexposed means that a photo is too bright. Colors look washed out, and even "blown out" in very bright areas. An underexposed photo is too dark, so dark that you can't see any details because portions of the photo seem to have become black.

The exposure controls on your camera act as a kind of valve that regulates the flow of light to your sensor. As with a simple electrical circuit, if you let too much current into the circuit, a light bulb on the circuit might blow out (overexposure). If you don't let enough light into the circuit, the bulb might never light up at all (underexposure).

It's usually pretty easy to see when you review your photo in the LCD whether significant portions have been over or underexposed. Most digital cameras will also display an exposure histogram that you can use to analyze an exposure, either before or after it has been captured.

When enabled, the exposure histogram is usually displayed above or below a photo displayed in LCD. It can also usually be displayed in the viewfinder prior to exposing an image. The black "bars" in the exposure histogram show the distribution of light and dark values. If the bars are tall and clumped over to the left side in an exposure histogram, then a great deal of the photo will be dark; if the bars are tall and grouped on

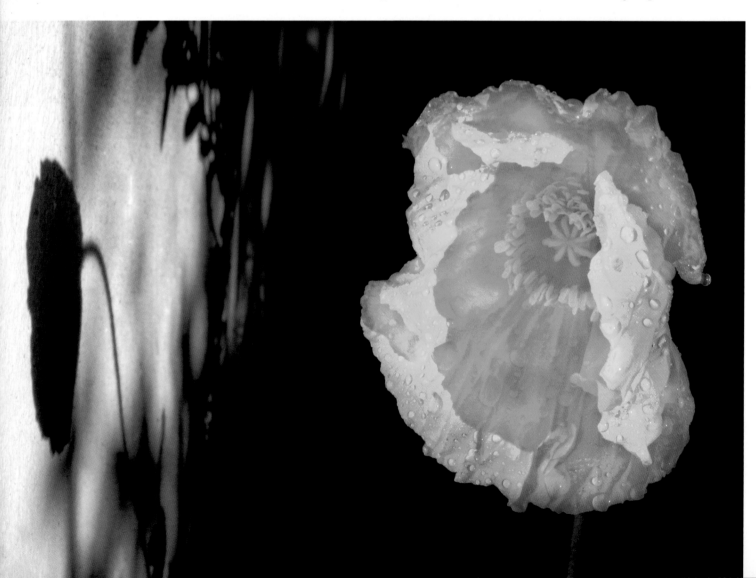

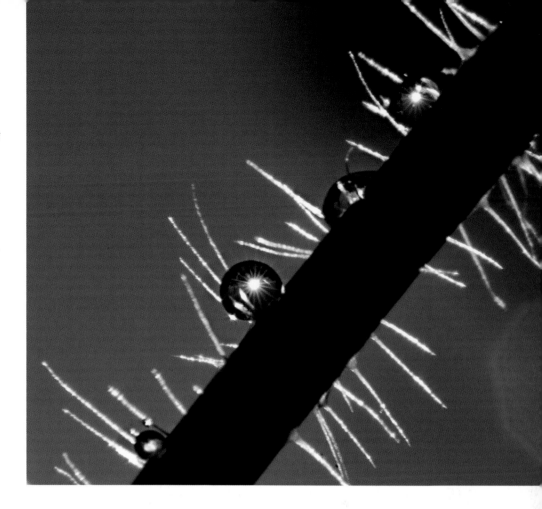

▶ This macro photograph showed a situation of potentially impossible exposure range, from the brightness of the sunbursts in the water drops to the dark plant stem in full shadow.

I decided that it was fine to let the stem go black, but key to render the small bright details, so I intentionally underexposed, taking my initial exposure reading of 1/8 of a second and shortening it to 1/60 of a second.

200mm f/4 macro lens, 1/60 of a second at f/32 and ISO 100, tripod mounted.

◀ I photographed this Icelandic Poppy in bright sunshine against a deeply shaded background. Clearly, I could not properly expose for the sunshine on the wall in the background, the brightly lit flower, and the deep shadows behind the flower. I determined that the flower itself was the most important element of this photo, so I started by measuring the light on it.

I could see that the resulting exposure was too bright (parts of the flower were overexposed and blown out). So I took the exposure down by a factor of 4X, from f/16 to f/32.

The resulting underexposure worked for the flower, but the bright areas on the wall were now too bright. To isolate the flower, and make it the most important part of the image, I worked in Photoshop to make the wall on the left darker.

Sigma 50mm f/2.8 macro lens, 1/140 of a second at f/32 and ISO 100, tripod mounted.

the right side of a histogram it shows the possibility of an overexposure.

Many photographs have both light and dark areas. It may simply not be possible to find an exposure that avoids all over or underexposures in any image (and many images will have both over and underexposed areas no matter what exposure settings you select). Furthermore, there's nothing inherently wrong with really dark areas or blown-out white areas if you want them—it's all a matter of creative control.

If you are photographing a luminous flower translucent on a bright white background, your camera's light meter (if it is not in spot mode) will average the scene and come up with an exposure that is way too dark for the flower portion of the image. If you are photographing a moon in a dark sky, or a bright face on a black background, the camera's idea of an average light reading will greatly overexpose the moon or face. These cases are easy. With the flower on white, you'll need to override an overall light reading for the area of the image, and expose the image so it is two or three times brighter than the camera thinks is right. Conversely, with the bright subjects on a black background, you should select an exposure that lets in considerably less light than the camera's light meter (in averaging mode) thinks is right.

A photo that presents significant areas of deep shadow combined with ares of bright luminosity is said to have a high *dynamic range*. There's no one-size-fits-all answer for how to expose a high dynamic range image. The best in-camera single exposure solution to a high dynamic range exposure problem is to identify the most important element in your composition and expose for that element.

Suppose you have a photo with bright and dark areas and are considering whether to expose for the bright areas (and underexpose the dark areas) or expose for the dark areas (and overexpose the bright areas). In this case, it's a good idea to keep in mind that it's usually possible to rescue dark shadow areas caused by underexposure in the digital darkroom (see Chapter 6, starting on page 150) but virtually impossible to do anything about blown-out highlights caused by overexposure.

The problem of a photographic subject with too great a dynamic range for a single exposure solution is sometimes addressed by taking multiple photos at different exposures. These multiple exposures can then be combined using software such as Photoshop. The combined images are usually called *high dynamic range* (or HDR) photos. If you want to try creating HDR photos, be sure to vary the shutter speed rather than the aperture (if you vary the aperture, you'll get variations in the depth of field, making a viable composite impossible).

A better approach than composite HDR imaging to the problem of a large dynamic range in a single photo is to use the range of exposures inherent in a single RAW capture in combination to create a single properly exposed image. The various exposures created off one single RAW exposure are recombined in Photoshop or other software. This approach assumes you are photographing using the RAW format, and is explained in Chapter 6 on page 164.

Understanding RAW Captures

For the most part, cameras save photographs as JPEGs or as RAW captures. A JPEG is an industry-standard format designed to be used as an e-mail attachment or on the Web. Creating a JPEG involves an interpretation by the camera's processor of what a photo should look like, and also means that not all the original capture has been saved. Advanced photographers primarily use JPEG when the speed of post-processing is the primary consideration (for example, you have hundreds of photos of a soccer game or of a wedding).

RAW capture files do save all the original data generated by an exposure, so to get the most out of your photos it is essential that you save your files using a RAW format. One wrinkle here is that each manufacturer uses a proprietary file format to save RAW data. For example, Nikon saves RAW image data as NEF files and Canon saves RAW photos created using Canon hardware as CRW or CR2 files.

It really doesn't matter what the camera manufacturer calls the RAW data created by your photos. To use the full power of digital the important thing is to save your photos in RAW so that you'll have all the capture data available when you need it. (See Chapter 6, starting on page 150, for more information about processing RAW photos.)

You'll find that the default factory setting, even on some expensive digital SLRs, is to save files as JPEGs. So stop, put this book down, and find your way through your camera's menu to change this setting right now. (Note: Many cameras allow you to save photos as both JPEG and RAW, with the only downside being that a bit more of your memory is used and you have more files to manage.)

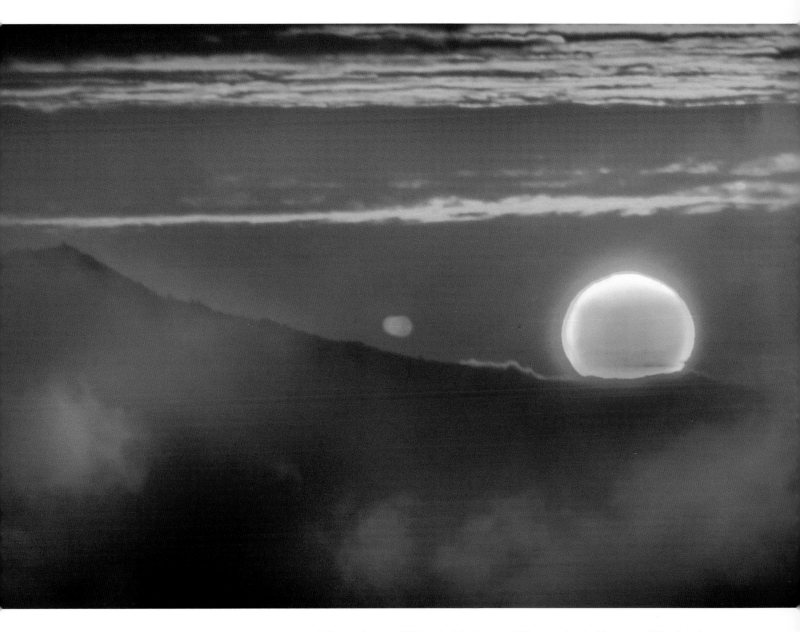

▲ I hiked to the top of Wildcat Peak in Berkeley, California and waited for sunset. With a long lens mounted via a tripod collar on my tripod, I watched as the sun slipped down towards the slopes of Mount Tamalpais.

Knowing that any automated exposure directly at the sun would lead to overexposure, I used manual exposure controls to intentionally underexpose. The sun was bright enough that I couldn't really see the results in my LCD, so I varied the settings (all on the underexposed side) as much as possible, and kept exposing until the sun had gone down. This exposure was one of the most underexposed (darkest) of the set, and is an example of a proper creative exposure that differs from the exposure reading of the camera.

70–200mm VR zoom lens at 200mm, 2X teleconverter (600mm effective focal length in 35mm terms), 1/20 of a second at f/32 and ISO 100, tripod mounted.

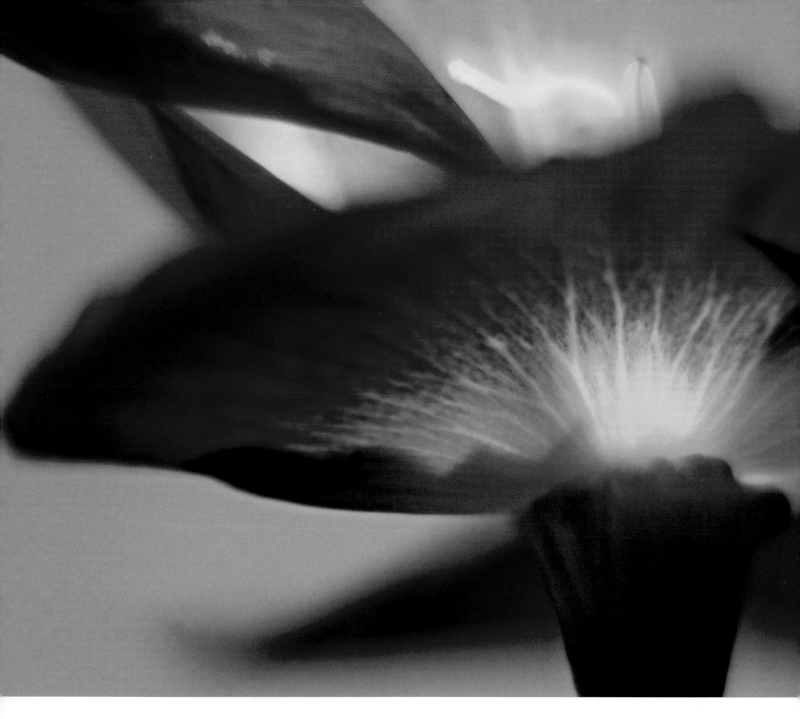

▲ It was definitely a risky business pointing a long macro lens at this unusual purple Poppy lit from above by bright sunlight. You never know how photographs shot towards bright sunlight are going to come out. There's a distinct danger of blowing out highlights. Taking risks is half the fun of creative photography!

As I took each capture, I carefully reviewed it in my camera's LCD display. It became clear to me that changing the aperture was key to determining how the photo would come out. As I experimented with aperture settings, I realized that I really liked the way the flower looked with low depth of field, apparently blazing and burning in the bright sunshine.

Using f/8, the aperture that created the effect I liked, I tried various shutter speeds. According to the histogram in my camera, the image was overexposed at 1/250 of a second. But I liked the fact that you could see detail in the brighter, shadowed areas. Also, I was prepared to accept the blown-out highlight on the lower right (this blown-out area appears as the slightly out-of-focus white oval area).

200 mm f/4 macro lens, 1/250 of a second at f/8 and ISO 200, tripod mounted.

▼ As part of a brand identity advertising campaign, I was asked to photograph Roses and make them look translucent. To photograph this Rose, I placed it on a light box, lighting it from above and below.

I knew that to achieve the desired effect I would need to intentionally overexpose the photo. My initial overall light reading showed an exposure of 1/10 of a second and f/32 and ISO 100.

Next, I made a sequence of exposures manually, each exposure letting in more light than the previous exposure. I then compared the group of exposures on my computer monitor. This exposure met the needs of the assignment best, and is an intentional overexposure of almost six times.

105mm f/2.8 macro lens, 2/5 of a second at f/22 and ISO 100, tripod mounted.

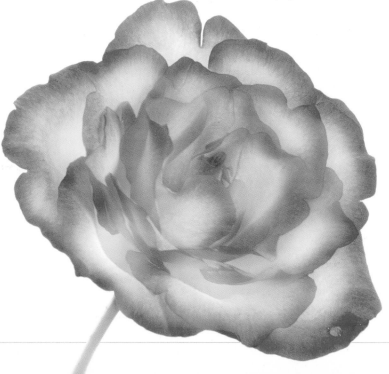

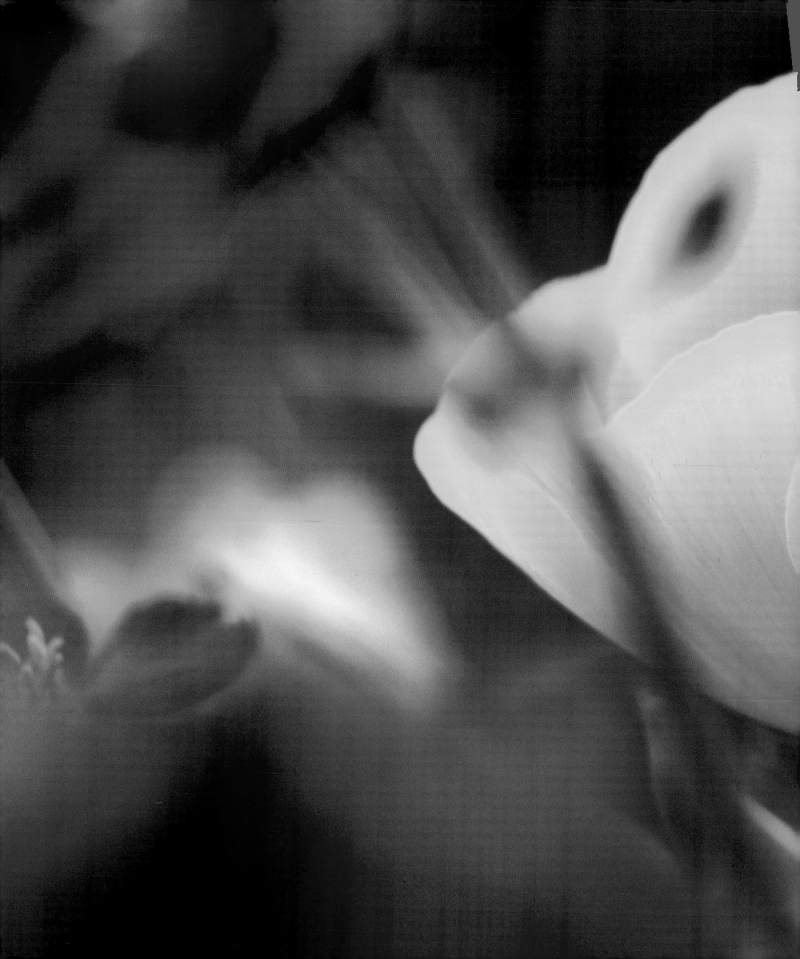

Aperture and Depth of Field

As a photographer, it's important to have a good general sense of how aperture relates to depth of field. Add to this a sense of where you should focus for maximum depth of field, and you'll have a great head start in using aperture creatively in your photos.

But the rubber meets the road, or the finger meets the shutter release, when you are actually taking photos. How can you get a sense in real time, while you are taking photos, of the impact of your aperture choices (so that you can adjust aperture as necessary)?

In Chapter 1, I explained that aperture, one of the three components of an exposure, refers to the size of the opening in the camera lens. Aperture plays a crucial role, along with shutter speed and sensitivity, as one of the three components of an exposure.

As I described in Chapter 1, the notation commonly used for aperture is the f-stop, written f/*n*. *n* is called the f-number, and corresponds to the diameter of the opening in the lens. Unlike the other two exposure components, you can't use f-stops or f-numbers in a direct arithmetic calculation to adjust exposures.

Understanding f-Numbers and f-Stops

The *focal length* of a lens means the distance from the end of the lens to the sensor. An f-number is defined as the ratio of focal length to the aperture diameter. This means an f-stop is one over the ratio of focal length to aperture diameter. (So if you know the f-stop, you know the f-number, and vice versa.)

As I explained in Chapter 1, and show in the table on page 53, full f-stop numbers are picked because each full stop lets in half the light of the preceding full stop. What you really need to know is that each full f-stop lets in half the light of the preceding stop, and that the larger the f-number the smaller the opening.

You can get a good sense of how an f-stop relates to the actual opening in a lens that it designates by setting a lens to the f-stop. Next, look at the aperture by peering through the business end of the lens. (You will likely need to use the depth of field preview on your camera, described on page 53, to actually stop your lens down

to see the aperture.) By changing the f-stop, you'll see the effect on the actual opening in your lens.

Here's a diagram showing the comparative area of full f-stop apertures:

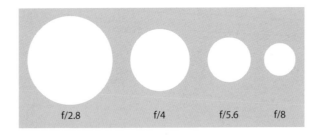

f/2.8 f/4 f/5.6 f/8

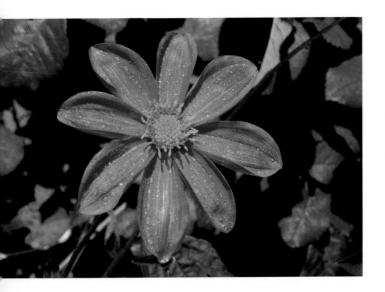

These two photos of a Dahlia taken from the same position in the same light illustrate the impact of aperture on depth of field.

◀ The photo on the left, taken with the lens stopped down all the way for maximum depth of field at f/32, shows the flower in focus as well as a recognizable background.

▶ The photo on the right, with the lens almost all the way wide open for minimal depth of field at f/4, shows the flower in focus, but the background is elegantly blurred.

While the high depth-of-field photo (left) might show the green foliage more exactly, there's little doubt in my mind that the low depth-of-field version (right) is a more visually pleasing image because the background blur is attractive and because the flower appears isolated from the background.

Both photos: 105mm f/2.8 macro lens, ISO 100, tripod mounted. Left: 1/20 of a second at f/32. Right: 1/1250 of a second at f/4.

Besides its role in partially controlling the amount of light let into your camera for an exposure, the major aesthetic role of aperture in a photograph is to control the extent of depth of field (the distance in front and behind a subject that is apparently in focus). There are physical limits to the minimum and maximum depth of field in an image that have to do with the optical properties of the specific lens in use (and of the scene photographed). But within these limits, setting depth of field by manipulating the aperture used is a key element of creative decision making in photography.

Remember, a large number as an f-number means a small lens aperture (the lens is said to be "fully stopped down") which leads to high depth of field. (Higher depth of field is an optical property of smaller openings; for example, you'll notice the effect of things seeming sharper when you squint your eyes.)

Conversely, a small number for the f-number means the opening in the lens is "wide open" which implies shallow, or low, depth of field.

The table to the right shows full f-stops (each of which lets in half the light of the f-stop preceding it in the table), the relative decrease in amount of light let in compared to the maximum aperture, and a description of the depth of field you can expect. (Of course, maximum and minimum apertures are hardware determined, and not all lenses will open as wide as f/1.4

Full F-stops	Light Allowed in Compared to Max Aperture	Depth of Field
f/1.4 (max aperture)	N/A	Lowest
f/2	1/2	Shallow
f/2.8	1/4	Shallow
f/4	1/8	Shallow
f/5.6	1/16	Medium
f/8	1/32	Medium
f/11	1/64	Medium
f/16	1/128	High
f/22	1/256	High
f/32 (min aperture)	1/512	Highest

or stop down as far as f/32.) Many photographers, as they get used to noticing the f-stop as they take photos, end up memorizing the progression of full f-stops shown in the table.

It's important to understand that you are not limited to full f-stops. With most cameras, it's possible to choose f-stops in between the full stops, like f/6.3 or f/9 (which choices you have available is hardware dependent). The point of the sequence of full f-stops is to give you a way to compare possible exposures settings, not that you are always limited to using full f-stops.

Extremely high depth of field can be used to make an entire image appear sharp, for example from the

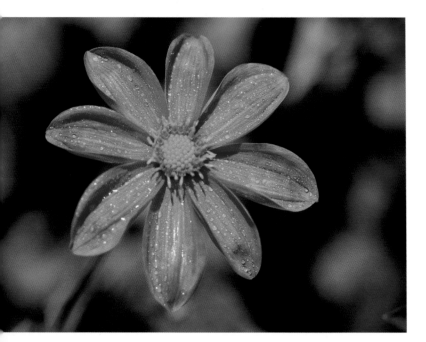

▲ **Chapter opener:** I was all set to photograph flowers at one of my favorite local nurseries. The problem was that the flowers (and everything else) were blowing around in a fierce wind. So much for flower close-ups! (Close-up photos are also called *macros*; see pages 76–77 for more information.)

I stabilized my camera by mounting it on a tripod, and decided to experiment with allowing flowers to blur as they moved in the fast wind. I realized that to create a striking image, I needed a flower that wasn't in motion (at least for an instant). That flower would also have to be isolated from the flowers in motion, using low depth of field.

Choosing an aperture of f/5.6 to give me my low depth of field, I waited patiently for the California Poppy shown in the chapter opener to stay still while the surrounding flowers were moving. The result shows pleasing foreground and background blur.

70–200mm VR zoom lens at 130mm, 1/125 of a second at f/5.6 and ISO 200, tripod mounted.

flowers two feet in front of you to the distant cumulus clouds in the back of the scene. Of course, this envisioned photo takes some doing. The lens will likely be stopped down at its smallest aperture, implying a slow shutter speed, implying that the camera is stable on a tripod and also that any subject motion shows as a blur. Since macro photos have an inherently low depth of field, almost any macro photo requires a small aperture to get much of the image to appear in focus.

Wide angle lenses (lenses that capture a wider angle of view than the normal human perception, considered to be about 53 degrees) have greater inherent depth of field than telephoto lenses (which capture a narrower angle of view than the normal human perception). But even using a wide angle lens, set for maximum depth of field, getting all the elements of a disparate scene in focus requires correctly setting the point of focus.

Depth of field, as I've mentioned, is officially defined as the distance in front and behind a subject that is apparently in focus. But focus is not always the same thing as sharpness. It's really important to understand that a photo can have high depth of field and still not appear sharp. In fact, sometimes a low depth of field image with a single element in focus appears sharper (at least the element does) than the image would with loads more depth of field.

The distinction is important enough to bear repeating: Depth of field is not sharpness. Essentially, maximum sharpness is only possible at one distance. Other points may appear acceptably sharp, depending on aperture and a variety of other factors. However, in the real world, apparent sharpness is controlled by a variety of factors that have nothing to do with depth of field, including the optical quality (sharpness) of the lens, whether the sensor or optical surfaces of the lens are dirty, whether the lens is in precise alignment with the camera, whether there is haze in the environment when the photo is exposed, and whether there is camera shake or subject motion (see Chapter 3).

In this connection, you should know that lenses are seldom at their optical sharpest at either their maximum or minimum apertures. Optical performance tends to be best in a two- or three-stop range, stopped down two or three stops from the maximum aperture of the lens (although there are exceptions to this generalization, so there is no substitute for getting to know your own lenses by taking lots of photos and examining them at high magnifications). For example, a lens with a maximum aperture of f/2 might well be sharpest between f/5.6 and f/11, with significant deterioration at either f/2 or f/32.

Depth of field, as opposed to optical sharpness, does play a gigantic role in *apparent* sharpness in a photo. A photo with very high depth of field can present a hyper-real view of a grand vista, or of a close-up. A photo with low depth of field can emphasize a single element that is in focus against a blurred background, making the element appear significant (and apparently sharper than if the entire photo were in focus).

The *hyperfocal distance* is the closest distance at which a lens at a given aperture can be focused while keeping objects at infinity acceptable sharp. *Infinity* (∞) is the farthest distance a lens can focus. Note that, despite its name, infinity in photography is actually a finite distance: it's the distance beyond which everything is in focus, even at the widest-open aperture.

Keeping Parallel to Your Subject

Since depth of field is so important an element in low depth-of-field photos, it is very important to leverage the depth of field you do have. A photo of a flower in focus against a blurred background may not work if the flower (as well as the background) is partially out of focus. And, yes, even flowers and other "thin" subjects do in fact have some depth.

Most of the objects in this kind of photo will be out of focus, other than the element you have made the subject. It's important to try to maximize the focus depth you do have by placing the camera as parallel as possible to the primary subject of the photo. With the camera body parallel to the subject, variation in the depth of the subject relative to the camera is minimized. This means you get the most advantage of the depth of field you do have!

If a photo is in fact taken at a focus of infinity, and the entire subject is at a distance of infinity, the photo will be in focus (although not necessarily sharp). Depth of field is irrelevant, and your choice of aperture makes no difference from the viewpoint of depth of field. Wide angle lenses have a closer hyperfocal distance than telephoto lenses. So it's quite possible, depending on your lens and its focal length, that everything from, say, thirty feet on is in focus no matter what aperture you select.

However, if you stop a lens all the way down for maximum depth of field, objects from roughly half the distance of infinity out to infinity should be in focus. So in the hypothetical example of a slightly wide angle lens with an infinity focusing distance of 30 feet, with the aperture closed down to as small an opening as possible (depending on your lens, it might be f/32), then everything beyond about 15 feet (the hyperfocal distance) should be in focus.

In this hypothetical example, you'll get an even greater field of focus if you focus at 15 feet (rather than infinity) because some of the distances less than 15 feet also come into focus. (Some photographers like to say that focusing on infinity in this situation is "wasting" the depth of field.)

The optical formulas that are used to calculate depth of field show that there is always more depth of field behind a subject than in front of it. The implication is that the best place to focus, from the viewpoint of maximizing depth of field, is slightly in front of your subject. (How much in front depend upon how much depth of field you have to use, which depends upon your aperture choice.)

In the digital era, its a good plan to take the photo and check your LCD. If you don't like what you see, adjust your aperture setting, and try again.

Sometimes bright light makes it difficult to clearly see the image in the LCD. In addition, you might want to understand depth of field before you make the exposure (perhaps you or your subject is moving).

Many digital cameras, and almost all digital SLRs, have a depth-of-field preview control (check your manual). Using the depth-of-field preview lets you see the photo with the lens stopped down to the actual aperture you selected, a good way to gauge for yourself the impact on depth of field of your aperture choice (and where you focused). If your selected aperture is so small that the image is too dark for you to see what's going on, open the lens up a stop or two, let your eyes adjust, and then slowly stop the lens down again.

▶ Water drops present a particularly ticklish depth-of-field problem, because the distance from the scene reflected in the water drop to the surface of the water drop is usually quite great in comparison to the size of the water drop. Most water drops involve extreme close-up work, with the consequent inherent low depth of field.

Making matters even more difficult, the water on the surface of a drop is usually in constant motion from the forces of gravity, capillary action, and the wind. This motion is amplified because of the small subject size. Camera vibration is also a problem.

In this water drop photo, I took advantage of the bright sunlight to tackle these problems with a relatively fast shutter speed even with the lens stopped down for maximum depth of field, and waited for a still moment. As the sunlight lit the water drop, stars appeared at its edges. The starbursts and the octagonal prismatic effect at the upper left were a reward for the effort involved in taking this photo.

200mm f/4 macro lens, 1/5 of a second at f/40 and ISO 100, tripod mounted.

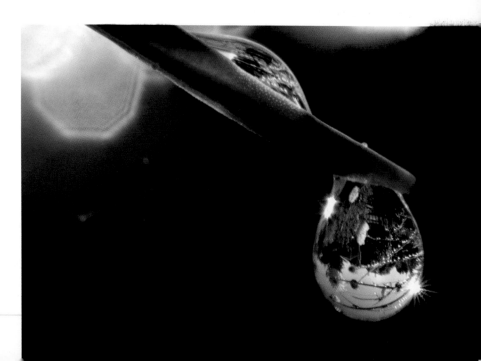

Smaller Size Sensors and Depth of Field

Many photographers understand that wide angle lenses have inherently greater depth of field than telephoto lenses, that macro photography usually requires high depth of field, and that small apertures (e.g., f/32) create more depth of field than larger apertures (e.g., f/1.4). It's perhaps less well understood that the size of the sensor has a direct impact on depth of field. The smaller the sensor size, the greater the depth of field at a given effective focal length and f-stop.

Sensors are classified by their *crop factor*, which compares the sensor with a frame of 35mm film. For example, some Nikon dSLRs have a sensor crop factor of 1.5, meaning that comparing width to width, the Nikon sensor is smaller in a ratio of 1/1.5 than a 35mm frame. (Some of the Canon dSLRs have sensors with a 1:1 ratio compared to the 35mm frame, and other Canons have a 1.6:1 ratio).

Compact fixed-lens digital cameras use much smaller sensors, with typical crop factors in the 2.5 to 5 range. Compared to the sensor in a dSLR, these sensors are small, with camera phone and lower-end camera sensor widths between 1/4 and 2/3 of an inch.

Given lenses of roughly similar effective focal length, depth of field is directly proportionate to sensor size. An f/8 or f/11 aperture is often the smallest opening on a compact digital camera, providing the most possible depth of field. Because of the small sensor size, this compares with an aperture of f/16 or f/22 on a dSLR with a larger sensor.

At the other end of the range, it is almost impossible to create photos with truly low depth of field using a camera with a small sensor. If your sensor is small, even a wide open aperture like f/2.8 provides high depth of field.

For many photos, high depth of field is good. Small sensors provide higher depth of field, so maybe they are good, too? What, in fact, are the advantages and disadvantages of small sensor size?

More depth of field at moderate apertures on the small sensor fixed-lens digital cameras means that you can take images with everything in focus without having to use long exposure times.

In addition, wide angle photos taken with a camera that has a small sensor will exhibit very high depth of field, often a good thing. On the other hand, even at the biggest aperture settings you still have plenty of depth of field with small sensor cameras. This means that it's hard to take photos that isolate subjects, like flowers against a blurred background, or portraits where the background is out of focus.

Leaving depth of field out of the picture, it is a fact of physics that smaller sensor images will always have inherently more noise than larger sensor images. It also seems to be a fact of life that sensors and the related software are continually improving—so tomorrow's small-sized sensor may perform better than today's larger sensor.

◀ Macro mode on this fixed-lens digital camera brought me extremely close to this watch mechanism. Due to the smaller sensor size of the camera I had an extraordinary amount of depth of field for the magnification. At f/8, the lens was stopped down as far as it would go, but I was still able to make a relatively short exposure (1/10 of a second).

Canon Powershot G3 fixed lens camera, sensor with a crop factor of approximately 4.5X, 28.8mm (140mm in 35mm equivalent terms), macro mode, 1/10 of a second at f/8 and ISO 50, tripod mounted.

▲ I took this photo using an older fixed-lens digital camera with a quite small sensor. I used the camera's manual exposure controls to stop the lens as far down as it would go (the smallest aperture was f/8).

Due to the small sensor size, the f/8 setting gave a remarkable amount of depth of field for a macro photo (more like you'd expect in the f/16 to f/22 range when using a moderate telephoto on a dSLR with a larger sensor).

Canon Powershot G3 fixed-lens camera, sensor with a crop factor of approximately 4.5X, 28.8mm (140mm in 35mm equivalent terms), macro mode, 4/5 of a second at f/8 and ISO 50, tripod mounted.

▼ With wireless flash units seated on a ring at the end of my macro telephoto lens, both camera settings and the amount of light the strobes emitted were controlled from my camera. I knew that at the 1/60 of second flash synch speed, the motion of the bee on the flower would be stopped by the effective exposure time, namely the duration of the flash—a lot shorter, of course, than 1/60 of a second. (Depending on the flash unit and its power source, the flash duration can range between 1/10,000 of a second and 1/250 of a second.)

Using the flash, the exposure time was determined by the flash, leaving aperture as the creative variable in the exposure equation. Using aperture, I could control depth of field. I set the aperture to f/16, so that there would be enough depth of field to make the entire bee from wingspan to wingspan appear in focus, with the flower behind slightly out of focus.

200mm f/4 macro lens, 1/60 of a second at f/16 and ISO 100, wireless strobe, tripod mounted.

▲ With this Easter Lily photo, I was looking to create an image that went beyond the cliché image of a white Easter Lily.

At the extreme close-up range of this photo, focused on the Easter Lily anther and pistils, I piled on as much depth of field as I could by using an f/40 aperture. Even so, the background of the Lily itself became a graphic blur, more resembling a star in shape than a flower.

200mm f/4 macro lens, 2 seconds at f/40 and ISO 100, tripod mounted.

▼ These water drops, suspended on a web, reflected sunlight and the colors of the garden around them. I took advantage of the dark background to underexpose the image, bringing out the colors, and an intermediate depth of field setting (f/18) so that a horizontal cross section of drops were fully in focus.

Allowing the drops in front and behind to go out of focus made their fantastic reflected colors more abstract and interesting. I was particularly pleased with the way the specular highlights (out of focus bright areas that appear to be optical artifacts) came out in this photo and in the water drop photo on the facing page.

200mm f/4 macro lens, 1/60 of a second at f/18 and ISO 100, tripod mounted.

▼ These water drops were suspended on a strand of a spider's web. The rain had stopped, and the sun emerged from the clouds. The drops shimmered in the sunlight.

I used the depth-of-field preview prior to this exposure to see how my choice of aperture changed the image. After some experimenting, I selected a wide-open aperture of f/8 to provide enough depth of field that a single drop was entirely in focus, but the other drops were out of focus. The comparatively wide-open aperture also enhanced the specular highlights where bright sunshine was reflected off the drops towards the upper right of the photo.

200mm f/4 macro lens, 1/80 of a second at f/8 and ISO 100, tripod mounted.

Selective Focus and Bokeh

Almost everyone can recognize sharpness of an entire composition as effective. However, edge-to-edge sharpness is not always attainable. To achieve the effect of edge-to-edge sharpness, all elements of a photograph must be in focus (this happens in landscape photos at infinity) and everything must be still enough so there is no motion blur. Complete sharpness, even if achievable, isn't creatively right for many photos.

Since many photographs have some blurring and out-of-focus elements (and this is often a good thing!), it's smart to learn to work with selective focus rather than fighting it. The best technique for enhancing selective focus is to choose a wide-open aperture for shallow depth of field, and focus on the most important element of your composition.

The term *bokeh* comes from the Japanese word meaning to blur in ink-wash painting. In photography, bokeh is used to refer to blurring in a selective focus photograph. Good bokeh is smooth and pleasing, whereas bad bokeh produces a jagged and discordant effect.

This may sound subjective, but pretty quickly you can get to recognize excellent bokeh when you see it in a photo. Bright, out of focus areas that look like optical artifacts are examples of bokeh sometimes called *specular highlights*.

The quality of bokeh is largely dependent on the construction of the lens. For this reason, lenses that provide high-quality bokeh are prized.

Focus blur can occur anywhere in a photo, although it is more common in the background than the foreground. In the relatively rare situation where you have attractive foreground blur, try to take advantage of it. Foreground blur can create very interesting effects.

It's often the case that slight changes in camera position, aperture, or the precise point of focus make a huge difference to selective focus effects and to bokeh. It's worth paying close attention to these issues. Use your depth of field preview button to observe the effect of aperture changes, and consider shifting your position or focus slightly. Most of all: experiment!

▶ At the low-light limit of what can be hand-held, even with image stabilization, this photo of a Stellar's Jay works because of selective focus. If the background, as well as the bird, had been in focus, the blue feathers would not seem nearly as distinct.

18–200mm VR zoom lens at 200mm, 1/13 of a second at f/5.6 and ISO 200, hand-held.

▶ Selective focus isolates the Poppy seeds, and makes it clear that they are the subject of this photo. The soft background bokeh contrasts pleasantly with the more abrupt edges of the Poppy core.

105mm f/2.8 macro lens, 1/15 of a second at f/9 and ISO 200, tripod mounted.

◀ The combination of a long macro lens with very shallow depth of field in an extreme close-up creates a glowing selective focus bokeh effect around the pistil of the flower on the left. I used a tripod for this shot (to hold the camera and close-up equipment steady) even though at a shutter speed of 1/250 of a second I might have contemplated hand-holding the exposure.

200mm f/4 macro lens, 56mm combined exten-sion tubes, +4 diopters close-up filter, 1/250 of a second at f/5.6 and ISO 100, tripod mounted.

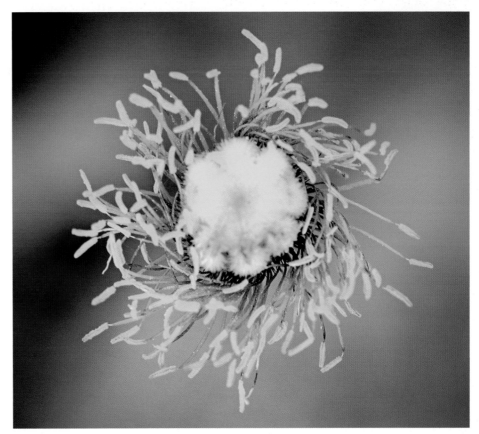

▲ The lens I used for this photo has specially designed curved blades in the diaphragm (the mechanical device used to form the aperture). This design is intended to enhance bokeh and specular highlight effects when the lens is used with very small apertures (like the f/40 aperture I selected in the photo).

85mm f/2.8 macro lens, 1/15 of a second at f/40 and ISO 100, tripod mounted.

▲ In this image, I chose an intermediate aperture for shallow depth of field. Next, I selectively focused on the water drops through Peony petals in the foreground. The foreground blur of the pink Peony petals makes for an abstract and unusual effect in a flower macro.

200mm f/4 macro lens, 1/250 of a second at f/9 and ISO 100, tripod mounted.

Aperture and Narrative

While the story may not be immediately obvious, all photographs do tell one. The narrative component of a photograph is usually the most emotionally important part of an image. Even if the viewer of the photograph is not conscious of the story the photo tells, it is the story the viewer responds to viscerally.

Since narrative is so important to the success of an image, it is worth every photographer's while to think about the story a photo tells. What is going on in the photo? What came before the photo? What will come afterwards? Will a casual observer who wasn't at the scene see the same story that you do? What can you do to introduce compelling or interesting narrative into a photo? Don't be scared of questions: often the narrative itself consists of more questions than answers.

Of course, many things influence the role of narrative in your photos, including your choice of subject matter and composition. Aperture choice also plays a big role in the effectiveness of the narrative structure behind a photo.

The choice of a small aperture (and high depth of field) can bring disparate elements of a photo together to create a unified story, particularly in a wide-angle composition.

On the other hand, a large aperture (and low depth of field) isolates, and makes more important, the elements that *are* in focus in a composition. Selective focus combined with low depth of field tells the viewer of a photo what the story is about. If you really hit the jackpot, out of focus elements can also give the viewer a hint about the backstory.

▲ I used a very wide angle setting (18mm in 35mm terms) and great depth of field (because of the f/22 aperture) to tell the story of the Serpent Mother and her egg.

12–24 zoom lens at 12mm, 18 seconds at f/22 and ISO 100, tripod mounted.

◄ The choice of a wide-open aperture and shallow depth of field helped me to isolate the boy and the geese from the out of focus and hazy city skyline. The result is an interesting, and somewhat eerie, narrative. What *is* that boy doing with the geese? These aren't Hitchcock's birds, are they?

The underexposure of the foreground of the photo causes the foregound elements (boy and geese) to go into silhouette, adding to the sense of mystery.

18–70 zoom lens at 52mm, 1/2000 of a second at f/5.6 and ISO 200, hand-held.

▼ I checked my sun and moon charts, and knew the full moon was rising at 9:20 PM, so I positioned myself at that time to photograph the moonrise from beneath the Golden Gate Bridge.

As the bright summer moon emerged from behind the San Francisco skyline, a cruise ship with passengers enjoying the night spectacle of San Francisco Bay passed in front. I used a moderate tele-photo to isolate the moon and ship beneath the bridge, and a moderate aperture with a 10-second time exposure to turn the cruise ship into an abstract composition of horizontal lines of light.

This exposure had the effect of showing the motion in the cruise ship, but not in the other parts of the composition. The story the exposure tells is of a cruise ship moving rapidly out to sea under the Golden Gate Bridge by the light of a glowing moon.

18-200mm VR zoom lens at 140mm, ten seconds at f/5.6 and ISO 100, tripod mounted.

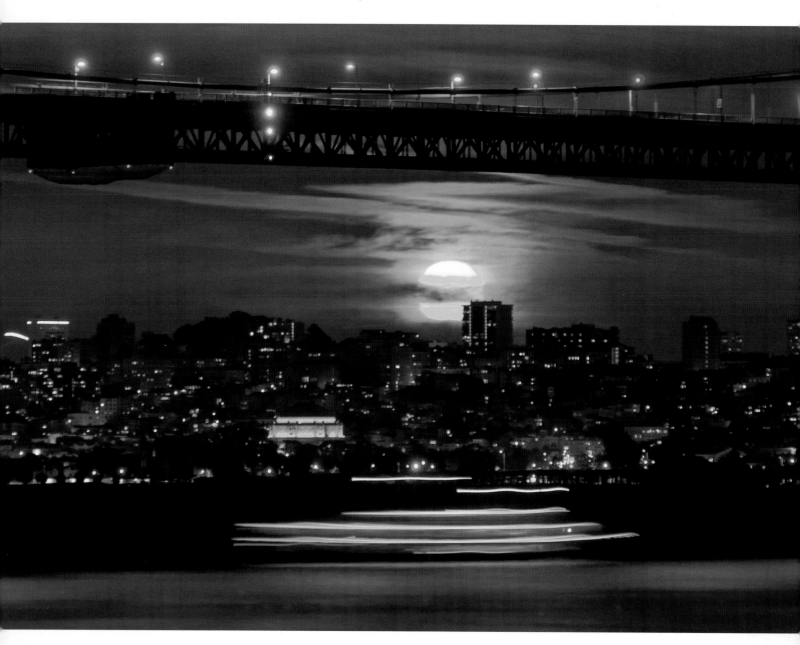

▲ I used a moderate aperture and shallow depth of field to capture the eye stalks of this hermit crab, and tell the story of an ocean creature hiding under a rock.

The hermit crab is hiding under his shell, a kind of crab mobile home, shown blurred and out of focus on the upper right of the photo.

200mm f/4 macro lens, 1/160 of a second at f/7.1 and ISO 100, tripod mounted.

▲ These water drops on a leaf seem to be in a line. Are they waiting for a bus? Are the two drops on either side part of the group? What does the pattern of water drops mean? Does it remind you of a sideways musical notation or some kind of glyph?

The choice of a small aperture and high depth of field allowed me to pose the conundrum of this pattern of water drops in the sun.

200mm f/4 macro lens, 1/10 of a second at f/32 and ISO 100, tripod mounted.

▲ I saw this hummingbird and didn't have time to make any elaborate preparations. The 400mm lens I used (600mm in 35mm equivalent terms) is far too long to expect to hand-hold effectively, although the image stabilization helped.

Hummingbirds have long tongues that are constantly in motion when they consume aphids and other small plant parasites. The wide-open aperture, and shallow depth of field, put the emphasis on the outstretched tongue rather than the whole hummingbird, and tells the relatively unknown story of this bird's voracious appetite for small insects.

70–200mm VR zoom lens at 200mm, 2X teleconverter (400mm), 1/80 of a second at f/5.6 and ISO 100, hand-held.

When Aperture Doesn't Matter

When you've said, "Sometimes the aperture doesn't matter," what more can you add? If aperture doesn't matter, it just doesn't matter. But the question is: In what situations does the aperture not matter?

Aperture doesn't matter when depth of field doesn't matter. But even if depth of field doesn't matter, you may be compelled to select a particular aperture when shutter speed is an issue because either the subject is in motion or the camera is unsteady. Take a look at Chapter 3 to learn more about this topic.

Depth of field doesn't matter when a photo is entirely in focus at infinity (and you are focused at infinity).

In every other case, there's a strong possibility that depth of field and aperture really do matter. So pay attention to them!

To sum it up: When you are focused at infinity, and your subject is entirely at infinity, there's no concern about depth of field and therefore aperture doesn't matter unless the exposure equation (because of shutter speed considerations) in fact compels a choice of aperture.

Of course, there are a great many situations that meet the criterion of being entirely in focus at infinity, such as distant landscapes and photos of buildings in cities. You should make a point of recognizing these situations so that you can shift your attention to the other creative aspects of photography besides aperture.

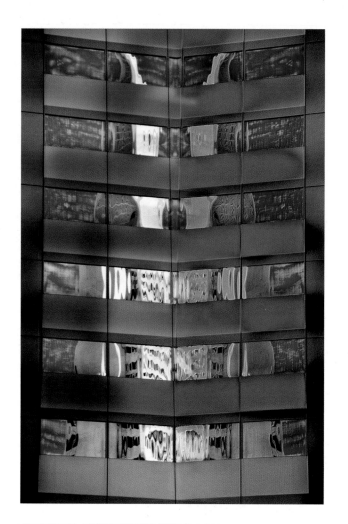

◄ The reflections of the Transamerica Tower in San Francisco were glowing in the sunset light in the windows of a facing office building. I used a polarizer, a filter that can be used to amplify reflections, to boost the clarity and saturation of colors in the reflections.

This is a photo entirely at infinity, with almost no depth from a focusing perspective. Since I didn't care about depth of field, I didn't care about aperture.

I also didn't care about shutter speed, since the subject wasn't in motion and the camera was on a tripod. So I set the camera to programmed automatic, and let it establish the exposure for me.

18–200mm VR zoom lens at 105mm, 1/90 of a second at f/5.3 and ISO 100, polarizer, tripod mounted.

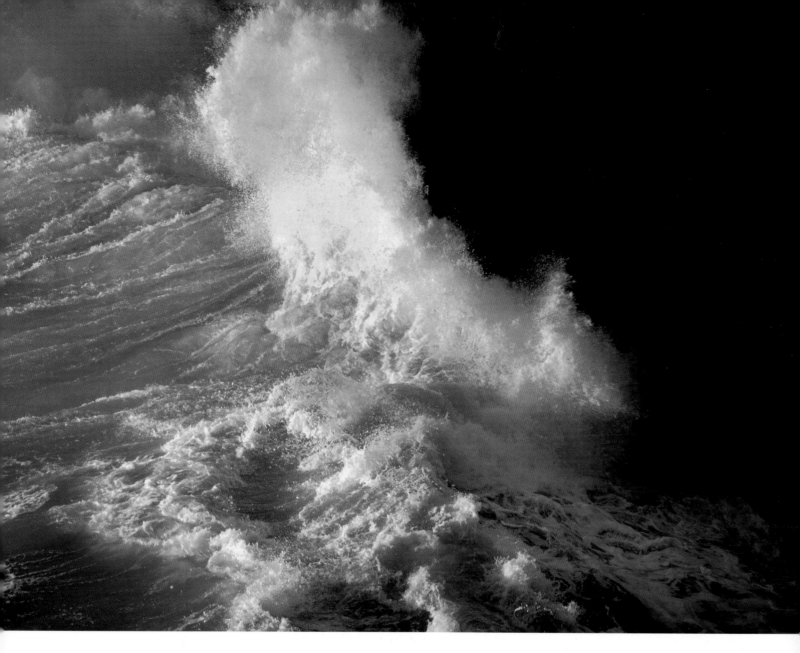

▲ I was struck by the contrast between the dramatic surf in the sunset and the dark shore in the shadow. I decided to create an interesting photo by exposing for the sunlit-breaking wave and letting the cliff go dark. Actually, you can't even really tell that it is a cliff, and the mystery about the dark shore helps make the image compelling.

The entire image was in focus at infinity, so depth of field wasn't an issue. I really didn't care what aperture I used. I used spot meter mode to get exposure settings based on the bright wave, and made sure that the shutter speed selected (1/250 of second) in shutter-preferred mode was fast enough to freeze the motion of the wave. With the shutter speed in place, I allowed the camera to select the aperture without worrying about it, and concentrated on depressing the shutter at the crucial moment when the wave was crashing on the shore.

18–200mm VR zoom lens at 200mm, 1/250 of a second at f/6.3 and ISO 100, hand-held.

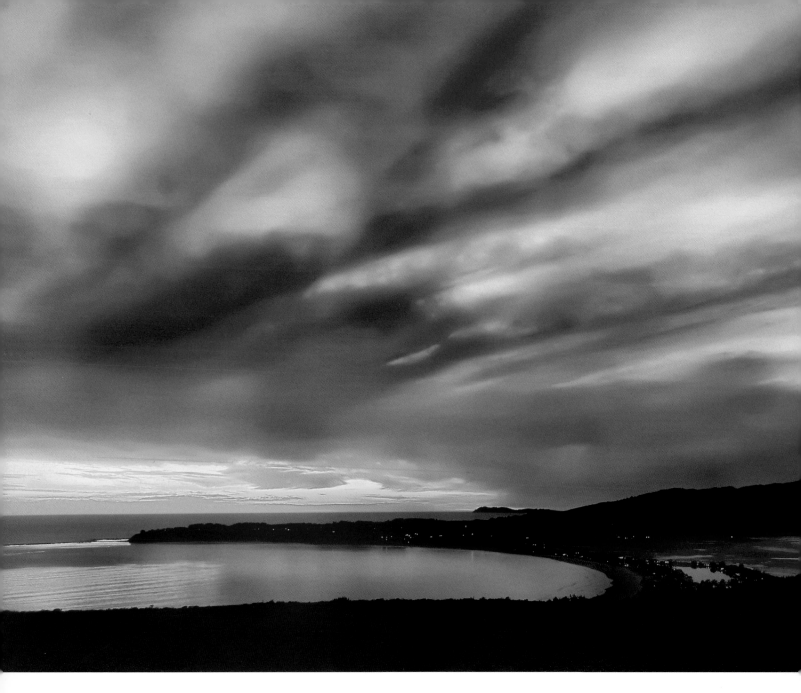

▲ Sunset lit the horizon and gave the clouds over Stinson Beach and Bolinas Lagoon (north of San Francisco) a water color-like appearance. But the scene was quickly fading into twilight, and there wasn't much light left.

I knew that the entire image was in focus at infinity, so I didn't worry about my choice of aperture, and chose the maximum aperture I had available to make the exposure of the landscape as short in duration as possible.

18–200mm VR zoom lens at 28mm, 3/5 of a second at f/4 and ISO 200, tripod mounted.

▲ In the early hours of a winter morning, I drove slowly past the ranches of the California Gold Rush country in the foothills of the western Sierra. The clearing morning fog provided a great atmospheric background for the dark silhouettes of the bare trees.

Since this entire image was in focus at infinity, I knew there was no particular advantage to higher depth of field. I therefore chose to enjoy the freedom of hand-holding the camera by choosing a relatively fast shutter speed (1/125 of a second) and a wide-open aperture.

18–200mm VR zoom lens at 200mm, 1/125 of second at f/6.3 and ISO 200, hand-held.

Macro Photography and Aperture

Some people use the phrase *macro photography* to apply to any close-up work. A more stringent definition is that macro photography is the creation of close images in which the physical size of the capture is greater than the size of the object being photographed. For example, if a coin with a one-inch diameter is captured by your sensor so that the pixels making up the coin measure an inch in diameter, that is called a 1:1 capture. If the pixels on the sensor made up a ratio of 1.5:1 compared to the subject, then the size of the capture is said to be greater than life.

How Do Extension Devices Work?

The best macro gear for dSLRs works by adding space between the lens and the camera. This is how extension tubes, bellows, and (in combination with special optics) macro lenses work. The added space increases the focal length of the lens combined with the extension device. (See "Understanding f-Numbers and f-Stops" on page 52 for a defintion of focal length.)

Since f-numbers are defined in terms of the ratio of effective focal length to the diameter of the aperture, in some cases very small f-stops result, like f/36, f/40, or even f/64, which may be smaller than the hardware rating for minimum f-stop of the lens without the extension device.

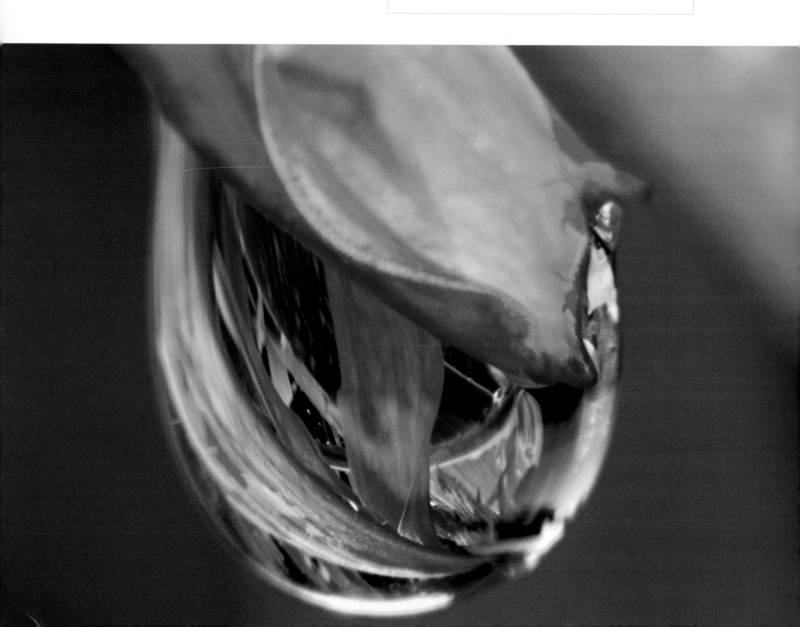

Loosely speaking, macro photography starts at about 1:4 (the capability of some fixed-lens camera's macro modes), and true macro photography involves captures with a ratio of 1:1 or greater.

Depth of field, and therefore aperture, is very important to effective macro photography for several reasons. For one thing, depth of field takes on even more than normal importance because focus on macro subjects is inherently shallow. Minute differences in distance from the lens create great shifts between in focus and out of focus areas.

Macro photographers use a lot of specialized equipment, which I've described in the sidebar.

It's important with macro photography to use a very steady tripod, both because you'll generally be using longer shutter speeds and because very small changes in camera position are extremely important. You want to be able to lock your camera in absolute position with the tripod, and then move either the subject or the camera (or both) with small motions until you get the focus right.

With relatively few exceptions, macro photographs need as much depth of field as possible. This means that you should pre-select a very small aperture, using either aperture-preferred metering or manual exposure to choose the shutter speed.

Get in the habit of checking the way the image looks before you expose it, by stopping down your lens with the depth-of-field preview control.

Finally, remember my advice to position the camera as parallel as possible to the subject. This holds especially true for macro photography since depth-of-field issues are critical.

Macro Equipment and Terminology

Close-up filters: Close-up filters, also called close-up lenses, screw onto the front thread of a lens. Close-up lens strength is measured in diopters, and close-up filters can be stacked, in which case the diopters of the individual filters are added. Close-up filters are generally inexpensive, but can degrade the optical quality of your photos.

Extension bellows: Fits between lens and camera, with accordian-like folds for flexible positioning to alter effective focal length. A possible drawback of bellows with digital photography is that the folds of the bellows collect dust, which can then get on the sensor.

Extension tubes: Fixed-length, hollow devices that fit between camera and lens to alter effective focal length. Can be combined with other extension tubes for additive effect. Like bellows, extension tubes contains no optics.

Focusing rail: A rail with precise and minute adjustment controls. The camera attaches to the focusing rail, and then is focused by moving the camera along a rail.

Lens reversal ring: Reverses the direction of a lens on a camera; can be used in some circumstances for extreme magnification macros.

Macro lens: A dSLR lens specially designed for close-up photography. Besides close-up work, most macro lenses do in fact focus to infinity, so can also be used for general purpose photography.

Macro mode: Many fixed-lens digital cameras have macro modes, designed for taking close-ups. Macro mode compact digital cameras will usually not get you as great a magnification as is possible with a macro lens on a dSLR.

◄ This is an extreme macro photo of a water drop on an Echinacea (Coneflower) petal, with internal reflections of the petals and foliage. I photographed the water drop at settings far larger than life, with a ratio of about 6:1. To get the high magnification, I used a combination of a macro lens, extension tubes, and a close-up filter. It was important to select the smallest possible aperture for the most possible depth of field.

Water drop photography involves contradiction and compromise. A water drop is constantly in motion, and you want to use a fast enough shutter speed to stop this motion. At the same time, you need as much depth of field as possible, which implies a small aperture in the lens and a slow shutter speed.

My technique was to focus accurately, and to be patient enough to wait for the subject to be still. If you've ever carefully observed water held in place by surface tension—like this water drop—you'll realize that it is seldom totally motionless, even when there is no wind. But sometimes, as in this capture, there is a point of balance when the drop is still for just long enough (in this case, a bit under a second). So, when you go out to photograph your own water drops, be sure to arm yourself with patience as well as macro gear.

200mm f/4 macro lens, 36mm extension tube, +4 diopters close-up filter, 4/5 of a second at f/36 and ISO 100, tripod mounted.

▼ This Fuchsia blossom was snipped from a plant in my garden. I lit the flower from below and behind with a light bulb. My idea was to capture the blossom from an unusual, low angle.

I used a specially designed piece of hardware called the Low Pod, sort of a metal tray with a handle and a tripod socket, to position the camera and lens close to the front of the flower.

I wanted to be sure that the flower's pistils were in focus, but I also wanted the rear of the flower to be slightly out of focus. So I checked my depth of field extremely carefully before exposing the photo.

200mm f/4 macro lens, 36mm extension tube, 8 seconds at f/32 and ISO 100, mounted on a Low Pod (made by Kirk Enterprises).

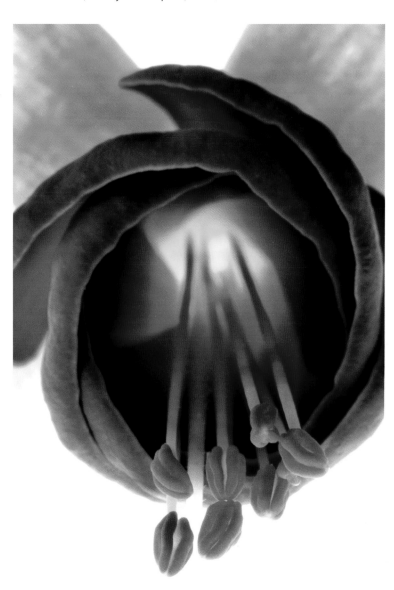

▼ My idea was to capture the inside of a Dandelion gone to seed. I knew that I would need to control the lighting, and that outdoors my photo would be vulnerable to wind, so I brought the Dandelion into my studio, and lit it from above and below.

I wanted to give the image an explosive effect, so that the viewer would see the Dandelion in the process of coming apart. To achieve this, I needed an angle on the Dandelion that made it seem like the photo was coming partially from inside the flower. I used a telephoto macro lens for this purpose to get optically extremely close to the parts of the Dandelion without actually touching the flower with the lens (which would have destroyed the Dandelion).

The point of focus in this image needed to extremely precise, so I used a focusing rail to control the position of my camera, and used the controls on the rail to ratchet my camera carefully into the right position.

200mm f/4 macro lens, 1/6 of a second at f/36 and ISO 100, tripod mounted.

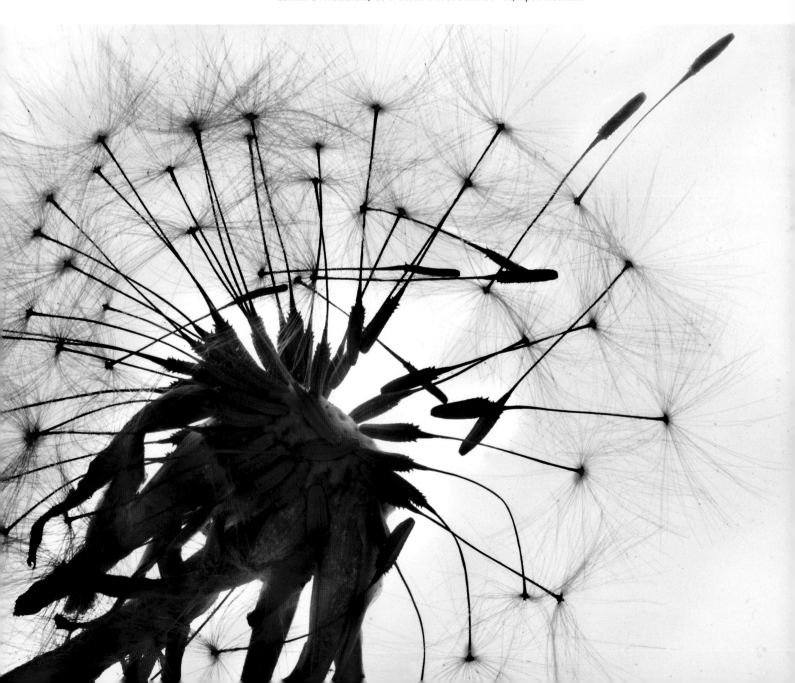

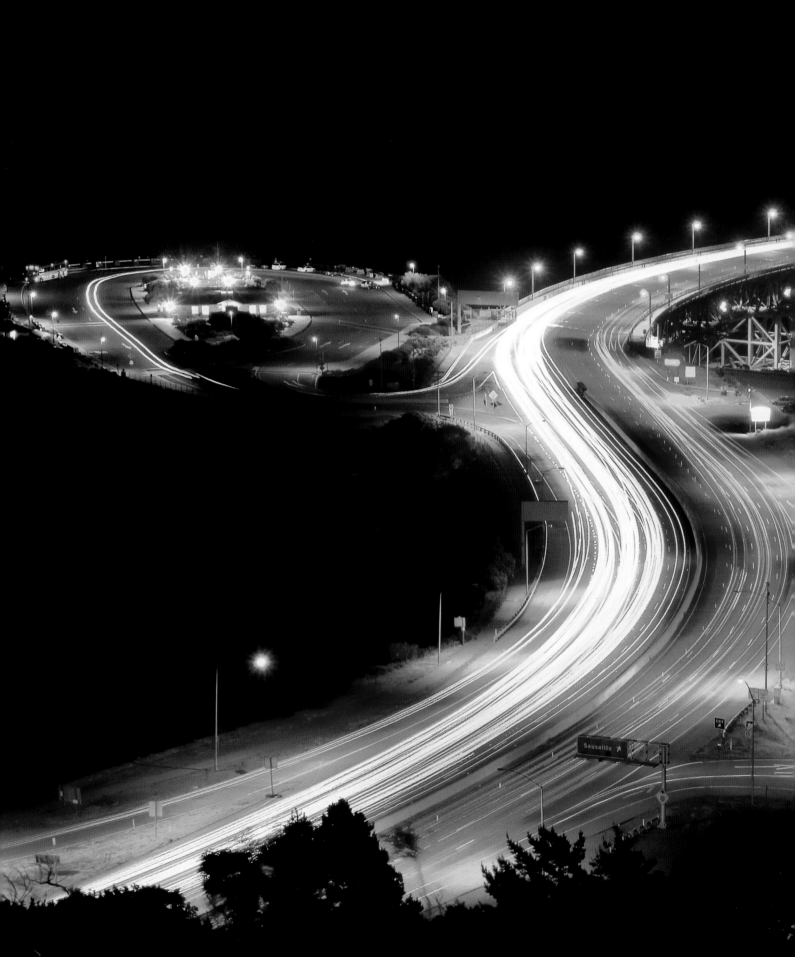

It's All about Time

Setting the shutter speed does not set a speed; rather this setting controls a *duration of time*; specifically, the duration of time that the shutter is open. During the time the shutter is open, light from the subject comes through the lens aperture and is recorded by the sensor.

As I explained in Chapter 1, shutter speed is one of the three components of the exposure equation, and one of the three settings used to make an exposure. The shutter speed setting is extremely important to almost every exposure. But sadly, shutter speed is badly named because the name misleads about the quantity that is being controlled. Once you understand what shutter speed controls (and it isn't a speed), you shouldn't have much conceptual problem with the setting.

As long as you understand that shutter speed is really a duration of time, not a speed, you'll find it easy to work with your shutter speed settings. So repeat after me: Shutter speed is all about time.

I'm sure you'll agree that a duration of 1/10 of a second lets in one tenth the light of a duration of one second, a duration of 1/125 of a second lets in twice the light of 1/250 of second, and so on. Shutter speeds have a direct, linear, arithmetical relationship to each other.

Once you are clear that shutter speed is a unit of time, manipulating shutter speed using units of time is easy. We're all reasonably used to calculating with time in our daily life. You don't really have to sweat the mechanics of shutter speed calculations the way you do with aperture (see Chapter 2). To let in twice as much light, you find the new, longer shutter speed by multiplying the original shutter speed by two (for example,

1/15 of second lets in twice the light of 1/30 of a second). To let in half the light, divide the shutter speed in half (1/60 of second lets in half the light of 1/30 of a second). It's as simple as that.

The trick isn't the mechanics of calculating with shutter speed, it's learning when to use which shutter speed. The choice of shutter speed is so important that you probably shouldn't leave it to the camera, except in situations where the shutter speed doesn't matter (see pages 85 and 93 to learn more about when shutter speed doesn't matter).

Although shutter speed is not a speed, this setting does control how an exposure renders *motion*. It's important to understand that there are two kinds of motion involved: the motion of your subject, and the motion of your camera. Each kind of motion has a role to play in an exposure.

When you consider shutter speed in relation to the movement of your camera, the considerations are more technical and mechanical: Will a slow shutter speed cause the photo to be blurred because of camera shake? Most of the time, if someone sees an unsharp photo, they will just walk away without looking further. They won't stop to examine the cause of the unsharpness.

Taking photos at a shutter speed that is too slow for holding the camera steady is one of the principal causes of lack of sharpness (blurring). It's simply a prerequisite for most good photos that they not show blur from this kind of camera shakiness.

▶ A foggy night above the Golden Gate Bridge and a long exposure combined to capture moving cars and the trails of airplanes.

18–200mm VR zoom lens at 18mm, 120 seconds at f/8 and ISO 100, tripod mounted.

▲ **Chapter opener:** I chose a long shutter speed to make an almost abstract composition out of the speeding cars. The two-minute exposure made the lights of speeding traffic look like solid lines in an S-curve.

18–200mm VR zoom lens at 55mm, 120 seconds at f/11 and ISO 100, tripod mounted.

▲ Water boomed down Nevada Falls in Yosemite. Leaning over the edge and pointing the camera straight down, I used a very fast shutter speed (1/1000 of a second) to "freeze" the motion of the water.

18–200mm VR zoom lens at 27mm, 1/1000 of a second at f/5.6 and ISO 100, hand-held.

If you are photographing an unmoving rock in bright sunlight, your choice of shutter speed probably won't matter much. For any other kind of subject and situation, you need to consider both the visual and mechanical aspects of shutter speed choice.

The fix for camera movement at slower shutter speeds is to constrain the camera so it doesn't move—most often with a tripod. It bears repeating that if the shutter speed is too slow for effective hand-holding, you should probably use a tripod.

If you are in the habit of using a tripod, sometimes the decision about what shutter speed to use will involve *both* considerations about how a moving subject will be captured aesthetically, and whether a tripod is handy.

When you use shutter speed to control how the camera renders motion in a subject, the choice is largely aesthetic and visual. Your choice will depend on what you want your photo to look like, with a range from motion implied by blur to motion frozen crisply in place.

Fast shutter speeds freeze motion. At shutter speeds of 1/250 of a second and faster, most things are likely to appear "frozen" in place no matter how fast they are moving.

At shutter speeds of 1 second and slower, solid objects in motion (even slow motion) will begin to appear as lines covering the trajectory of motion of the object across the area of the capture.

At shutter speeds between 1/250 of a second and 1 second, objects in motion will appear with some blurring, depending on the speed of the object, the shutter speed used, and the lighting.

Of course, the rendering of motion also depends on the speed of the moving object involved. It takes a much faster shutter speed to "freeze" a racing horse than to "freeze" a tortoise.

It's easier to take a photo hand-held that doesn't have a problem with camera motion when you are using a wide angle lens. It's harder to hold the camera steadily enough when you are using a lens at telephoto or macro setting. You should consider the focal length of the lens when thinking about what shutter speed to use, and whether you can successfully hand-hold an image.

The closer you are to a subject the more camera shake is a problem (because any camera motion is amplified relative to the size of the photo). This means that for a steady image, you need to use a faster shutter speed with a telephoto lens than you would with a wide angle lens. Photographing a subject close-up also calls for faster shutter speeds (or a tripod) to avoid loss of sharpness from camera motion.

If the light source for your exposure is a flash (also sometimes called a *strobe*), then the duration of the flash will control the rendering of motion, no matter what shutter speed you select. Effectively, the length of the burst of light from the flash takes the place of shutter speed of the camera in controlling the exposure.

Sometimes flash lighting is used to partially capture a scene, particularly to lighten areas of a scene that are in deep shadow. This use of flash lighting is called *fill flash*. When a strobe is used in fill-flash mode, the shutter speed component of the exposure is effectively determined both by the amount of time the shutter is open, and by the length of time of the burst of light put out by the flash.

Bottom line: shutter speed is all about time. The longer the time, the more light gets let in to make the exposure. The length of time of the shutter speed setting controls the way your photo deals with motion. From the viewpoint of a photographer, there are two kinds of motion: camera motion, and subject motion. The effects on your photos of both kinds of motion are largely determined by your choice of shutter speed.

▲ Working on a flower macro, I was surprised to find this lurking locust. I used aperture-preferred metering and an aperture of f/20 for enough depth of field to keep the insect in focus. With the wireless flash units, in aperture-preferred metering, the camera controlled the amount of light output for a good exposure. While the nominal shutter time was 1/60 of a second, the duration of the flash put out by the wireless units was the actual effective length of the exposure. I knew this duration of exposure would be short enough to "freeze" the constant motion of the locust.

200mm f/4 macro lens, 1/60 of a second using wireless macro strobe units at f/20 and ISO 100, tripod mounted.

▲ I focused on the eyes of this newt at a reasonably fast shutter speed with little depth of field to isolate the eyes. At 1/250 of a second, I knew I didn't have to worry too much about slight motions on the part of the subject. I used my flash in fill mode to "fill in" the shadow areas, creating an overall translucent effect.

200mm f/4 macro lens, 1/250 of a second using on-camera fill flash at f/5.6 and ISO 200, tripod mounted.

Shutter Speed and Camera Shake

Camera shake is a shorthand expression used to describe the situation in which camera movement or vibration causes a photo to be not acceptably sharp. If the shutter speed is fast enough, camera shake becomes a negligible issue.

Otherwise, addressing camera shake is essentially a mechanical issue. What, or who, is going to keep the camera steady in place?

Of course, sometimes you can create exciting motion effects by moving, or even tossing, your camera during an exposure, but generally camera motion is undesirable (see page 101 for a discussion of when you might want to move the camera during your exposure).

Human beings find it harder to stay really, really still than they sometimes think. Just ask anyone taking an introductory yoga or meditation class. How still you can hold your camera begins to be a significant issue at shutter speeds slower than 1/250 of a second. Take a look at the table below to see when to use a tripod in order to control camera motion.

Shutter Speed Range	Tripod Required?
1/250 of a second and faster	No (may be required with lens longer than 300mm)
Between 1/125 and 1/30 of a second	Maybe (see discussion below)
Slower than 1/30 of a second	Yes

Many exposures seem to lead to the middle territory where you might be able to effectively hand-hold the camera. In these situations, check your aperture to see if you can let more light in and use a faster shutter speed without losing necessary depth of field (Chapter 2).

Hand-holding a Camera

To hold a camera as still as possible, first get yourself into a still position. If possible, brace yourself against the wall, floor, or a rock.

Next, brace your camera close against your body (usually your forehead). Use both hands to hold the camera steady.

It's a good idea to practice holding your camera steady before you get into a situation where you need to be still. What works best for you? Where can you grip the camera without inadvertently pressing buttons?

Also, consider boosting the ISO (see Chapter 4) to use a faster shutter speed.

Factors you should consider to see whether you can successfully hand-hold a photo in the intermediate zone of shutter speeds include whether you are using image stabilization (see sidebar), and whether you are using a wide angle or telephoto lens. The longer the focal length of the lens (and the more telephoto the lens is), the more camera motion is a problem. If you are taking a macro photo (close-ups show camera shake more), this should tell you to probably use a tripod. A final consideration is how still you think you can hold your camera.

Some photographers have an exaggerated notion of their ability to hand-hold at slow shutter speeds. (I've heard this can even be a macho thing: real men don't let their camera wiggle, even at slow shutter speeds.)

Before assuming you can successfully hand-hold in slow shutter speed situations, consider that professional photo editors generally advise against it. Examine some test photos at extremely high magnification on your computer, looking for shaded pixels next to edges. These "extra" lines indicate subtle blurring that will show if you make a large print of the photo.

Image Stabilization

A mechanism called variously *image stabilization* (IS) or *vibration reduction* (VR) is built into many cameras (generally, fixed-lens cameras) and lenses (intended for use on a dSLR). Manufacturers claim that image stabilization gives you a two to three f-stop exposure advantage, which translates to the ability to use a shutter speed up to eight times slower than without IS.

There's no doubt that you can get some hand-held shots with image stabilization in marginal low light conditions that would be impossible without the IS technology.

If you are taking advantage of IS to use slower shutter speeds, you should be sure to make several shots of each photo because the technology is erratic and doesn't always work. In my experience, for every three shots taken using image stabilization at slow shutter speeds, one shot adjusts properly for camera shake and the other two do not.

Image stabilization should always be turned off if you are using a tripod because IS can actually make tripod shots *less* steady (unless your camera or lens with IS has a mode specially designed to be used with a tripod).

▲ A shutter speed of 2 seconds was long enough to create a nice, white motion blur where this woodland creek tumbled over the rocks, but not so long as to lose the detail in the still water. I was careful to use a tripod so the camera stayed compeletly still during the exposure.

18–200mm VR zoom lens, 2 seconds at f/25 and ISO 200, tripod mounted.

For a macro as close as this water drop shot, 1/5 of a second is a very fast shutter speed because the closeness of the subject to the camera amplifies any camera motion.

I knew I could get away with it because of the bright sunshine lighting the drop, indicated by the specular highlight just to the rear of the drop.

200mm f/4 macro lens, 1/5 of a second at f/32 and ISO 100, tripod mounted.

▲ The sunset was glorious, and the waves were blowing in hard and fast from the Pacific. 4/5 of a second shutter speed was long enough to pleasantly soften the waves, but short enough so that the shape of the waves could still be seen.

18–200mm VR zoom lens at 56mm, 4/5 of a second at f/9 and ISO 100, tripod mounted.

Shutter Speed and Subject Motion

I've explained how camera motion can negatively effect a photo, but in my opinion, it's much more exciting to realize that shutter speed has a huge creative impact on the way motion in the subject of your photo appears in the finished photo.

I've already noted that if you are photographing something that doesn't move, like a still life or a rock, you don't have to consider the motion of the subject. But once water flows around the rock, the situation has changed. Time, that is, the duration of time determined by the shutter speed setting, changes the way the motion of the stream that surrounds the rock is rendered.

Indeed, being able to show the impact of time passing in the single frame of a photo is one of the great gifts of still photography. When you make your choice of shutter speed, if your subject is in motion, you choose how this motion will be stopped and rendered visually in your photo.

A very fast shutter speed will appear to completely stop motion. Using these shutter speeds, even the fastest of moving objects, such as birds in flight, racing cars, and crashing waves, appear "frozen."

Intermediate shutter speeds will mostly (but not completely) stop motion. At these shutter speeds, a lot depends on your precise choice of shutter speed and on the motion of the subject. Motion is generally stopped in place, with some blurring. Panning the camera in the same direction that the subject is moving can produce interesting effects with shutter speeds towards the slower end of this range.

Very long exposures require a different way of looking at the world to pre-visualize the impact of your shutter speed. An object in motion will "flow" across your photo, meaning that it is only partially exposed at any one point in your capture. Flowing water, and the headlights of moving cars, elongate and become lacy, abstract designs.

The table below shows how shutter speed ranges render various objects in motion, and also notes whether a tripod is required.

Shutter Speed Range	Impact	Tripod Required?
Very fast: 1/250 of a second and faster	Motion is stopped, "frozen," rendered crisply.	No
Intermediate: between 1/125 of a second and 1/30 of a second	Objects in motion appear distinct but slightly blurred.	Maybe (see page 88 for more info)
Long: between 1/15 of a second and 4 seconds	Objects in motion are recognizable but somewhat blurred.	Yes
Very long: longer than 4 seconds	Objects in motion will probably "travel" across the capture frame; these objects are rendered abstractly.	Yes

As a case in point, consider water in motion. Water helps make the world beautiful, and is part of many photographic compositions of nature.

At fast shutter speed settings, waves and falling water are crisp and "frozen" in place (see photos on pages 73, 84, and 95.)

Objects in Motion and Exposure Adjustments

If a moving object is exposed as it moves across your camera frame during a very long exposure, it will be underexposed at each place in its journey (because the object hasn't stayed in the spot for the entire length of the exposure). "Underexposed" means that the moving object appears to be darker than it would have appeared had it stayed in one place for the entire exposure. To some extent, this underexposure is balanced when you have multiple objects in motion: as one object leaves the frame, another replaces it.

It's my experience when photographing moving objects, particularly in a dark overall environment, that increasing exposure time works well (see the photos on pages 80–81 and on page 102 for examples where I intentionally overexposed the image). However, the best advice when you are dealing with motion is to experiment with exposure values. You probably won't know what will work best until after you've tried many possibilities.

At intermediate shutter speed settings, moving water is essentially distinct, but slightly blurred if you look closely (for an example, see the photo on page 21). Incidentally, this can be a very attractive shutter speed range for rendering moving water.

When the shutter speed setting gets longer, moving water begins to take on an abstract look (example photos, pages 14 and 89). At the very longest shutter speed settings, water takes on an alien look, and appears to be a continuous, white sheet devoid of details (example photo, page 94).

In Chapter 2, I explained that sometimes aperture doesn't matter (pages 72–75). Shutter speed also sometimes doesn't matter: when camera shake isn't an issue and when the subject isn't in motion. At all other times, shutter speed considerations are extremely important to the photographer. Your photos will show the benefit of taking the time to fully understand the creative implications of your shutter speed choices.

Making Very Long Exposures

Anything longer than a couple of seconds should be considered a very long exposure, and requires a tripod. I recommend investing in a good tripod to minimize frustration. Some of the better tripod systems use a plate permanently attached to the camera body, so that it is easy to quickly mount the camera and release it from the tripod.

There also are a great many alternative supports that you can use for long exposures, ranging from bean bags to "Gorilla" pods with interlocking, flexible plastic legs. It's worth experimenting!

You also need to find a way to make long exposures without touching the camera, because manually pressing the shutter release will introduce camera motion into a long exposure. The self-timer that is built into your camera will serve this purpose in many cases.

Most cameras have a longest shutter speed setting of no more than 15 or 30 seconds. To make exposures longer than this, your camera should have a Bulb setting (not all cameras can make Bulb exposures).

When you use the Bulb setting, the shutter stays open as long as the shutter release button is engaged. You won't be able to use the self-timer to make exposures using the Bulb setting because the shutter needs to be continuously released to keep the exposure going. To make Bulb exposures, you need a remote control. Unfortunately, with digital cameras remotes are not the simple, inexpensive standardized cable releases of the analog era, but if you plan to make long exposures you simply must have one.

It's worth noting that a very long exposure time always introduces noise into a capture. If your camera has a setting that processes long exposures to reduce noise, you should make sure it is turned on.

▶ I thought this flying Canadian goose caught in the act of flight made an interesting juxtaposition with the industrial crane in the background. I used a very fast shutter speed (1/1000 of a second) to "freeze" the motion of the goose.

70–200 VR zoom lens at 200mm, 1/1000 of a second at f/5.6 and ISO 200, hand-held.

▼ My concept with this photograph of Yosemite Falls was to use a slow shutter speed to blur the motion of the water. To get a slow enough shutter speed, I needed to reduce the amount of light reaching the sensor by choosing a small aperture (f/25). Using this small aperture allowed me to select a very long shutter speed (three minutes).

18–200mm VR zoom lens at 95mm, 180 seconds at f/25 and ISO 100, tripod mounted.

▲ I was wandering around the bluffs high above the sheltered, southern side of Point Reyes late one afternoon. Looking straight down, I saw that the wind was moving the water in one direction (out to sea) and the waves were coming in directly opposite the wind. The two lines of water created this way touched, intersected, and made interesting patterns. I realized that to "freeze" these patterns I needed to use a relatively high shutter speed (1/180 of a second).

To make this image, I used a circular polarizer filter. A polarizer can deepen colors, and amplify (or reduce) reflections, particularly reflections in water. To use the polarizer, with it mounted on the end of your lens, rotate it until you are pleased with the effect.

The polarizer did reduce the amount of light reaching the sensor; without it, I would have been able to use a faster shutter speed.

18–200mm VR zoom lens at 105mm, 1/180 of a second at f/7.1 and ISO 100, hand-held, circular polarizer.

▼ A fast shutter speed (1/250 of second) caught this hovering dragonfly in the sun.

105mm f/2.8 macro lens, 1/250 of a second at f/8 and ISO 200, hand-held.

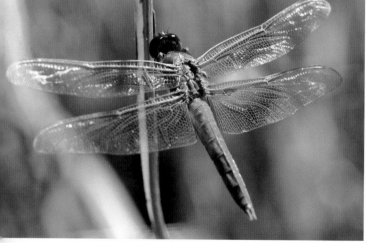

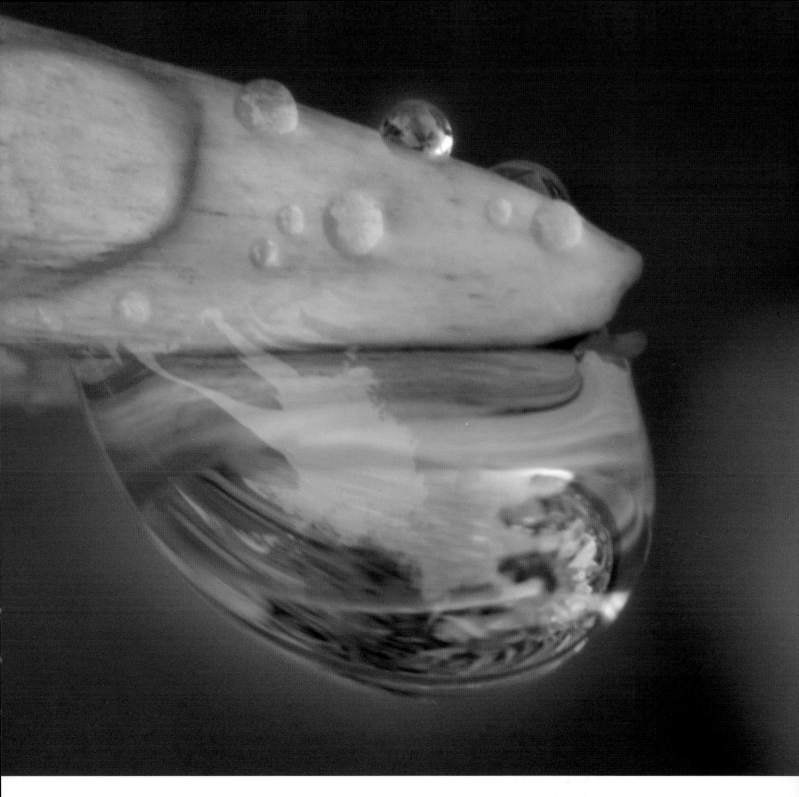

▲ I was lucky that this water drop on a flower petal was still for the 1.5 seconds required to make this exposure at sufficient depth of field. At this long shutter speed, you can see the motion in the upper (pink) part of the large water drop, while the reflection of the drop within the flower is perfectly still.

200mm f/4 macro lens, 1.5 seconds at f/45 and ISO 100, tripod mounted.

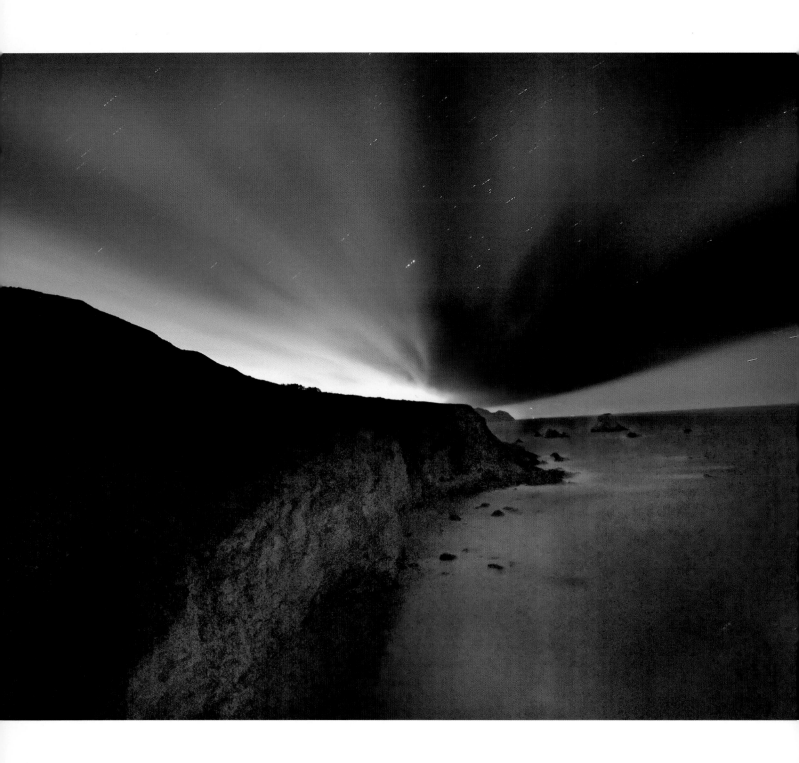

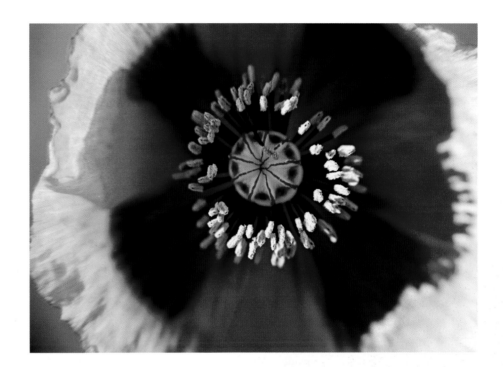

▲ This opium Poppy was blowing in a stiff breeze. I used a fast shutter speed (1/320 of second) to freeze its motion.

18–200mm VR zoom lens at 120mm, 1/320 of second at f/5.6 and ISO 200, hand-held.

◄ I exposed this photo of cliffs and sea in full night, lit by stars and the glow of distant San Francisco, for five minutes. There was no possibility of a shorter exposure without boosting the sensitivity, and I wanted to keep noise, which is always an issue in very long exposure photos, as low as possible. To some degree, noise can be reduced in post-processing as I explain in Chapter 6; in this image I felt that the noise in the cliff and ocean enhanced the overall effect.

12–24mm zoom lens at 12mm, 300 seconds at f/4 and ISO 100, tripod mounted.

Creative Use of Motion

As you gain experience in creatively portraying motion, it's likely you'll sometimes want to consider the amount of time it will take for a moving object to travel across your photo. If you choose this amount of time as your shutter speed, you'll see a large trajectory of motion of the object in the finished photo (see the photo of the setting moon on page 102 for an example).

In relation to shutter speed, you should always be thinking about how fast an object in motion is travelling, and how this speed relates to your shutter speed.

Objects in motion over time are among the most important elements in any photo (unless you are photographing still lifes, statues, or rocks). Flowing water, fast-moving clouds, running vehicles, people: they all move. Since motion is such an important part of life and photography, you should consider what you can do in each photo to maximize the impact of the motion that you are capturing, and also the relationship of the motion you are capturing to the framing of your photo.

So I'm suggesting you think about how *far* the object will travel during the length of time of your exposure in relation to the area that your photo is capturing; interesting visual interactions between the trajectory of

a moving object and the background of the photo can make powerful compositions, but to achieve this you need to know how far the object will travel. Also worth considering: Will the distance of an object in motion lead to a change in focus, and should you therefore change the aperture to get more or less depth of field as explained in Chapter 2?

Motion is powerful. Don't forget the simple things you can do with it. Not all creative photos of motion involve complicated calculations.

The simplest form of the creative use of motion is to use the different ways the shutter speed setting interacts with motion. Depending on your choice of shutter speed, the same bird moving across your photo can be crisply captured, frozen in space, or rendered as translucent lines tracing a flight path, or something in between the two extremes.

Indeed, as I've said, the shutter speed setting is all about time and motion.

Fast shutter speeds "stop" motion; slow shutter speeds show a record of the object in motion in its entire trajectory across the photo.

Try experimenting with different shutter speeds to see what fast and slow shutter speeds do to moving water, people and animals in motion, grass and clouds in the wind, moving cars, and car lights at night. You may well be surprised at what you come up with! By taking photos at different shutter speeds of these moving objects, you'll gain experience of the likely impact of your shutter speed choice, and understand how to creatively approach particular situations. Using this experience as background, when you are thrust into a situation involving dynamic motion you may be able to instinctively pick a shutter speed that helps create a great photo.

As I've emphasized throughout this chapter, the amount of time used for the shutter speed setting controls the camera's interpretation of two sources of motion: motion in subjects being photographed, and motion of the camera itself. Using shutter speed to play with subject motion can create photos that are dynamic, dignified, or powerful. Moving the camera intentionally while the camera is open, on the other hand, produces images that are, well, experimental.

I'm not suggesting you recklessly throw your camera around while holding the shutter open (although some photographers actually try this). But keep in mind that motion goes both ways. As you learn to work with shutter speed and the subjects of your photographs, be aware that some effects can actually be enhanced using camera motion (for an example, see the photo on page 103). Just one word of warning: if you toss your camera in the air while making an exposure, it's a good idea to catch the camera before it hits the ground.

◀ A rain cloud was approaching and the dry grass rustled in the breeze. Photographed into almost complete night, the long (30 second) exposure softened the motion of the approaching rain clouds and the waving grass.

10.5mm digital fisheye lens, 30 seconds at f/2.8 and ISO 100, tripod mounted.

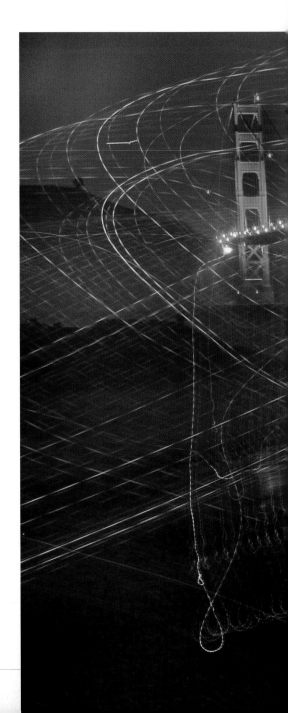

▲ I guessed it was about four minutes until the moon set, so I decided to hold my shutter open for that length of time by setting the shutter speed to Bulb and using a remote, programmable release. My idea was to capture the moon descending to the horizon.

18–200 VR zoom lens at 200mm, 240 seconds at f/5.6 and ISO 100, tripod mounted.

▼ I was photographing the Golden Gate Bridge from Baker Beach in San Francisco as the sun set. My tripod was positioned near the water line, with the feet sometimes getting wet in the surf. As evening wore on, my exposure times got longer, until I was exposing at 30 seconds with the lens wide open.

All of a sudden, during an exposure, a giant wave came along. To avoid having my camera and tripod swept into the Pacific Ocean, I picked the tripod up and carried it and camera back onto the beach. As I placed the tripod down, I changed the focal length of the zoom setting from 60mm to 80mm for the balance of the exposure. The exposure continued before, during, and after the camera-and-tripod move, with the results you see. Who could have predicted these results?

18–200mm VR zoom lens at about 60mm and about 80mm, 30 seconds at f/4.8 and ISO 100, tripod mounted.

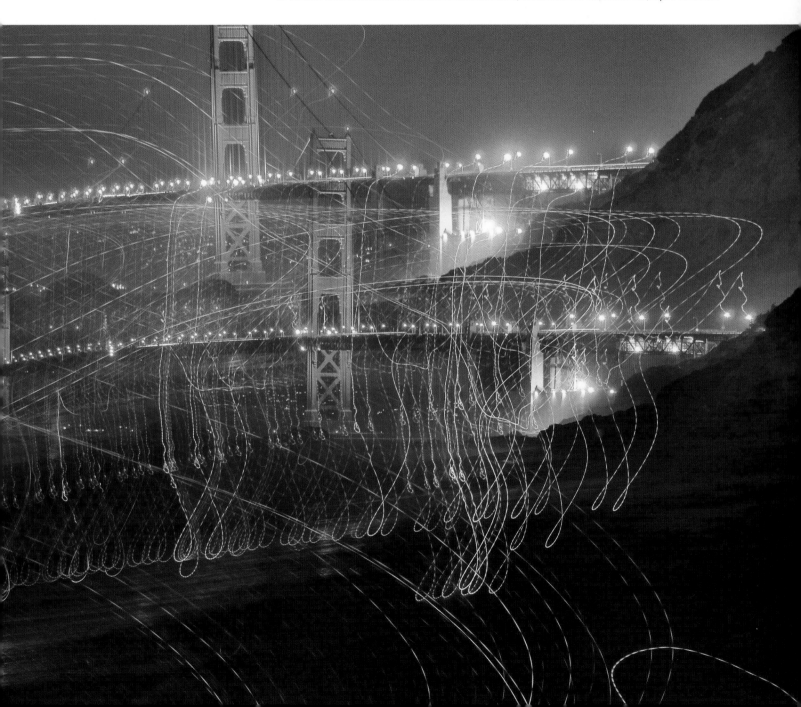

Understanding Light Sensitivity

Photographers coming to digital from film are astounded at digital's powerful and flexible ability to "dial in" light sensitivity (called ISO). With a film camera, you are limited by the sensitivity to light of the film in the camera. Not so with digital!

It seems that it should be possible to tell a digital camera how sensitive to light its sensor should be by setting a menu item or twisting a dial. In fact, using a higher ISO doesn't actually increase a sensor's inherent sensitivity to light. When you increase the ISO, you are amplifying the signal captured by the sensor. All captures are subject to some *noise* related to heat created by the sensor and the theoretical limitations of electronic circuitry. Amplifying the signal increases the baseline noise present in all photos.

So what, exactly, is noise? As a general matter, from the viewpoint of information theory as applied to computing and communications, noise is data not used to transmit a signal. In other words, digital noise is simply an inherent (and unwanted) effect.

With film, the higher the sensitivity rating of the film, the more "grain"—visible particles that are residues of the silver halide chemistry that makes film sensitive to light. With digital, as sensitivity is increased, noise (rather than grain) also increases. Some think that noise lacks the aesthetic quality of grain, important to

Where Does Noise Come From?

Noise in a digital image comes from many sources, including:

- The inherent abilities of the sensor
- The size of the sensor (the smaller the sensor the more noise)
- The light-sensitivity setting applied to the sensor (see text for more discussion)
- The size of the image (the larger the image file, the more noise)
- Long exposure time (once you get exposures of more than a few seconds, the longer the time the more inherent noise)
- The quality of the light source, in particular the exposure settings used when a light source is very bright

many analog photographic prints. The quality of noise does vary from camera to camera, with some equipment producing more "grain-like" noise than others.

Noise comes from many sources other than increasing the light sensitivity setting (see sidebar). The most important factors that increase noise (and are to some degree controlled by the photographer) are the sensitivity setting (ISO) used, whether a long exposure time is involved, and the exposure settings used when photographing with very bright light sources.

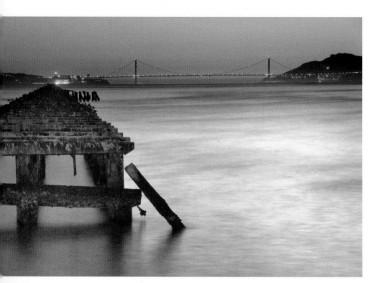

These two photos of the Golden Gate Bridge at sunset from the Berkeley Pier show how noise increases when you raise the ISO. (It's not quite an apples-to-apples comparison, because the lower ISO photo was taken at a slightly longer exposure time, which may have increased noise a little even in the lower-ISO image.) The photos were taken one right after the other, and post-processed identically.

◄ The photo on the left, taken at ISO 100, shows relatively little Gaussian noise.

► The photo on the right, taken at ISO 1600, shows considerable noise dispersed throughout the entire image and particularly noticeable in the darker areas on the left.

Both photos: 18–200mm VR zoom lens at 95mm, tripod mounted. Left: 30 seconds at f/11 and ISO 100. Right: 20 seconds at f/36 and ISO 1600.

▲ **Chapter opener:** Taking this photo of a tiny Lobelia flower backlit by strong sunlight at a relatively high ISO, I could see the noise even in my LCD display. My thought was "If you can't beat them, join them": I planned to use the noise to create an interesting, almost abstract, patterned effect.

Lensbaby 2.0 using close-up filters, 1/200 of a second at f/5.6 and ISO 640, hand-held.

With digital images, noise comes in two flavors:

- *Random* noise (also called *independent* noise) shows up as radically miscolored pixels. For example, a random noisy pixel might be white in the middle of an otherwise solid area of red. Random noise is caused by sensor flaws, and dirt on the sensor (or on the lens). If random noise is apparent in an image, it usually can be fairly easily retouched out. Random noise is not really an exposure consideration.

- *Gaussian* noise (also called *dependent* noise) is distributed throughout an image, and distorts all the pixels in a photo. Every pixel in the photo is changed.

Raising the sensitivity setting (ISO) on a digital camera increases the Gaussian noise in your photos. The amount of this noise increase is dependent on a distribution of probabilities, but it's certainly safe to assume that the higher the ISO the greater the noise simply because of the signal amplification.

It's important to understand that the same phenomenon, of the signal to noise ratio (SNR) worsening because of signal amplification, can be detected when you pump up the volume on a headset. You can really hear this increase in noise if you turn up the volume on an old-fashioned radio, or if (like me) you have a baby monitor in your house. Hint: it's the static sound. Noise is just "static" in a photo.

Taking the general concept of noise-as-static a little further, anything that increases the overall signal strength also increases the noise level. That's why long exposure times amplify noise and worsen the SNR. The sheer quantity of data inherent in some bright-light situations also explains why there can be more noise (for example, when shooting into the sun).

As a practical matter, sometimes I like to use noise in my photos for visual impact. However, digital noise is often very unwelcome.

Welcome or unwelcome, be aware that noise will always be with you, that it increases as you increase ISO and shutter time, and that noise usually cannot be observed on your LCD (see the "In-Camera Noise Reduction" sidebar below).

Noise is almost always more apparent in dark areas of a photo than in lighter areas. This implies that to reduce apparent noise you should expose a photo so that it is overall lighter by keeping your shutter speed open for a longer amount of time or by opening your lens wider (or both). This intentional "overexposure" works well to reduce noise in long exposure situations (but may not be an option if blowing out highlights is a concern).

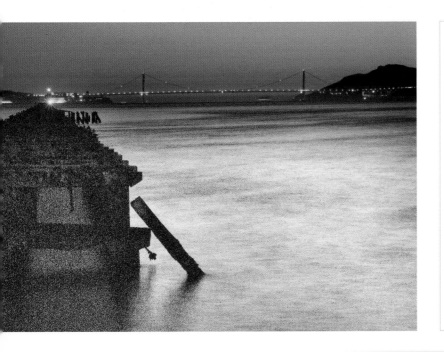

In-Camera Noise Reduction

Many digital cameras (including most dSLRs) can process images to reduce noise immediately after the image has been captured. In-camera noise processing is designed to reduce noise caused by using a high ISO and/or using a long exposure time. Even if you process for noise reduction in your camera at the time you take your photo, you may also want to reduce noise in the digital darkroom (see page 113).

Depending on your camera model, you may have to turn noise reduction on using a menu item. Noise reduction does add to processing time and battery drain. Even so, most of the time you'll want to take advantage of in-camera noise reduction for both long exposure times and high ISO (these may be separate menu items).

After all, the designers of a particular camera understand the noise characteristics of their sensor (read: electronic circuit) better than anyone else (and are therefore best able to know how to process out the noise the sensor creates). In-camera noise reduction can also take advantage of data that is only available to the sensor at the time of the capture.

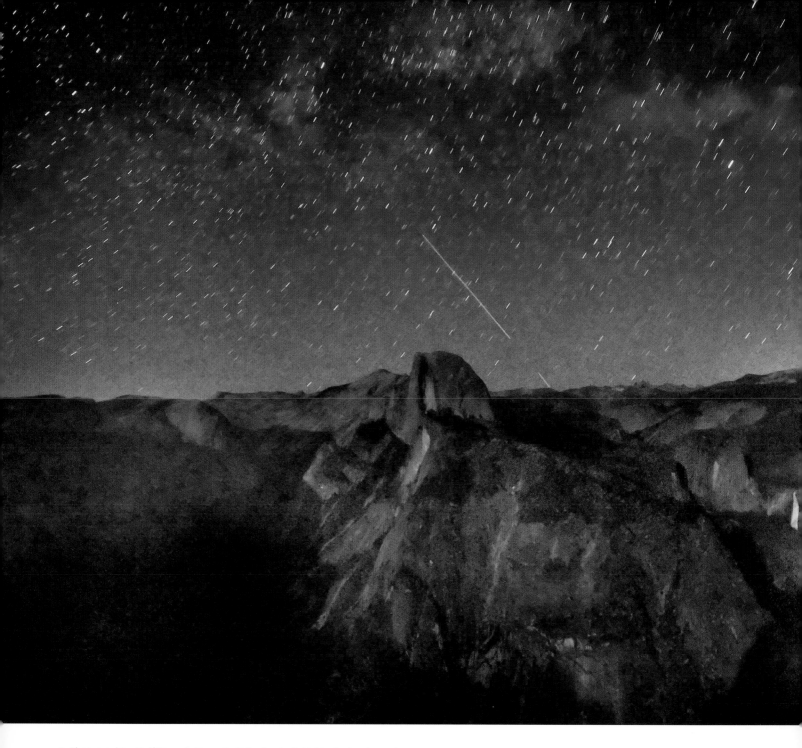

▲ Photographing Half Dome in Yosemite Valley by starlight, I took advantage of a boosted ISO (640) to create a strange, otherwordly effect in this 2 1/2 minute exposure. To get a comparable exposure at ISO 100 would have meant an exposure time of 16 minutes, which would probably have led to a much noisier image.

12–24mm zoom lens at 12mm , 150 seconds at f/4 and ISO 640, tripod mounted.

▲ Hand-held, up close, and personal,
I knew I needed to boost the ISO to
get a photo that was acceptably free
from camera shake. My thought was
to emphasize the redness of the image
rather than clarity and fine details.

*Lensbaby 2.0 using close-up filters, 1/80 of
a second at f/4 and ISO 1600, hand-held.*

When to Boost ISO

I've said it before, and I'll say it again: all other things being equal, you'll probably want to shoot with as low an ISO as possible because raising the ISO increases the noise in a photo. It's a judgement call when "all other things" are (or are not) equal, but the most common situations involve circumstances in which there is no other good way to get the shot.

Typically, it makes sense to boost the ISO in situations in which you don't have enough light to use as small an aperture as you'd like (see Chapter 2) or as fast a shutter speed as you need to freeze motion or prevent camera shake (see Chapter 3). Add to the mix the unwillingness to use a flash (perhaps because you don't want to disturb the subject) or inability to use a flash (the subject is at too great a distance) and you've got a perfect recipe for higher ISO.

People dancing in the dark? Celebrities at a political rally? Kids racing around in the shadows? Motion in the moonlight? These are all good candidates for a boosted ISO.

Another way of saying this is that it makes sense to boost your ISO if otherwise your exposure time would just be too dang long.

Different cameras have differing abilities to gracefully handle amplification of the signal that is processed by the sensor. So it's hard to make generalizations about what ISO you can safely use without generating overtly noisy images. The best advice is to run some tests with your specific equipment to find out what is acceptable to you. Be sure to examine the test images at high magnification.

In addition, the technology of noise processing generally is making rapid strides. But the table gives you a general idea of what to expect as of early 2008. What's unacceptably noisy in 2008 may work fine a few years from now.

ISO	Noise in Image
Lowest	Least noise
200–600	Fairly low noise levels
600–1000	Noise may be acceptable
Above 1000	Noise always obvious

To summarize, if you don't want to creatively use noise in your photo, and you can't get the shot in another way, you are probably safe going up as high as ISO 600 (but safer still at ISO 200 or lower).

Author J. K. Rowling notes that it is a bad idea to trust anything when you don't know where it keeps its brains. In that spirit, I'd like to repeat my warning to be careful of auto ISO. Substituting the camera's judgement for your own in this arena is a really bad idea, because you really can't tell about noise until you review your image on a large monitor, and you often won't be clear about the ISO the camera is using at the time you take the photo.

◄ Kids are always in motion. If you are photographing children in a dimly lit area, and you want to freeze the motion, you need to use a relatively fast shutter speed, or a flash. Using a flash can have some disadvantages (it can be disruptive or cast harsh lighting), and to be able to use an adequate shutter speed in a poorly lit situation implies boosting the ISO.

For example, Mathew, shown at left, was playing in a deeply shadowed tree. I raised my ISO to 400, exposed for the child in the shadows and letting the highlights blow out, and grabbed this photo at 1/50 of a second before Mathew went on to something else.

18–200mm VR zoom lens at 200mm, 1/50 of a second at f/5.6 and ISO 400, hand-held.

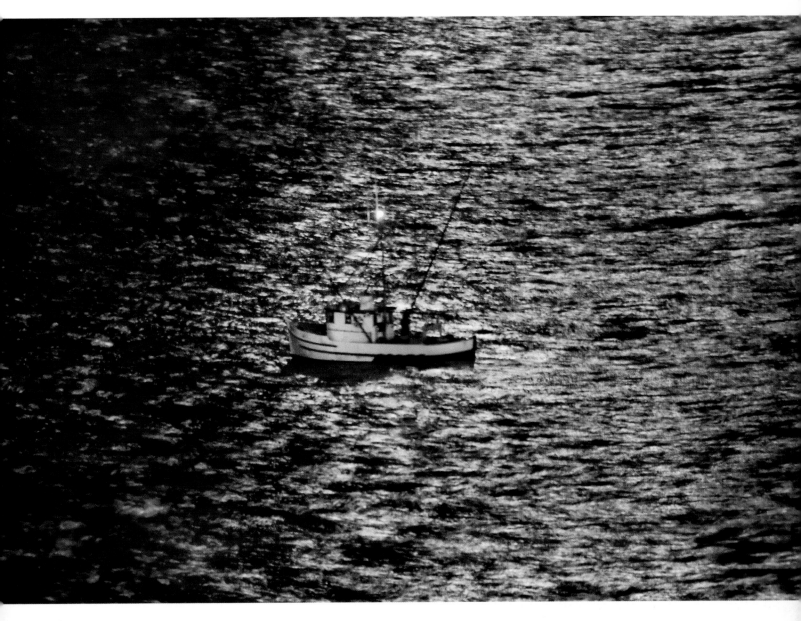

▲ The fishing trawler was returning to port through the Golden Gate. As the boat headed for the channel of moonlight, I realized that a long time exposure just wouldn't do because I wanted to capture the trawler in the moonlight, not an abstraction of the boat rendered into colored lines of motion. So I boosted the ISO to 1000 and opened the shutter for a brief (for a night time exposure) period of 2/5 of a second.

18–200mm VR zoom lens at 200mm, 2/5 of a second at f/5.6 and ISO 1000, tripod mounted.

Using Noise Creatively

Have a hankering to be a pointillist like painter Georges Seurat? Sure you can use a Photoshop filter to achieve almost any effect (including pointillism), but how much more authentic is it to use high levels of noise to make the individual pixels in your photos apparent?

In the previous section, I wrote that you probably want to use as low an ISO as possible to keep noise down. In other words, noise is bad. But there's another way of looking at this: maybe noise is good.

The more noise in an image, the more you have at least the illusion of being able to see the individual pixels

that make up a photo. Creating photos that seem to show their pixilated origins is a case-in-point for the good design principle of form following function. Depending on the photo, some noisy pixels may enhance the sense of sharing the scene with the photographer (the photo on this page is an example). In other cases, the noise inherent in the image can become part of the design and aesthetic of the image (the photo on pages 104–105 is an example).

In many images, noise works well if it appears at different levels of intensity in some parts of the image,

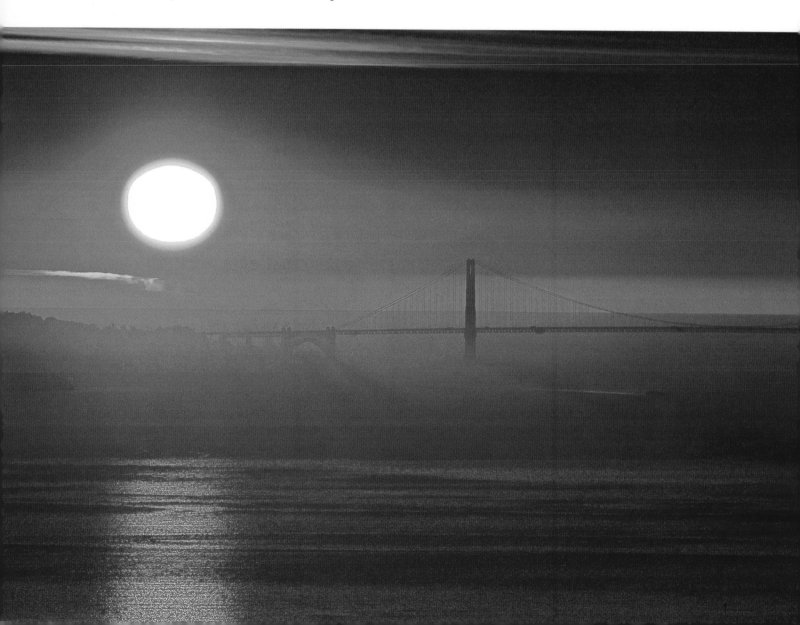

but neither overall, nor in uniform strength across the elements in the photo (the photos on pages 114–115 are examples).

To achieve effects with varying levels of noise within a single photo, you need to capture the photo at high noise levels, and then apply selective noise reduction in post-processing (see sidebar).

Creative use of noise in photos usually involves two steps: accepting (and planning for) noise in the original capture, and post-processing the noise to achieve a pleasing image impact in line with your vision.

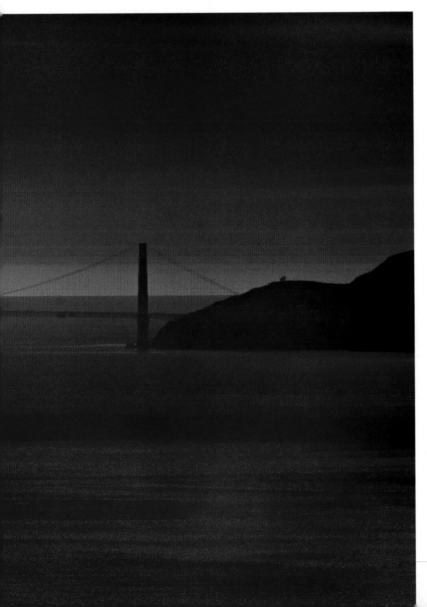

◀ With a composition that included the white ball of the setting sun, I knew that the image was likely to be noisy. I exposed for the background landscape, hoping to create visual impact using a combination of noise with the saturated colors everywhere (but not in the actual disk of the sun).

70–200mm VR zoom lens at 170mm, 1/800 of a second at f/11 and ISO 200, tripod mounted.

Post-processing for Noise Reduction

If you don't want to have noise in your photo, it's a truism that it is best not to have noise in the first place. Starting with a low-noise photo is usually more satisfactory (and less effort) than getting rid of noise after the fact in post-processing.

But noise is inevitable with high ISO and long exposure images, so it is wise to plan to post-process for noise if you are taking these kinds of photos. Photoshop and other image processing programs offer noise reduction filters, and third-party software like Noise Ninja and Nik Software's Dfine add quite a bit of power to noise reduction.

I find that I like to use noise as a creative element in many of my photos. In most of these cases, I want to post-process some parts of the photo (but not all) to reduce noise. It's likely that I'll want to use different strength noise reductions in different areas, and I usually use layers and masking to achieve this kind of result. For more information about these techniques, and about post-processing, see Chapter 6, particularly the section explaining noise reduction on pages 162–163.

▼ This photo shows a translucent Dahlia petal with water drops resting on the petal. The petal was blowing slightly in the wind. In order to get the depth of field I needed at a fast enough shutter speed to stop the motion crisply (1/40 of a second), I boosted my sensitivity setting to ISO 640. I selectively processed the image for noise, eliminating noise from the background but leaving the noise in the primary subject of the photo, the petal with water drops.

200mm f/4 macro lens, 36mm extension tube, +4.4 diopter close-up filter, 1/40 of a second at f/5.6 and ISO 640, tripod mounted.

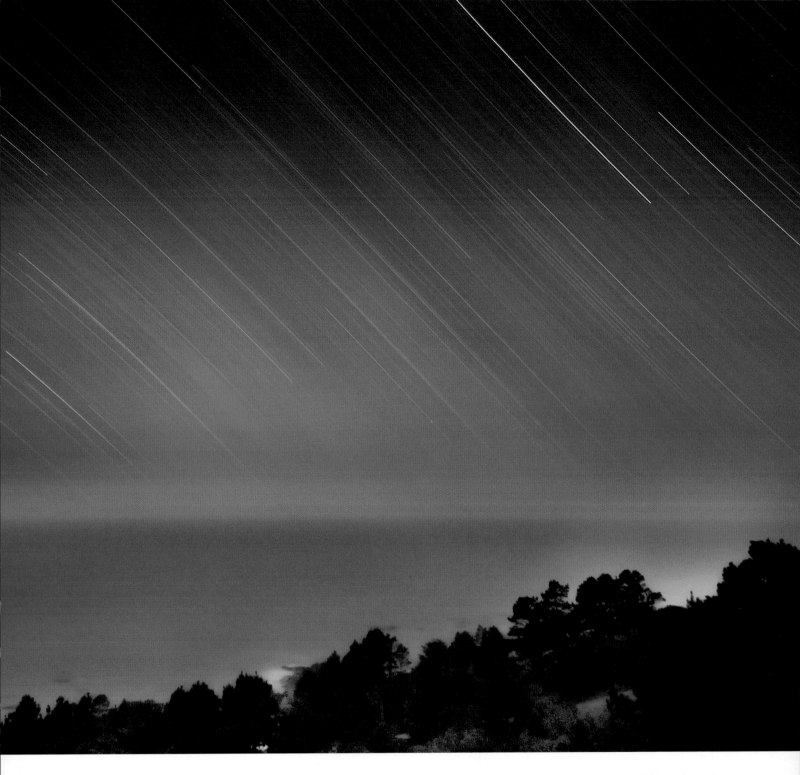

▲ I knew this almost two-hour exposure of star trails over the Pacific Ocean would have plenty of noise simply because of the length of the exposure. So I intentionally overexposed the photo to minimize apparent noise as much as possible. Looking at the image in the RAW capture, I decided I needed to leave the noise in the sky (otherwise the star trails would lose their crisp definition). But I decided to process the lower half of the image for noise, letting the ocean and hillside go soft and dreamy.

12–24mm zoom lens at 18mm, 6,554 seconds at f/5.6 and ISO 100, tripod mounted.

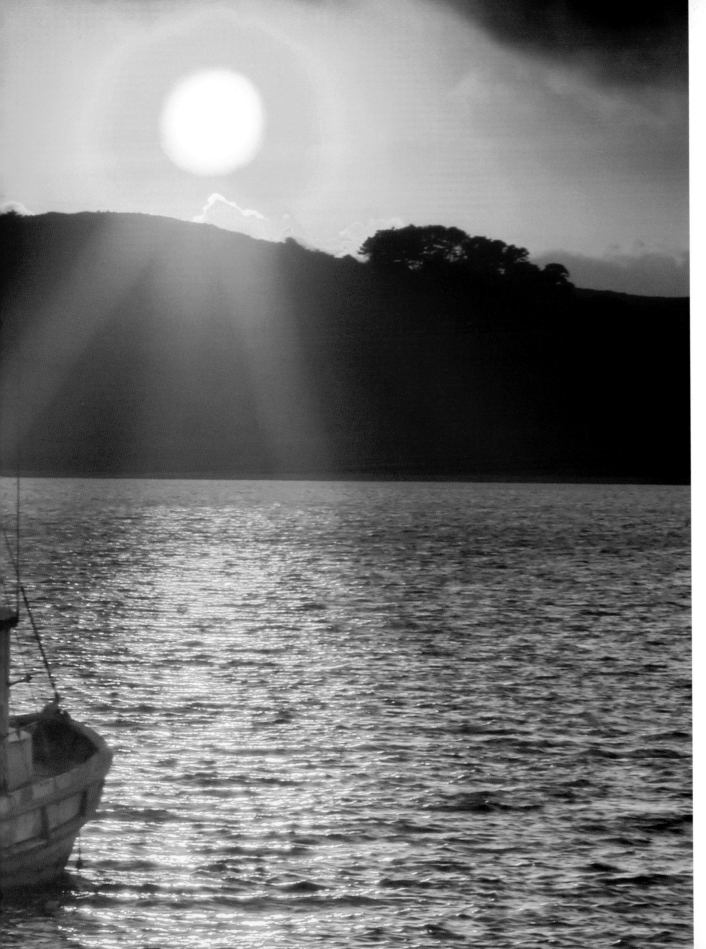

Creative Exposure

In Chapter 1, I explained that an overexposure lets too much light into your camera, and results in a capture that is too bright. On the other hand, an underexposure doesn't let enough light into your camera, and results in an exposure that is too dark. Whether a subject is exposed using "too much" or "too little" light is usually established by comparison with a reading from your camera's light meter. The amount of light let into the sensor is controlled by varying one or more of the settings that are on the camera's side of the exposure equation: aperture (Chapter 2), shutter speed (Chapter 3), and sensitivity (Chapter 4) as shown below.

> **To overexpose:** With other variables held constant, use a bigger lens aperture (a smaller f-number) or increase the time the shutter is held open or raise the ISO.
>
> **To underexpose:** With other variables held constant, use a smaller lens aperture (a bigger f-number) or decrease the time the shutter is held open or lower the ISO.

Good photographers often use their own judgement to modify the light reading obtained by their equipment and intentionally over (or under) expose a photo (see pages 46–51). Perhaps the exposure meter is simply wrong. For example, light meters tend to average every-thing to middle gray, which can lead to overexposure of bright subjects (like snowfields).

Other times the point of the exposure modification is to capture one part of the photo just right (letting other parts of the photo go too dark or light). Other times, the purpose of the exposure modification is to create an overall effect, and increase the visual impact of the photo.

In both cases, the modified exposure (at least if the photo "works") is sometimes called the correct *creative exposure*.

With digital photography, the rules of the road for creative exposing have changed. It was always reasonable to expose for specific areas in a photo with a high dynamic range (meaning great contrast between light and dark areas). It was sometimes reasonable to overexpose or underexpose to create a dramatic effect: very dark darks contrasting against a dimly lit central subject, or over-brightness used for the purposes of narrative.

This kind of rationale for creative exposure is still valid, but there's also a new option (and consideration) in play. In a RAW digital capture (for more about RAW, see page 48), there's an eight f-stop exposure variation that can be tweaked out of the capture in the digital darkroom (Chapter 6 is devoted to post-processing in the digital darkroom).

It's now the case that correct creative exposures can be used to expose for one area of a subject, with the understanding that other parts of the photo will be adjusted in post-processing. You can have dramatic effects of contrast if you want, but you also don't *have* to have dramatic contrasts. You do need to consider which of the possible creative exposures will lead to the best results once the photo has been post-processed in the digital darkroom.

◄ I enhanced the apparent transparency of these Oregano leaves by "overexposing" (compared to what my camera's light meter suggested). I knew I wanted to shoot with the aperture fully stopped down for enhanced depth of field (at f/36). The camera suggested a shutter speed of 1 second, but I chose instead to expose for 4 seconds. The brighter the white background got, the better.

200mm f/4 macro lens, 4 seconds at f/36 and ISO 100, tripod mounted.

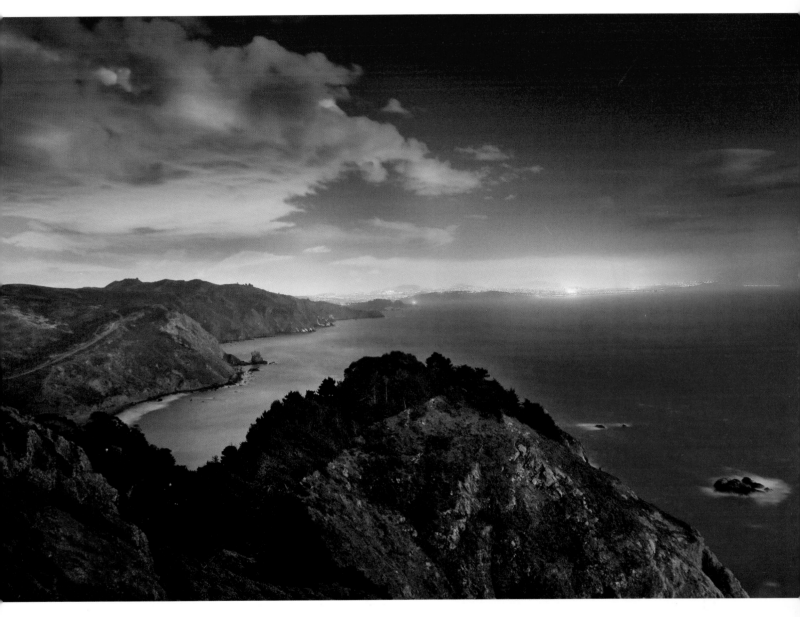

▲ I knew that the crucial parts of this photo were the city lights and saturated clouds, so I exposed for these areas of the photo, allowing the foreground landscape to go black. Later, I fixed the "underexposure" of the foreground in the digital darkroom (see Chapter 6).

12–24mm zoom lens at 20mm, 25 seconds at f/6.3 and ISO 100, tripod mounted.

▲ **Chapter opener:** The sun was setting across Tomales Bay. I underexposed for the shaft of sunlight by several f-stops to bring out the prismatic colors coming through the fishing trawler, and later worked in the digital darkroom (see Chapter 6) to make the areas of the photo that were dark acceptably lighter.

105mm f/2.8 macro lens, 1/15 of a second at f/32 and ISO 100, tripod mounted.

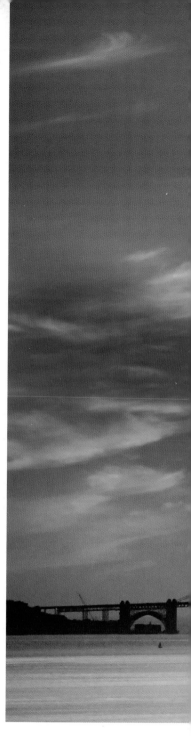

▲ The important thing in this photo was to capture
the Alstromeria petal glowing in the sunshine. I
exposed for this bright area in this photo, allow-
ing the photo as a whole to "underexpose." I then
worked to lighten areas that seemed too dark as
part of my post-processing (see Chapter 6).

*200mm f/4 macro lens, 1/180 of a second at f/7.1
and ISO 100, tripod mounted.*

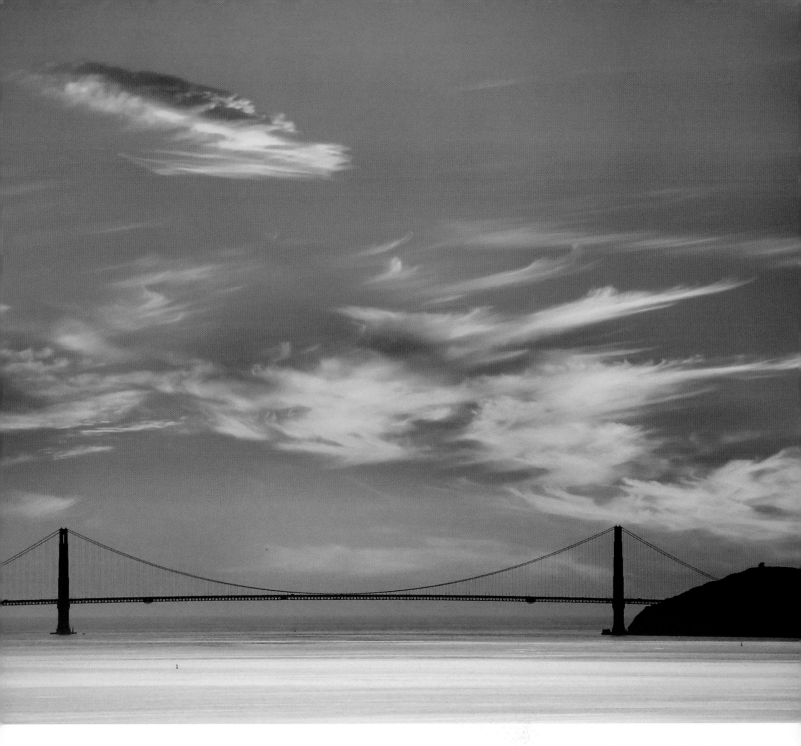

▲ To emphasize the impact of the glowing sky, I intentionally "overexposed" this photo.
70–200mm VR zoom lens at 200mm, 1/320 of a second at f/5.6 and ISO 200, tripod mounted.

Finding the Best Light

There are two sides to the exposure equation explained in Chapter 1: the exposure setting used in the camera, and the light the camera is capturing. So far, this book has mostly looked at the camera's side of the equation; in this chapter it's time to pay some attention to the other side (you might say the "bright side"), light itself.

It has been said that 90 percent of photography is just being there. If photography is about writing with light, to give yourself a chance of taking great photos, how do you increase your chances of "being there" when the light is great (so that you can "write" with it)?

There's no single answer to this very important question. The best advice I can give you is to become a careful observer of light. As you watch light, and gain understanding of how light sources interact with each other and the weather, you'll begin to be better able to predict how light will change. This experience will help guide your quest for the perfect light.

One approach is to create your own light using flash (pages 144–145) or other light sources, possibly in a studio (pages 146–149). (As I'll explain, a studio doesn't have to be fancy; sometimes an ordinary household light will work fine as the light source.) And often, even if you are not the originator of the way a subject is lit, you may want to modify the lighting, by adding lights, or reflectors, or by shifting things around.

My point is that even in situations involving artificial light that you have partially or completely created, your most important tools are your experience observing light, your ability to predict the impact of changes in lighting, and your skill in translating observed light into an interesting composition.

Knowing that the sun rises in the east and sets in the west (and the specific times for sunrise and sunset in your location) is a good start. You also need to know that the setting sun travels from north to south and back again along the western horizon in the course of a year. Do you know where in this journey the sun is setting tonight in your area?

The appearance of light on the earth is a function of the interaction of these natural light sources with atmosphere and weather. If you are interested in photographing in a particular area, you are well advised to start tracking local weather patterns and other natural phenomena. For example, photographers in coastal areas may want to track information about high and low tides. Information about when wildflowers start to bloom locally may be invaluable.

◄ The storm front broke just at sunset, and I looked for the edge of the weather so I could contrast clear skies with the darkness of the clouds.

18–200mm VR zoom lens at 34mm, 3.6 seconds at f/25 and ISO 100, tripod mounted.

► A bright sun emerged after a spring shower, and I knew there was a good chance of interesting sun "star" effects in any water drops that remained. It's worth bearing in mind that water drops evaporate very quickly in full sunshine, and you probably have only a few minutes in which conditions are prime.

200mm f/4 macro lens, 36mm extension tube, 1/3 of a second at f/40 and ISO 200, tripod mounted.

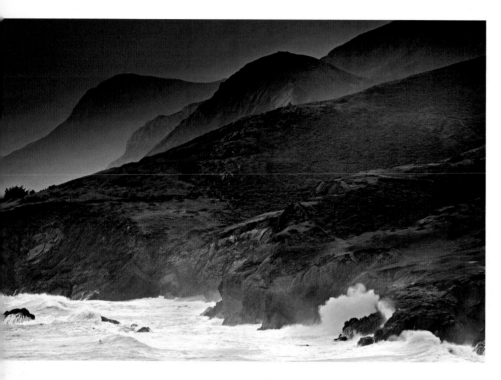

▲ I photographed the Marin coast of California and these abnormally high seas at high tide in bright overcast light during a protracted rain storm.

70–200mm VR zoom lens at 200mm, 1/640 of a second at f/2.8 and ISO 200, hand-held.

▼ Night was coming on fast. I looked for the crescent moon that I knew should be setting into the sky in the west. Finally, the moon emerged from the clouds and I made the exposure in the last glow of sunset before the moon disappeared into the fog bank. Literally a minute later, the scene was dark and devoid of color.

18–200mm VR zoom lens at 200mm, 13 seconds at f/5.6 and ISO 100, tripod mounted.

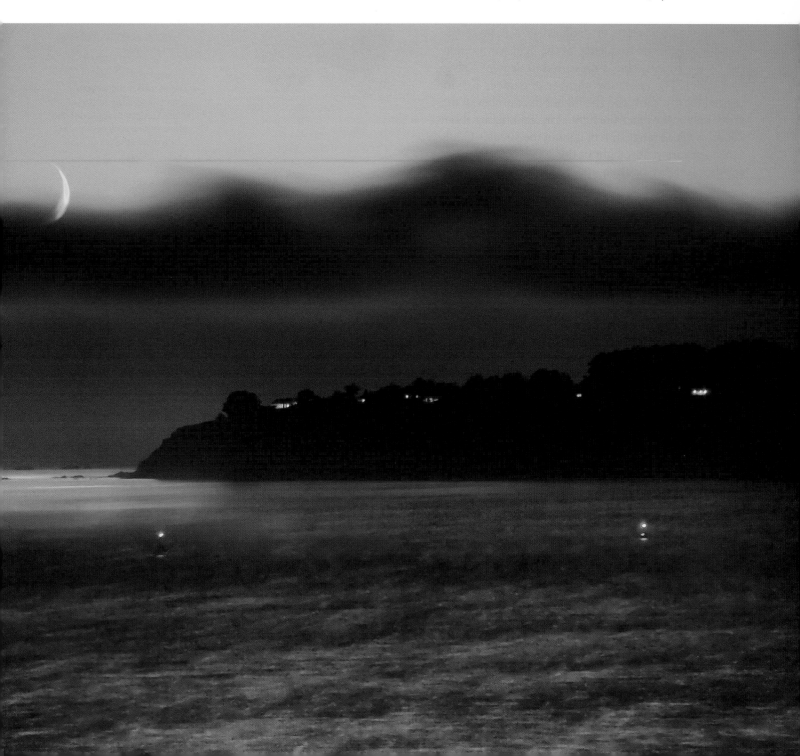

Light and Color Temperature

So far, I've explained light as something that has an intensity (or strength) that can be measured and defined using exposure settings. In addition to this quantitative view of light, any given light source has a level of warmth or coolness.

This apparent warmth or coolness of a light source corresponds to the frequency of the light waves emitted by the source, and is measured in degrees Kelvin (see table). The lower the number of degrees Kelvin, the redder the light; and the higher the number of degrees Kelvin the bluer the light. Any light below about 2000K is very orange or red, light in the 3000K–4000K range appears yellow, light in the 5000K–6000K range appears roughly neutral, and any light source above 7000K seems blue.

Below is a table showing the color temperature of light in degrees Kelvin. The asterisk (*) indicates a pre-set at that temperature in Adobe Camera Raw.

Color Temperature	Description
1850K	Candlelight (red light)
2850K	Tungsten* (household incandescent light bulb)
3400K	Some studio lighting
3800K	Fluorescent
4100K	Moonlight
5500K	Daylight*, flash*
6500K	Cloudy*
7500K	Shade* (blue light)

Another way of describing the scale of Kelvin values is that light moves from warm in the psychological perceptual sense (at lower Kelvin values) to cool, again perceptually (at higher Kelvin values).

In the old analog days, photographers used color film that was balanced for a particular light source (and color temperature). This color balance could not be changed, except by changing the light source itself or by using a filter on the camera designed to change the color temperature of the light. Photos shot using mismatched film and light sources often looked "wrong" and were said to have a *color cast*.

I photographed the inside of a Lily using a number of light sources, including daylight and tungsten.

All three versions: 105mm f/2.8 macro lens, 36mm extension tube, +4 diopter close-up filter, 20 seconds at f/40 and ISO 200, tripod mounted.

◄ This version is shown with a color temperature setting of 2850K (tungsten) applied to the photo during RAW conversion, which makes the photo more blue (see text).

◄ This version is the one I ended up using, and was converted using a color temperature setting closest to the actual mix of light sources at the time I took the photo. It is shown with a setting of 4650K applied to the photo.

◄ This version is shown with a color temperature setting of 7500K (shade) applied to the photo. Shade is blue light, but applying the setting makes the photo redder.

Things have greatly changed with digital. You can set the light that a shot is balanced for using the *white balance* setting in your camera, and readjust this setting after the fact if you've shot in RAW (see pages 128–131 and 160–161 for more about working with white balance settings).

The three photos to the left of the stamen of a Lily show three different color temperatures applied to the photo after the fact. Changing the color temperature as part of the post-processing process is like playing a "what if" game: What if I had shot this photo at the new color temperature?

Applying the proper color temperature settings at the time you take the picture is supposed to produce an essentially color neutral effect. However, applying a color temperature retroactively to an existing RAW capture introduces a color bias opposite to what you might expect. Consider the version of the Lily stamen with the 2850K (tungsten) setting applied (left-most version). This light source is yellowish towards red, but the application of the setting produces a more blue image.

Real-world color temperatures are far more complex than the simple table of values in this section might lead you to think. The majority of photographs involve lighting from mixed sources. And even one kind of lighting can vary greatly (for example, real-world sunshine can vary between 3000K and 8000K; fluorescent lights have been measured between 2000K and 12,000K).

As a practical matter, I don't worry too much about measuring the color temperature of light (although it's a great idea to become a careful observer of the temperature of light). I expect to adjust my color temperature on the basis of what looks right, after I have taken my photos.

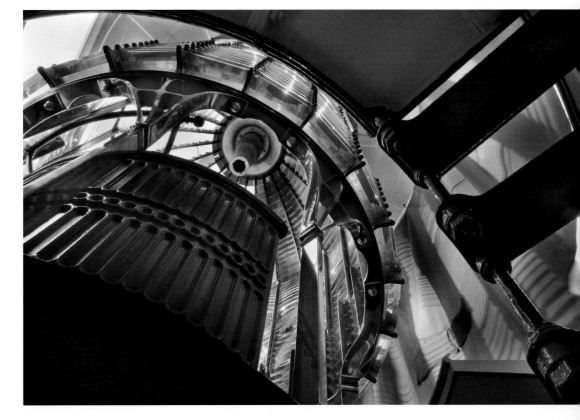

▶ The inside of the Point Reyes Lighthouse was a melange of different color temperatures, with the light sources including tungsten, flourescent, daylight, and refractions from the antique fresnel lens. As I shot this photo, I realized that to get good results I would need to combine several versions of the RAW capture, with the different versions using different color temperatures (see pages 156–167).

12–24mm zoom lens at 18mm, 3 seconds at f/22 and ISO 100, tripod mounted.

Working with White Balance

White balance probably intimidates more photographers than any other digital camera setting, so I am happy right here and now to make white balance simple for you: *The white balance setting in your camera doesn't much matter.*

"Wait!" you cry. "How can this be? There's so much fuss made about white balance, and now you're telling me it doesn't matter?"

Well, OK, white balance itself does matter. But your initial white balance settings aren't really a big deal (at least if you are shooting RAW). Let's start at the beginning.

Setting the white balance tells your camera the color temperature (explained on pages 126–127) of the light source for your photo. If the white balance is correctly set, theoretically the photo should appear to be neutrally lit without a color cast.

You set the white balance in a camera to a specific Kelvin value or a pre-set, like tungsten (2850K) or sunlight (5500K).

Most digital cameras also have an auto white balance setting, in which the camera analyzes pixels to do a rea-

sonably good job of coming up with the color temperature of the light source. I'm usually not a great fan of automatic settings, but if you leave your camera on auto

Using a Neutral Gray Card

If you are taking photos in lighting than can be controlled (it's very important that the light is constant), there are several useful ways to use a neutral gray card to improve white balance accuracy.

Neutral gray cards are 18 percent gray. You can get one from any photo supply source.

You can point many digital cameras at the neutral gray card, and use the a special control on the camera to input a custom white balance value. This kind of reading should be quite accurate (check your camera manual for instructions about how this works on your model).

An alternative approach works if you plan to take a series of photos using a light source that doesn't vary too much. Include the neutral gray card in one of the photos. The software used for post-processing RAW images will allow you to click on the gray card in the image on your monitor, derive an accurate white balance setting from it, and apply the white balance gained this way to all the photos in your series.

white balance you'll mostly do pretty well. (Auto white balance doesn't always get it right, but as I discuss in a moment it doesn't really matter for RAW captures.)

In addition, many digital cameras have a mechanism for reading the actual white balance off a neutral gray card. This can be extremely useful (see the "Using a Neutral Gray Card" sidebar on page 128).

Achieving color neutrality seems like an important goal, but there's less to the camera white balance setting than meets the eye.

Setting the white balance in the camera for a photo associates the color temperature value specified by the white balance with a photo that is about to be taken, but in the case of a RAW capture it is not an irrevocable association. Making the association between the white balance (hopefully assigning a balanced color temperature related to the light source) and a photo has the following implications (and only these implications) for a photo:

- The white balance setting is "baked into" a JPEG version of the photo (note that you can still do retroactive color adjustments using white balance, but they're just not as powerful as white balance adjustments made during the RAW conversion process).

- The JPEG version is used to display the photo on the camera's LCD following capture.

- The white balance setting is associated with the RAW capture, and is initially assigned to the RAW photo when you open it for post-processing (see Chapter 6).

That's absolutely it! From the viewpoint of a photographer shooting RAW, the white balance setting changes the way captures are displayed in the camera review and also the setting assigned to the RAW image when it is first opened in the digital darkroom.

Therefore, my approach is not to pay too much attention to in-camera white balance. Sure, sometimes adjusting the white balance setting in my camera makes the display on my LCD look nicer. But in a real world full of varying color temperatures and multiple light sources, the right place for the real work with white balance is the digital darkroom.

Bear in mind that my goal is to create photos that use color in an interesting and attractive way. If my primary mission were accurate reproduction of specific colors (for example, museum photography of paintings), then I would be more careful about my initial white balance settings (see "Using a Neutral Gray Card").

Profiling Your Monitor

If you can't see colors accurately when you review photos on your computer monitor, then the whole topic of setting the color temperature of the light source using white balance isn't very useful.

Even leaving color temperatures and white balance point out of it, it's extremely important for photographers to be able to consistently and accurately view their work.

The secret to accuracy and consistency in viewing photos on a computer monitor is to profile the monitor (and to keep the profile up to date).

Adobe Gamma (Mac and Windows, ships with Photoshop) and ColorSync (Mac, included with OS X and a free download from Apple for older operating systems) are software tools that you can use to profile your monitor. A somewhat more accurate option

is to use a spectrophotometer (a popular version is the Pantone Eye-One Display, which costs less than $250.00).

The spectrophotometer sits on top of your monitor, "reads" the colors displayed, and uses the software that ships with the device to accurately calibrate your monitor.

LCD monitors should be profiled (at a minimum) once a month, and CRT monitors need to be profiled more often. You should take care to profile the monitors using room lighting you will actually use to work on photos. It's important to keep the lighting in the room where you work with your computer consistent, so that this lighting doesn't become a variable when you are looking at the colors in photos on the monitor. Shifting daylight can be a problem, so you may be better off calibrating (and working) using artificial light.

◄ This photograph shows the view through Arch Rock in Point Reyes National Seashore, California. At high tide the ocean was lit by moonlight in the foreground. Light from the setting sun predominated in the background of the photo.

I took the exposure with the camera set to auto white balance, and processed the water within the arch at a setting of 4300K and the clouds at a setting of 5800K, and combined the different white balance versions in the digital darkroom (see pages 156–167).

12–24mm zoom lens at 24mm, 2.5 seconds at f/14 and ISO 100, tripod mounted.

▲ I set my tripod up on a path within a cedar break, used to cut the wind, on the Sea Ranch plateau in northern California. I reviewed my initial exposure in my LCD, and was surprised that the photo seemed to look dull and gray. However, when I switched my camera's white balance setting from auto to cloudy (6500K), the next exposure glowed warmly when I reviewed it on the LCD. My camera's auto white balance setting had simply gotten this one wrong.

105mm f/2.8 macro lens, 5 seconds at f/32 and ISO 100, tripod mounted

▲ A break in a storm unveiled this vignette of a tree on the cliffside in Yosemite Valley. However, the image looked lifeless and devoid of color when I looked at it on my monitor using the initial while balance setting (derived from the camera's auto white balance). I adjusted the white balance by eyeball to make the colors much warmer.

18–200mm VR zoom lens at 200mm, 1/400 of a second at f/10 and ISO 200, hand-held.

Front Lighting

An exposure measures an amount of light. A characteristic of light is its color temperature, set using white balance. In addition to amount and color, a source of light can also usefully be described by the *direction* of the light source. If you understand the amount, color, and direction of a light source, then you have a good appreciation for the *quality* of that light.

Developing an eye for the quality of light is one of the most important keys to success as a photographer. It's worth taking the time to pay close attention to the direction and interaction of light sources as crucial components of the quality of light.

In other words, if you are aware of what light does to things you are well on your way to being an accomplished photographer.

When it comes to the direction of light, it's easiest to think of things from the viewpoint of the object being illuminated, rather than the light's directional relationship to the camera.

Front lighting hits the front of the object you are photographing. This usually means the light is coming from behind the camera, although the light source may also be a lot higher than the camera position, and it might be somewhat angled.

Front light is great for illuminating details, and lighting everything so it can easily be seen. However, if the light source is too strong, front lighting can lead to highlight blow-outs. If you are photographing people, front lighting is often not particularly flattering, and can lead to photos in which the subjects are squinting into light shining right into their eyes. (A problem with on-camera flash is that this light source only provides front lighting.)

Front lighting is not a particularly subtle light, but when it works, it can be powerful. If you are working with front lighting, look for low levels of light intensity.

Outdoors, think about sunset and sunrise as the best times for front lighting. Another approach is to look for situations in which a shaft of front lighting isolates your subject; for example, a beam coming down to the forest floor through a canopy of leaves.

Indoors, consider modulating front light by adding diffusion and other light sources (see pages 146–149).

◀ A sunbeam passing through the trees overhead lit the front of this Succulent through a gap in the leaves, and I paused to capture the golden light.

105mm f/2.8 macro lens, 1/4 of a second at f/36 and ISO 200, tripod mounted.

▲ The sun rose behind me, lighting the eastern side of Half Dome with its famous and perilous ladder to the summit.

12–24mm zoom lens at 14mm, 1/180 of a second at f/7.1 and ISO 100, tripod mounted.

Side Lighting

Side lighting, as the name implies, is light that predominantly hits the side of the subject. The source of this light is to the left or right of, and either in front of or behind, the camera. If side lighting comes from behind the subject (rather than behind the camera), it can verge on back lighting (pages 136–137).

Side lighting is strong lighting, with a distinctive character. This lighting creates shadows and strong contrasts. Patterns and textures come to life. Volumes and shapes are clearly delineated, and the three-dimensionality of the world is very apparent.

When the source of side lighting is behind the camera, highlight blow-out can be an issue. In any case, side lighting is not subtle. It is harsh, dramatic, and renders delicate colors without great sympathy.

Side-lit photos of landscapes taken early or late in the day can be very dramatic, but they will include dark shadow areas. These shadows themselves are an important part of any side-lit photo.

If your idea is to let the shadow areas go black, then it certainly makes sense to expose for the brighter areas of the photo. On the other hand, if you are concerned about preserving details in shadow areas, you should plan to expose for the lighter end of the shadow area spectrum. In any case, many side-lit photos require post-processing corrections in the digital darkroom (Chapter 6) to achieve their full potential.

Indoors, it's great fun to experiment with side lighting—either as the sole light source for drama, or in combination with other, gentler lighting to add some narrative flair. Subjects lit from both front sides can look very three-dimensional, and this can be a good recipe for successful portrait lighting.

▲ Sunshine, coming from the rear left of the bridge tower, passed through
the tower and projected an unusual sideways shadow onto the fog.

*70–200mm VR zoom lens at 135mm, 1/1000 of a second at f/8 and ISO 200,
hand-held.*

◄ The strong side lighting, coming from behind and to the left of the
camera, created an interesting pattern of strong contrasts in this New
Mexico forest in early spring.

105mm f/2.8 macro lens, 1/180 of a second at f/14 and ISO 200, hand-held.

Back Lighting

Back lighting is lighting that comes from behind a subject. In other words, the camera is looking directly at the light source, or would be, except for the subject that's between the light and the camera.

If the subject is entirely opaque, a back-lit photo will probably be entirely dark except for the outline of the subject and (perhaps) light peeking around its edges. This usually isn't the point of back lighting (although it might be a fun effect to experiment with). When back lighting works, the photos that result are largely about transparency.

For this reason, back lighting is an unusual choice for portraits of people, because usually you want to see the features of someone's face in a portrait. Back lighting, as an accent, in combination with other lighting, can add a dramatic touch to ordinary portraits (see the photo of Mathew on page 110 for an example).

Transparency usually implies a subject that is at least somewhat translucent, as well as a light source that can be positioned behind the subject. Flowers, grasses, and leaves are often great natural subjects with high transparent qualities. Surprisingly, non-botanical subjects such as clouds can also work well (there's an example of a photo showing back-lit clouds on page 121). You might also consider things liked old-fashioned glass jars, windows, and doors; stained glass (example on page 7); and translucent industrial materials such as plexiglass.

Outdoors, the sun is the obvious light source, but it will only work to back light subjects when it is close to the horizon. This typically means early morning or late afternoon, but runs up against the requirement that a back-lighting source must be intense enough to render the subject's transparency. In other words, if you are lucky enough to find a suitably transparent subject outdoors and a correctly directed back-lighting source of appropriate strength, seize the moment!

Indoors, there are more options for back-lighting because you can control the lighting (pages 146–149) and subject motion may not be as great a concern. With a static subject protected from the wind, your light source doesn't need to be very strong (you can use a slow shutter speed for a long exposure as explained in Chapter 3).

Some back-lit photos use the hard shadows created by the light source and subject to great advantage. But my favorite back-lit compositions are soft, lacy, revealing, and intimate.

◄ The strong early morning sunlight coming through this California Poppy cast a shadow on the inside wall of the flower.

105mm f/2.8 macro lens, 1/250 of a second at f/7.1 and ISO 200, hand-held.

► By lighting this Orchid from behind using a light box, I was able to capture delicate details in the translucent petals.

85mm f/2.8 perspective-correcting macro lens, 4 seconds at f/51 and ISO 100, tripod mounted.

Overcast Lighting

Outdoors, colors are often saturated and dramatic (because of higher than normal water content in the air on overcast days). The color temperature of overcast light is considerably warmer than direct sunlight, so photos taken in this light often have very attractive color tonality. The trick to great overcast lighting photos is to take advantage of this strength, because overcast lighting's weakness is that it lacks drama: overcast lighting is lighting without an obvious direction. Shadows are weak and subdued, if they exist at all.

Indoors, non-directional lighting (the analog to outdoor overcast lighting) can be implemented fairly easily using a light tent, either purchased or put together on a home-made basis (see pages 146–149). This kind of lighting setup is often used when there's a need to shoot a lot of products for a catalog or web site. Each product needs to be shown distinctly, but there isn't the time or inclination to introduce distinctive or emotional lighting for each object that needs to be shot.

So in the studio, non-directional lighting is often used for the most generic kinds of photography. In contrast, outdoors overcast lighting can lead to strikingly beautiful and distinctive landscape photos—provided that a white sky is not an issue.

This implies that on overcast days you should concentrate on images that don't have much sky because they are primarily showing a ground level view. Another thing to consider is that overcast, bright, non-directional light can be excellent for outdoor close-ups (for an example, check out the photo showing sharp water drops in the background with a blurred foreground on page 67).

You should look for situations in which there is general overcast light from cloud cover that is breaking up, or where shafts of direct light are piercing a veil of overcast, non-directional lighting. While these situations are comparatively rare, particularly at the beginning or end of the day when light is at its finest, it's a combination that can make for superlatively interesting photos.

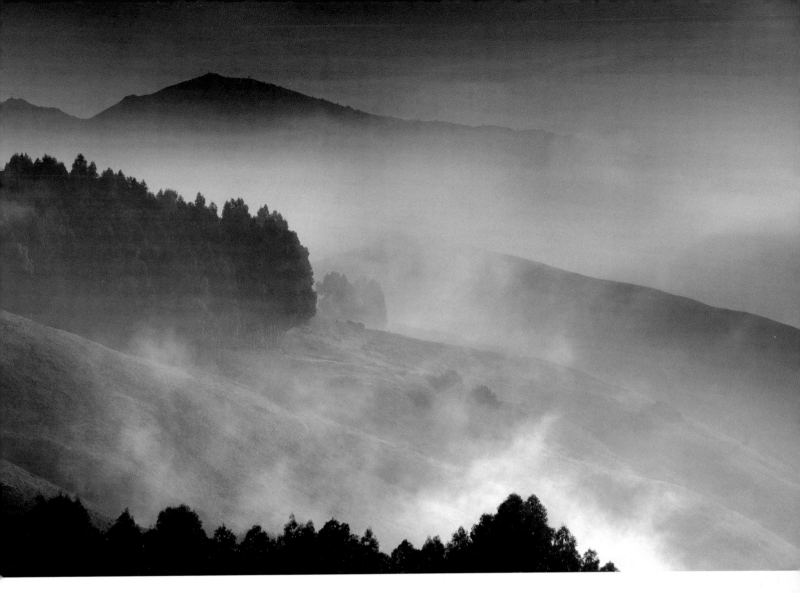

▲ It was an early morning of thick fog in the California hills. As the fog began to break up, several areas of light began to form with the general overcast, helping me to create a dramatic image.

70–200mm VR zoom lens at 120mm, 1/640 of a second at f/10 and ISO 200, hand-held.

◄ A bright, but overcast, day lit the forest floor and trees In Yosemite Valley. The overcast light helped bring out rich brown and green colors.

18–200mm VR zoom lens at 18mm, 1/4 of a second at f/22 and ISO 100, tripod mounted.

Night Photography

Digital photography opens new realms for image creation at night, along with new problems and pitfalls. Digital sensors don't see the night the way our human eyes do (or the way film did, for that matter).

Your digital sensor doesn't really care that there isn't very much light out there in the night. You may be stumbling around in the dark trying not to fall off of a cliff (the chief occupational risk to night photographers), but provided you expose your camera so that the sensor gets plenty of light, your photos won't portray the scene as dark at all.

The fly in this ointment is that exposing a night scene properly means using a high ISO, or a very long shutter speed (sometimes in minutes), or both, resulting in substantial levels of noise (see Chapter 4 for more about noise, and pages 162–163 for information about noise reduction in the digital darkroom).

Your digital sensor will be able to pick up and record light you can barely see, particularly after sunset. For example, even after the glow of sunset has faded from a cliff to human eyes, it is often still colorful and vibrant to a digital camera, provided the photo is properly exposed and post-processed.

Sometimes the beautiful after effects of sunset are invisible to the naked eye, but picked up by the camera, and don't emerge until the photo is post-processed in the digital darkroom.

Most likely, the light meter in your camera will be useless in low-light night conditions. There are a couple of other constraints that make night exposures harder to get right:

- The image in your LCD may be completely dark (even when the RAW capture contains plenty of good information), making it difficult to review images in the field. You'll need to learn to decode images in your LCD that bear a only a slight relationship to the actual finished image.

- Individual captures can take a long time, particularly when long exposure noise reduction is turned on (as it should be, see page 95); you may not have the opportunity to make more than one or two exposures per night, with each exposure draining an entire battery.

Obviously, if you are going to be doing much night work, you need to get good at guesstimating exposures with relatively little information in night conditions. Two techniques I've found that help come up with reasonable exposures are to:

- Start photographing before it is entirely dark, and keep photographing as it becomes apparently black. This helps me understand the exposure realities as full night does take over, and gives me a starting place for deriving my full night exposures.

- Use a boosted ISO and a faster shutter speed to establish a correct exposure, then use the comparative version of the exposure equation to capture a version at lower ISO and a longer exposure time (see pages 28–29 for a night-time case study using this technique).

◄ Not all night photography is of grand vistas. This photos shows Christmas lights reflected in a water drop.

200mm f/4 macro lens, 30 seconds at f/25 and ISO 100, tripod mounted.

▶ This five-minute exposure of Mount Tamalpais at night shows stars, ambient light, and vehicles in motion.

18–200mm VR zoom lens at 18mm, 300 seconds at f/3.5 and ISO 100, tripod mounted.

Besides the ability to make elegant captures in what seems like impossibly dark conditions, digital sensors capture light beyond the spectrum that is visible to us at night. There's light in the UV (ultraviolet) and IR (infrared) range that we can't see in the night landscape, but your camera can see some of it. Don't be surprised to see striking colors in your photos of the night that you never knew were there!

Preparing for Night Photography

Night is a different realm than the day. The dark of night is strange territory to most of us. Humans, even those who like the night life in big cities, are fairly emphatically diurnal. To become a successful night photographer, you must learn to unleash your inner nocturnal being and become a creature of the night. (And say that sentence with a Transylvanian accent, please!)

The first step is to become accustomed to the night. Take your time, and start with someplace familiar, like your own back yard. Don't try to take any photos yet. Let your eyes adjust. What do the stars look like if you observe them for a long time? How much darkness can your vision penetrate?

Move on to a night quest, possibly still without your camera. Hike overnight to someplace you know will not have any ambient light pollution from humans (street lights, car headlights, city glow, and so on). Sit outside and watch the progress of the night from a special, dark place. I like to think of night photography as a slow form of exposure that shows the world as it is perceived by a plant or a rock. So in your quest, become the rock and let a rock view of the night roll over you.

Once you are ready to take photos in the night, you should plan to bring a good tripod, a remote for taking long time exposures, and extra fully-charged batteries for your camera. Your camera should be able to take Bulb exposures to work for night photography (there's some information about using a remote control to take long Bulb exposures on page 95).

Night time can be surprisingly cold, particularly if you are sitting around observing or waiting for a photo. Bring warm clothing. A good pair of shoes is important when it's hard to see terrain well. You'll want a personal light source (head lamps work better than flashlights because a head lamp leaves your hands free to operate your camera).

Photography at night has some inherent hazards (I'm thinking primarily of accidental falls when it is hard to see where you are going). For safety's sake, consider taking a companion, and starting to learn night photography by going with a group or taking a workshop.

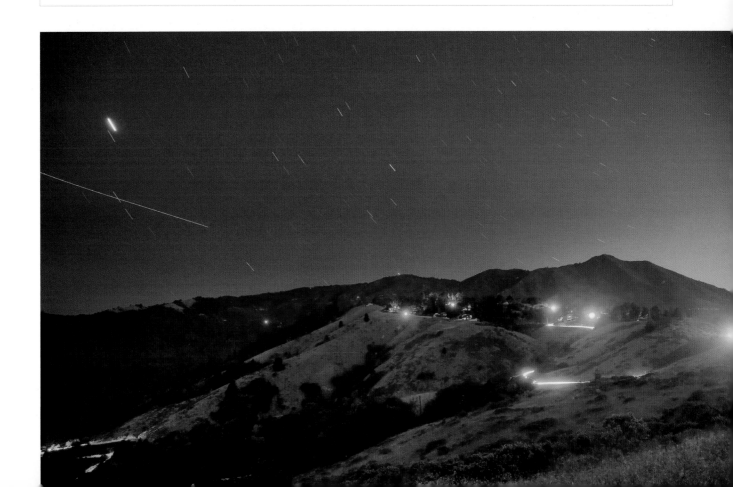

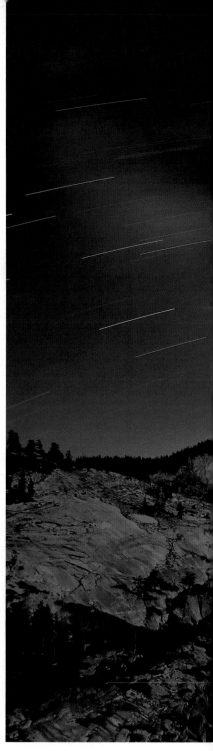

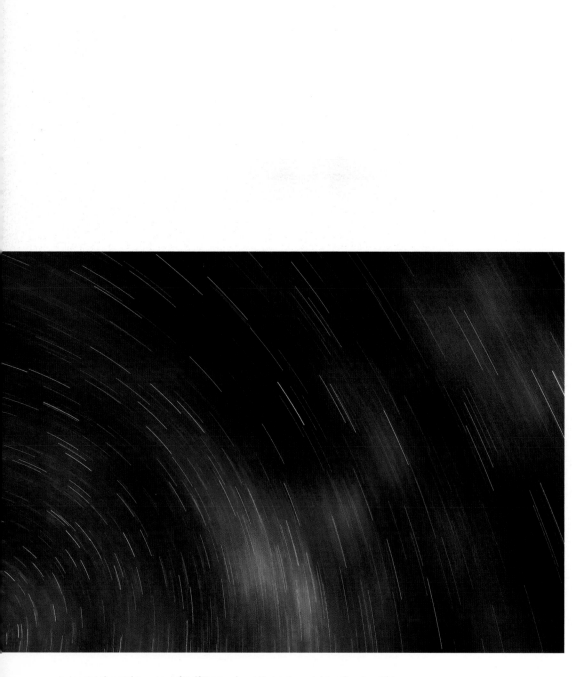

▲ I spent the night on top of Half Dome above Yosemite watching the stars. This 36-minute exposure looking straight up drained a fully-charged battery completely.

12–24mm zoom lens at 16mm, 2,187 seconds at f/8 and ISO 100, tripod mounted.

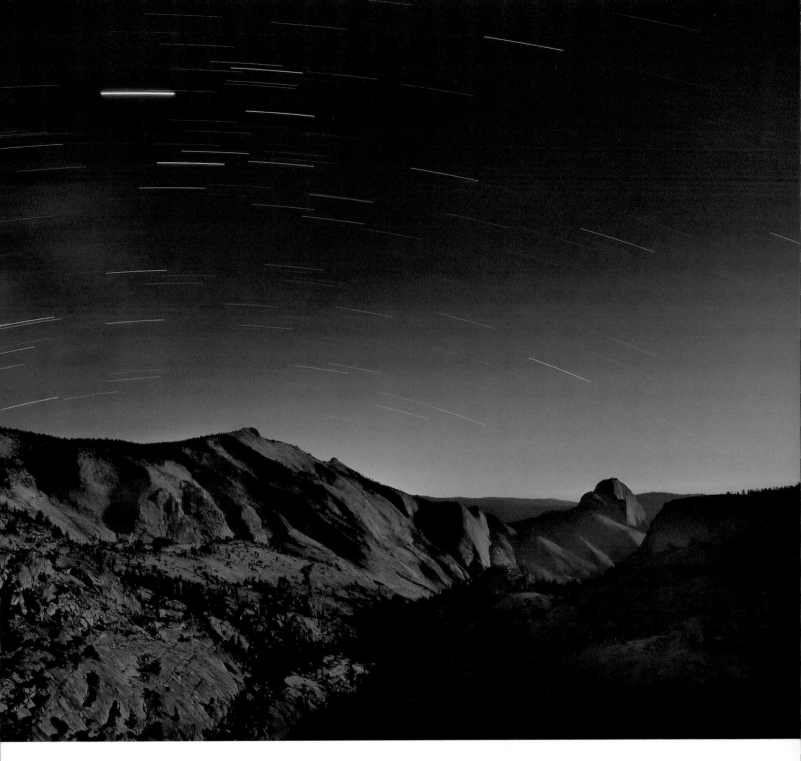

▲ The moon had set, and I hiked a half mile by starlight to this vista point. My 23-minute exposure caught the stars whirling over Tenaya Canyon with Half Dome in the distance.

12–24mm zoom lens at 15mm, 1348 seconds at f/8 and ISO 100, tripod mounted.

Using Flash

Flash lighting can have many benefits. Chief among these benefits:

- Flash can stop motion more effectively than even the fastest shutter speed.

- Flash is (usually) very portable.

- Flash has the same color temperature (5500K) as sunlight, so flash can often be used very effectively in fill mode in conjunction with natural light.

- Flash is a particularly good light source for photographing people, because unlike other like artificial light sources it does not generate heat, and also tends to reproduce skin tones fairly naturally.

- Flash gives you the potential for completely controlling the light source of an exposure.

Of course, there are downsides to weigh against these benefits, and I'll get to them in a moment.

Most digital cameras come with a built-in flash. If you use a built-in flash as your light source, your subject will be harshly front-lit.

A particular pitfall with dSLRs is to use a lens shade and the built-in flash simultaneously. The lens shade

often produces a huge, unattractive dark shadow obscuring a large portion of the photo. Resolve this problem simply by removing the lens shade when you use your built-in flash.

You can soften the characteristics of flash as a light source in several ways (these suggestions may not work with a flash unit built in to your camera).

It helps to fire the flash through diffusion material (often plastic, paper, or cloth). Diffusers can fit on the end of a flash unit like a filter (or you can tape material to the business end of the flash). Larger diffusers can be positioned a foot or two from the flash, and positioned between the flash and the subject. The diffuser can be held in place using a light stand and clamps, or just using materials that come to hand.

Generally, flash photos are more successful if the flash is off camera, or at least is an accessory unit with the capability of being angled. Assuming this is the case, the less the flash is pointed directly at the subject the better. The easiest way to accomplish this goal is to bounce the flash off something, rather than pointing the flash unit directly at the subject.

You can start by positioning the flash so it is bouncing off the ceiling.

Using rubber bands or tape to attach a white card used to reflect the light generated by the flash towards the subject is a good way to improve the character of flash light.

◄ This Hibiscus flower was blowing in the wind that followed a sudden rain storm. I was glad to be able to "freeze" the motion of the flower, and capture this image, using both daylight and flash in fill mode for the exposure.

200mm f/4 macro lens, 1/60 of a second using wireless macro flash units at f/20 and ISO 100, tripod mounted.

► Using flash on this water drop on a Cymbidium Orchid enabled me to stop the motion inherent in the subject, to control the reflection (by changing the direction of my flash units) and to make sure the background went entirely black.

200mm f/4 macro lens, 1/60 of a second using wireless macro flash units at f/45 and ISO 100, tripod mounted.

Taking bounce one step further, you can point the flash itself at a reflective surface (often a piece of white cardboard) rather than the subject. The reflective surface is angled to light the subject with light that is more mellow than the direct flash output.

The best thing you can do is to get the flash off your camera, particularly off the top of your camera. Of course, this can't readily be done with a built-in flash, so getting the flash off your camera implies the purchase of one or more flash units.

A major benefit of getting the flash unit away from your camera is that you can move away from front lighting your subject. With one or more off-camera flashes you can set up a side-lighting situation. Lighting a subject from both sides, with two off-camera flash units, works extremely well (one of the two units should be a somewhat stronger light source than the other).

Flash units that are off camera usually communicate wirelessly with the camera. If the camera is directing the amount of light put out, then the camera is called the *controller*, and the off-camera wireless units are *slaves*. Sometimes one of the flash units performs the role of controller when the on-camera flash isn't used. (Some slave flash units aren't actually communicating via wireless, they just fire in response to the burst of light emitted by the controller.)

Flash isn't perfect as light source, of course. Its range is limited. (If you've ever chuckled to see someone using a flash to take a photo of a vast landscape like the Grand Canyon, you'll know what I mean.)

The very act of flashing can be disturbing, impractical, or forbidden in many situations.

Kids who were happily and unself-consciously playing may freeze up once the flash starts going off. I believe that in this kind of situation where the use of flash is questionable, it is smarter to raise your ISO and use available light.

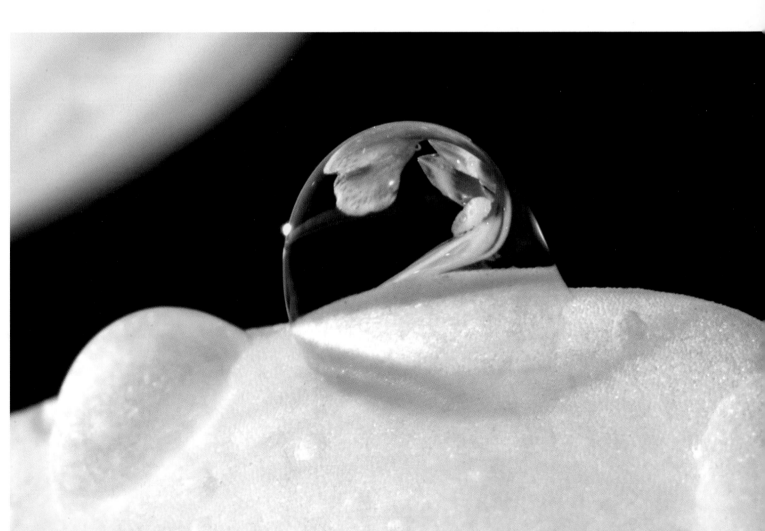

A Studio of Your Own

When you think of a photography studio, you might think of a big white urban loft room filled with fancy gear and specialized backdrops. (Not to mention attractive models and snooty assistants.)

Sure, we'd all like to be able to use a grand studio of this sort from time to time. But with a little creativity, imagination, and vision it's possible for anyone to have a surprisingly useful studio of their own. Depending on what you are interested in photographing, a small table will probably give you enough space.

To create good studio photos of your own, you need:

- Photographic gear
- Lighting
- Something to photograph
- Materials for constructing backgrounds and sets

Let's look at each of these items in turn.

Photographic gear: At a minimum, you'll need a tripod and a camera that can take close-ups. Studio work can be done with a fixed-lens digital camera using macro mode (see pages 58–59 for two examples). But these cameras are usually limited in the length of exposures they can take, so you'll probably be more productive with a digital SLR.

Along with your dSLR, any kind of close-up rig will work, but if you plan to do extensive macro work a dedicated macro lens is probably best (see page 79 for more about macro photography equipment).

You can use a self-timer to activate an exposure when the camera is on the tripod, but it's better to use a remote because there's less chance of introducing any camera motion.

Lighting: Experiment! The ability to "correct" color temperature after the fact in the digital darkroom (see

pages 160–161) means that you can use all kinds of ordinary (or just plain weird) light sources that would probably have been out of the question with color film photography.

Sunlight coming through a nearby window is a very charming light source. Use venetian blinds to control the direction of the light, and gauze or translucent fabric curtains to act as a diffuser.

Try using household light bulbs in a variety of lamps. You'll be surprised how much difference a lamp shade can make. A desktop lamp turned sideways can work as an excellent spot light to emphasize specific areas of your subjects.

Flashlights make interesting pinpoint light sources, as do LED head lamps. Even Christmas-tree lights can be used as an interesting source of illumination.

A small light box, which can be obtained from an art supply store, makes an excellent source of back-light for objects that are relatively two-dimensional like flowers (the Orchid shown on page 137 was lit this way).

Something to photograph: It's key to feel passionately about your photographic subjects, because without passion there are no good photographs.

Look around your household for ordinary objects to photograph that interest you. Eggs and fruit are excellent subjects. Take it as a challenge: How can you photograph an egg so that it is the most egg-shaped egg that ever there was? How do you make a piece of fruit seem luscious and desirable? For me, the passion and challenge of flowers cut from my garden is unending.

If your primary interest is photographing people, you should experiment with flash lighting setups, and with raising your ISO. If you are using flash to take controlled portraits of people, you'll probably want to use several off-camera units.

To photograph people, you'll likely want a corner with empty walls and a non-distracting background. You can always tack a big sheet of paper over a bookcase, or use a sheet to cover distracting background details.

Materials for constructing background and sets: If you look around, you'll find many materials that you can use to create backgrounds and tableaus. Towels and sheets can be great background material.

A good art supply store is a great source for colored paper, tissue paper, cardboard, spray paint, and all kinds of materials that can be used in endless combination.

When you visit your local art supply store, don't forget a tub of clear Museum Gel. You can use this sticky but transparent stuff to hold subjects in artificially upright positions while you photograph them, without any possibility of damaging the object.

The best thing about practicing photography with a studio of your own is that you really are in control of the light. Sure, you still have to expose properly—but you are the absolute dictator of the direction, intensity, and quality of the light.

With power comes responsibility. Since you are in charge of the light in your studio photos, make sure the light is interesting, and try to use the light to help your photo tell an emotional narrative with visual impact.

◄ I lit this pencil with natural sunlight from a window, directed the light using venetian blinds, and aimed a head lamp at the pencil point to produce the highlight on the pencil point.

It was easy to experiment with a variety of apertures in a studio environment; using a shallow depth of field turned out to be a better way to illustrate the point of the pencil than captures in which more of the pencil was in focus.

105mm f/2.8 macro lens, 1/20 of a second at f/8 and ISO 200, tripod mounted.

▲ A nautilus shell is a classic subject for still life photography, photographed here against a black paper background using a naked 60-watt household light bulb as the light source.

50mm Sigma f/2.8 macro lens, 8 seconds at f/32 and ISO 100, tripod mounted.

▲ I back lit this Iris with sun from a nearby window, and used a desk lamp to provide some gentle front lighting. Indoors, I was able to make sure there was no motion for a long exposure, as well as precisely controlling the lighting on this Iris.

105mm f/2.8 macro lens, 2.5 seconds at f/40 and ISO 200, tripod mounted.

RAW Conversion

Digital photography is one part photography and one part digital. In many ways, the fun in digital photography begins *after* you take the photo.

That's not to justify taking lousy photos. I'm a firm believer in taking the best photos you possibly can in the first place. Ideally, digital post-processing should enhance great captures, not fix problems in exposure and lighting. To take the best digital photos possible, you need to understand the power and capabilities of the digital darkroom in advance.

As I mentioned earlier, a RAW capture saves all the original data of a digital photo. Since all the data is present in a RAW capture, this kind of exposure is the best place to start in the digital darkroom to get the most from your photos. However, getting good results with a RAW photo requires an extensive process (see sidebar).

The key point to realize about a RAW conversion is that a RAW original file is a *potential* photo, not the photo itself. I've heard this put using a silver-halide metaphor: the RAW file is the negative, and the finished version is the print. While the metaphor isn't perfect (the finished version is a computer file, not a print, after all), the sentiment does accurately convey the sense that, like an old-fashioned print, a finished digital photo depends on the vision and skill of the craftsperson who converts the original RAW file.

You should keep in mind the ideas behind RAW processing steps that relate to light and exposure when you are shooting. Knowledge of digital post-processing informs the process of taking photos. If you don't understand the issues involved in post-processing, particularly in the RAW conversion step, you'll literally miss photographic opportunities.

RAW Digital Workflow

In the context of digital photography, workflow refers to the steps taken to handle an image after it has been captured (it's another word for digital post-processing). There's great variety in the workflows different photographers use to process RAW digital photos (and the software used to implement workflow).

It's only reasonable for photographers to customize their workflow to how they like to work. That said, a successful RAW digital workflow usually includes the following steps:

- Transferring the RAW photo files to your workstation
- Archiving the original RAW files
- Categorizing and selecting photos from the series shot
- Adjusting exposure and light in the selected RAW captures
- Converting each adjusted RAW capture to a format that can be processed (usually PSD or TIF) in an image editor (for example, Photoshop)
- Making further corrections to color and exposure, and enhancing globally or selectively as desired
- Sharpening the image and/or reducing noise as needed
- Creating versions for specific uses at specific sizes, for printing, for display on the Web, and so on
- Archiving the various finished versions of the photo

◄ By eye, this almost night-time scene was dark and monochromatic. I tried to expose to let plenty of light into the sensor. This is the original RAW capture shown using default exposure and light settings as I saw it on my camera LCD and, initially, on my computer monitor.

► When I post-processed the photo, I was able to tease out considerable light and color that had been hiding within the original RAW file.

Both: 18–200mm VR zoom lens at 40mm, 8 seconds at f/4.5 and ISO 100, tripod mounted.

▲ **Chapter opener:** To simulate the look of a palladium or platinum toned print with this photo of Yosemite in winter, I first converted this photo to black and white (see pages 172–173).

Here, I converted the black and white photo into a tritone image (an image consisting of three versions on top of one another of the same black and white photo). In other words, I added the colors used for the toning effect to the two versions of the photo placed on top of the original image, each of the two toned versions at less than 100 percent opacity.

18–200mm VR zoom lens at 18mm, 1/200 of a second at f/10 and ISO 200, hand-held.

Depending on the camera used, most RAW files contain the data for exposures that range from −4 f-stops to +4 f-stops from the exposure of the capture. This 8 f-stop range translates to a dynamic range of 128 times from darkest to lightest possible interpretation of a RAW original (see Chapter 2 for an explanation of how f-stops work).

Versions converted towards the extreme ends of this exposure range are likely to not be very usable because they are black (on the dark side of the range) or too noisy (on the light side). But still, there's an extensive usable range of potential exposure values within each RAW capture.

In addition to exposure, each RAW original contains a vast range of other exposure-related settings for potential versions, including white balance, contrast, brightness, saturation, and more.

In other words, there's very little that is set in stone about the image that will emerge from a RAW capture. You're not even stuck with a single potentiality: you can mix and match different exposure and color values from a single RAW capture, and apply each of the different settings to a different selected portion of the image (as you'll see when I explain multi-RAW processing). When this is done right, the final image presents the best of many potential settings, combined into a cohesive whole.

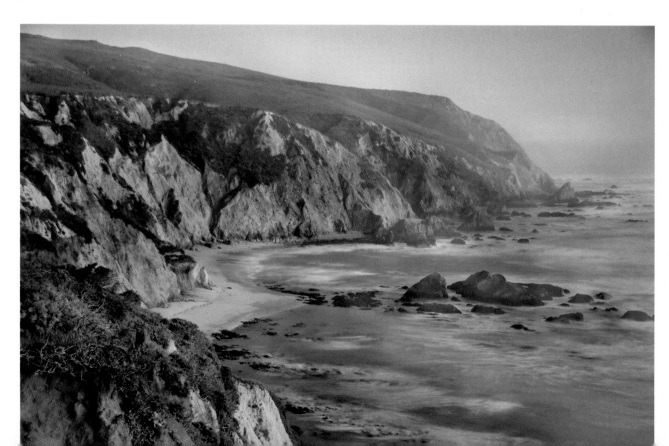

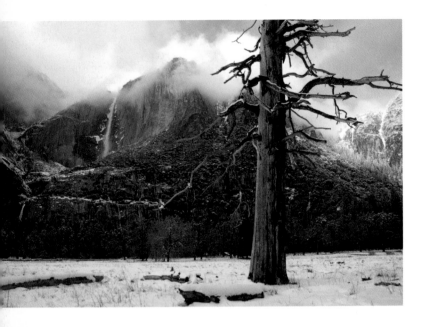

I photographed this dead tree in Leidig Meadow in Yosemite Valley, with Yosemite Falls in the rear, as a winter storm cleared.

◀ The original RAW capture at default light and exposure settings was interesting, but looked rather dark and gray to me.

◀ My first step in post-processing was to use the conversion from RAW to lighten the image and shift the white balance (and other color settings) so the colors were warmer, particularly the light falling on the tree.

▶ Following my RAW conversion, I used Photoshop's exposure adjustment controls to enhance the overall color cast of the image and to selectively modify the brightness of specific areas of the image. I finished the image by selectively processing for noise reduction, and sharpening.

All: 18–200mm VR zoom lens at 18mm, 1/250 of a second at f/10 and ISO 200, tripod mounted.

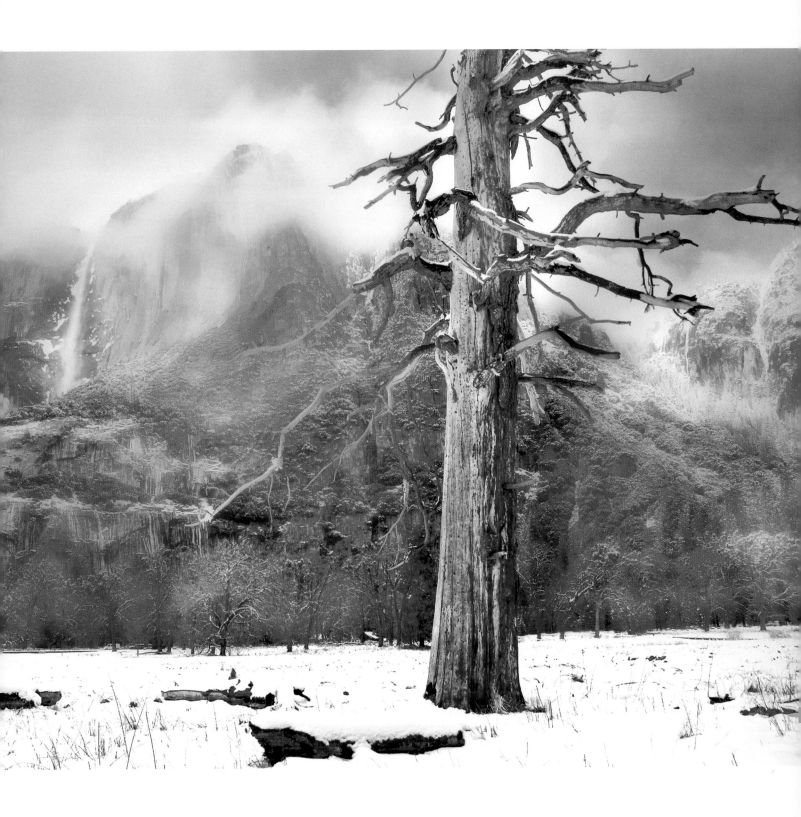

Adjusting Exposure

Once you understand that any RAW capture includes an almost infinite number of potential images that can be derived from the RAW original, it becomes clear that vision and planning are of the utmost importance. You need to know *where* you want to go (the image you want to end up with). With a fairly clear picture of the desired end result in mind, you should also stake out a road map of *how* you are going to get there. Of course, a road map of a proposed journey should never preclude productive detours along the way!

There are three general ways you can use Photoshop to adjust exposures:

- An overall exposure can be adjusted as part of the process of converting a RAW image.

- Several entirely separate exposure conversions can be made from a single RAW image, and combined.

- A variety of Photoshop mechanisms can be used to tweak and adjust the image once it has been converted from RAW.

The first of these two mechanisms are the most powerful. Most photographers, even those who are adept at using Photoshop (or other software) for post-processing, don't regularly take advantage of this power. The *big secret* of the digital darkroom is to take advantage of the power of RAW conversions, particularly multiple RAW conversions. And now that I've told you, it's no longer a secret for a select few digital photographers. You can use it in your own digital photography.

If you accept the default conversion settings for a RAW photo, and only adjust the exposure in Photoshop, then you might as well work on a JPEG version of your photo, and not bother with RAW at all. It amounts to the same thing. (Obviously, I don't recommend post-processing with JPEG files, but if you decide to do so anyway you should note that it is good practice to convert the JPEG file to Photoshop's native format before working on it.)

All my photos are processed in the digital darkroom before I show them. Without exception. Well, actually, there are a few exceptions—the original RAW captures presented (at their default settings) in this chapter. But it makes me feel quite uneasy to show you these originals. I need to show you these original RAW captures so you can really understand how far a photo goes in post-processing. But reproducing these originals, even in this context, makes me feel like being seen in public prancing in my underwear (trust me, not a sight you would necessarily find inspiring).

For every one of my photos, I use each of the three steps I've described for adjusting exposure. I adjust the exposure during RAW conversion, I combine more than one RAW conversion from a single photo, and

This is a photograph from the top of Mission Peak looking at downtown San Jose, California and Silicon Valley.

◄ When I saw the RAW capture at original, default settings, I loved the dark shadow "pointing" at San Jose. However, the overall image seemed way too dark (other than the city lights). I decided to adjust the exposure to lighten the hillside so that many otherwise hidden details would (hopefully) became visible. At the same time, I wanted to leave the city lights at about the initial exposure values, and the cloud pointing at San Jose dark, because the dark, finger-pointing cloud is part of what gives the photo interest and mystery.

► To achieve my goal, I made two entirely separate conversions from the RAW file. One used "lighter" exposure values to produce the detail I knew was really there in the hillside. The other version was "tuned" to the exposure value of the lights of San Jose and the sky.

I placed the two different versions on top of one another (in Photoshop, they became layers) so they were precisely aligned. Next, I used a layer mask and a diagonal gradient, creating a progressive blend of the two different layers.

Both: 18–200mm VR zoom lens at 34mm, 30 seconds at f/4.2 and ISO 100, tripod mounted.

I tweak the results in Photoshop. On pages 154–155, and again on pages 164–165, you'll see a single photo three ways:

- RAW original capture
- After exposure adjustment during RAW conversion
- Following further exposure enhancement in Adobe Photoshop

If you consider the complexity of the process, it is no wonder that I suggest you start with a goal (your vision) and a plan (your road map).

The Adobe Camera Raw plug-in is used to convert RAW images so they can be opened in Photoshop. As I've mentioned, the plug-in gives you an ability to adjust the exposure within an 8 f-stop range. You use a slider to choose an exposure between −4 f-stops and +4 f-stops, where 0 is the default exposure. (As I've already noted, exposures at the extreme ends of this range tend not to be usable because they are either completely dark or filled with noise.)

As I've said, there are quite a few other exposure-related controls in the Adobe Raw plug-in besides the exposure slider. Here are some that I frequently use to change the way an exposure looks:

- *Blacks:* Increases or decreases overall blackness; this setting defaults to 0 or a low number, so I usually increase it in conjunction with decreasing the overall exposure setting.
- *Brightness:* Increases or decreases overall brightness; this setting defaults to a fairly high number and I increase or decrease it in conjunction with adjusting the exposure up or down.
- *Contrast:* Increases or decreases overall contrast; I use this setting to increase the dynamic range within a photo.
- *Fill:* Simulates the action of flash in fill mode (see page 87), by lightening shadow areas.

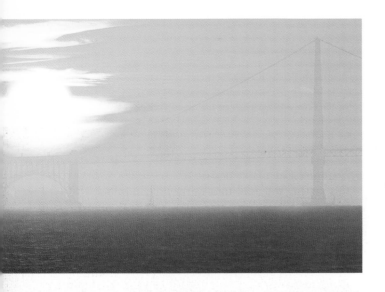

This photograph of the sun setting just to the left of the Golden Gate Bridge (the original is not shown here) was just too middle-of-the-road for me. There was no detail showing in the highlight areas (the sun), and at the same time the water was so dark that it didn't show any detail. I decided to process the image to bring out both highlight and dark area details.

◀ In this version, I adjusted the exposure up +.75 of an f-stop in Adobe Camera Raw. I like the way you can see the detail in the water, but the sun is clearly overexposed and blown out.

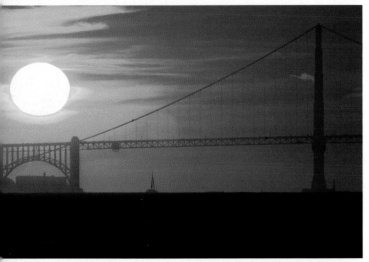

◀ I used a negative exposure adjustment of −.35 of an f-stop in Adobe Camera Raw to create this version, which is slightly underexposed compared to the default RAW settings. My plan was to use this version as the underlying "foundation" for the completed photo.

◀ I underexposed this version with a negative exposure adjustment of −.65 of an f-stop. There's a nice wisp of cloud now apparent over the face of the sun, and I like the colors in the upper left of the image. But most of the rest of the photo in this version is too dark, and loses details.

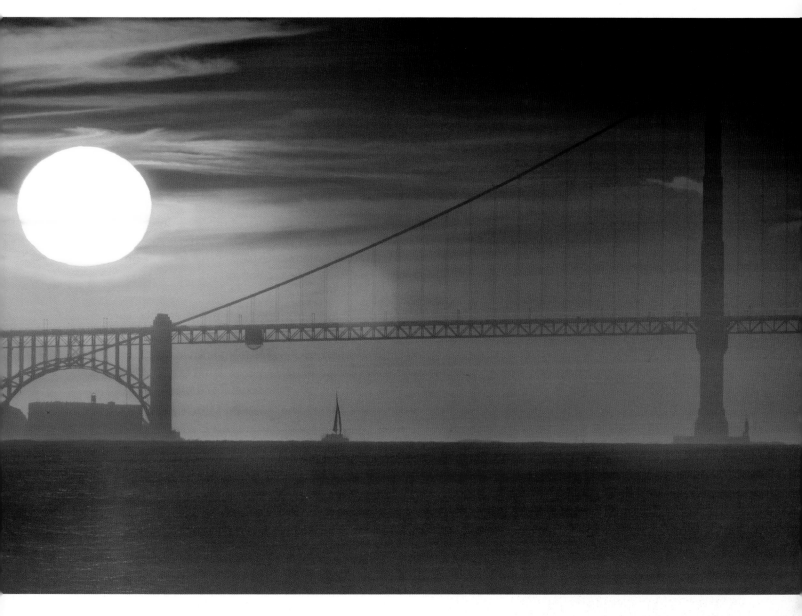

▲ For the final version of this photo, I combined the three different exposures. I used a layer mask and a gradient to blend the lighter foreground of the overexposed version into the darker versions. To incorporate the sun-with-details and attractive sunset colors from the darker version, I used a layer mask (see page 163) and "painted in" the areas (such as the sun) that I wanted to use.

All: 70–200mm VR zoom lens at 200mm, 2X teleconverter for a combined focal length of 400mm, 1/1000 of a second at f/25 and ISO 100, tripod mounted.

Adjusting White Balance

It's easy to fix the color temperature of a digital photo after the fact either when converting a RAW image or in the digital darkroom. An advantage of adjusting color temperature during RAW conversion is that the adjustment merely alters metadata rather than changing the photo itself.

I've explained earlier that applying a higher color temperature (in Kelvin degrees) for the white balance setting to a RAW capture makes the capture warmer (redder), and applying a lower color temperature setting makes the image cooler (bluer). This is a little backwards, because using the Kelvin scale light sources that are lower in color temperature are redder and warmer than light sources higher up the scale, which are cooler and bluer (see the table on page 126). But it's easy enough to adjust the white balance of your photo using this color temperature setting.

You crank the white balance slider up to higher values for warmer, redder colors, or decrease the values for cooler, bluer colors. Provided your monitor has been accurately calibrated (see the sidebar on page 129), when you like what you see, you are done.

If don't want to eyeball things, you can include a neutral gray card in one photo in a series, and set the white balance in Camera Raw by clicking on the card with the white balance tool (see page 128). For a first approximation, even if you haven't included a card, click on something in the photo with the tool that seems roughly neutral gray.

As with exposure adjustments in Camera Raw, you're not stuck with one white balance adjustment. You can process multiple versions from your RAW original at different white balance settings, and combine the different versions as layers in Photoshop. You can even mix and match different white balance settings with different exposure settings, in a veritable armada of variations.

Camera Raw offers a number of other controls that I often use for adjusting color when I make conversions from my RAW originals (I tend to increase all three settings to get more vivid colors on at least one version of any RAW conversion):

- *Tint:* Decreasing tint makes an image greener, and increasing tint makes an image more magenta.

- *Saturation:* Saturation controls the vividness of colors, on a scale of –100 (which is monochrome) to +100 (which is twice the normal vividness).

- *Vibrance:* Vibrance improves the saturation of lower-saturated colors without changing colors that are already highly saturated much. This comes in handy for increasing color saturation in a photo without making skin tones look weird.

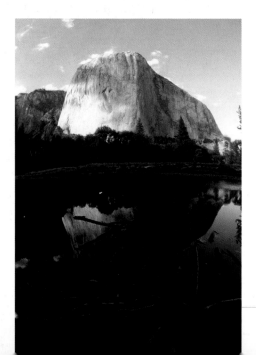

I liked the original fisheye shot of El Capitan in Yosemite Valley (shown on the left), but I did feel that it needed some work. In the first place, I needed to adjust the exposure to extensively lighten the foreground and somewhat darken the rear. Next, I wanted to adjust the white balance so the colors were warmer.

◀ My camera had been set on auto white balance. That translated in Camera Raw to an "as shot" white balance setting of 5000K.

▶ I adjusted the exposure, and applied a white balance setting of 5900K to the image. This had the effect of warming the color tones (see pages 126–129). I also increased the tint, vibrance, and saturation settings in Camera Raw.

When I was satisfied with my exposure and color settings, I cropped the image in Photoshop and applied some additional tweaks to arrive at my finished version.

Both: 10.5mm digital fisheye lens, 1/4 of a second at f/22 and ISO 100, tripod mounted.

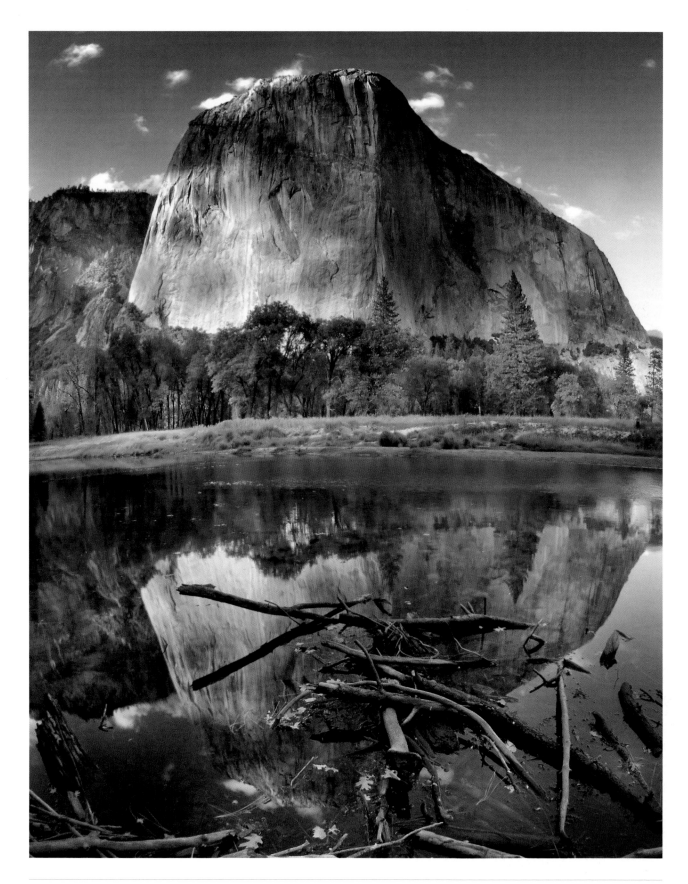

Noise Reduction

If you shoot a photo with the shutter open for a long amount of time, or at a high ISO, or in certain lighting conditions, your capture will include a great deal of noise despite the diligent effort of your camera's processor to reduce it (see Chapter 4 for more information about noise and its causes).

In Chapter 4, I gave some examples of using noise creatively in your photos. But a lot of the time, I don't want to use noise creatively, I just want the noise to "be gone."

There are tools that can help you vanquish noise as part of the conversion process in Adobe Camera Raw. You'll also find noise reduction filters in Photoshop. In addition, third-party vendors provide powerful noise reduction software as Photoshop plug-ins or stand-alone products (see sidebar on page 113).

It's often worth trying to reduce noise in the luminance data of a photo without reducing noise in the color data quite as much. *Luminance* refers to the black and white information in a color photo; luminance noise tends to be more visually objectionable than noise in the color data of a photo.

It's a fact of the digital photography universe that any effective noise reduction technique also softens the photo.

Understanding Layers, Blending Modes, and Masking

Layers are versions of a photo stacked one on top of the other. In the natural order of things, the top layer in a stack is all you'll see. However, each layer has an associated opacity property. If the opacity property of the top layer on the stack is less than 100%, then you will see the next layer down through the top layer, and so on down through the stack.

Besides opacity, each layer has an associated *blending mode*. The blending mode specifies how a layer mixes with the visible layers beneath it in the stack.

A *layer mask* is a grayscale channel (see sidebar on page 169) that can be added to a layer. An entirely white layer mask completely reveals a layer, and an entirely black layer mask completely hides the layer. Layer masks can be painted in white, gray, or black to reveal, partially reveal, or hide the layers stacked below. On a mask it's often useful to paint boundary areas gray in order to create a seamless visual transition.

I took this almost ten-minute exposure from the top of Half Dome looking down at Yosemite Valley, with the setting moon and the night lights of California's Central Valley cities in the background.

◄ This blow-up from the original shows a considerable amount of noise (take a look at the cliff behind Yosemite Village).

► I extensively processed the image to reduce noise in selective areas, maybe even going too far and creating a look that is unattractively soft in some key areas.

Both: 12–24mm zoom lens at 20mm, 569 seconds at f/4 and ISO 100, tripod mounted.

The more powerful noise reduction software has numerous settings that can be used to increase or decrease softening, and to vary the reduction effect in many ways. It's worth experimenting with these settings to discover what gives the best results on different photos.

In some cases, this softening can be used for a creative effect (the water on the lower right of the photo on page 153 has been softened using noise reduction with this in mind).

But even if you are creatively softening using noise reduction, you likely don't want to soften an entire photo. In addition, noise isn't equally distributed across an image. It tends to appear more in dark areas. Both issues call for the practice of selective noise reduction.

One good way to selectively apply a filter, such as a noise reduction filter, is to start by creating a duplicate layer. Position the duplicate layer on top of the original, and apply the noise reduction filter to the duplicate (which is now the topmost layer). Next, add a black layer mask to the topmost layer so that the noise reduction is invisible. Finally, selectively "paint in" noise reduction using a white or gray brush on the black layer mask. The whiter the area you paint, the more the noise reduction will "show through."

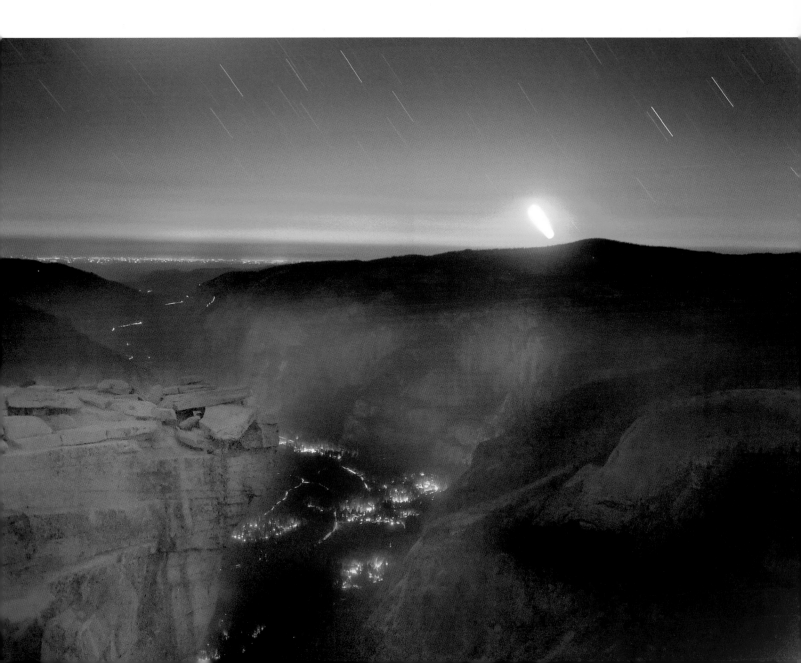

Multi-RAW Processing

Multi-RAW processing means combining multiple versions with differing exposures and color values from a single RAW original. Typically, these versions aren't "straight," meaning they are applied using a blending mode (see sidebar), and at some reduced percentage of opacity.

If you've processed two exposures from the same original (let's say one is much brighter than the other), you can drag one of the images onto the other image in Photoshop to create a single, two-layer image. If both images are the same size, its easy to align the two layers precisely. (The trick for precise alignment is to hold down the Shift key when you drag one image on top of the other.)

The requirement that the images be the same size for precise alignment is a good reason to wait until you are entirely through with combining RAW conversions before you do any cropping of your photo.

Quite often, I'll add a layer mask (see sidebar, page 163) to one of these multi-RAW layers and plan to either "paint in" specific areas, or to apply an overall gradient to let the layer blend in smoothly.

With all of the layers converted from RAW in place, my next step will be to proceed to enhancements in Photoshop itself.

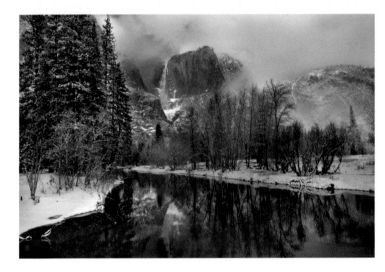

Blending Modes

Blending modes are used to describe how a layer mixes with the layers beneath it (layers are described in the sidebar on page 162).

Besides the default blending mode (called normal blending mode), I often use specialized blending modes when I multi-RAW process. I also use these blending modes at later steps in Photoshop.

Here are some of the blending modes (besides normal) that I frequently use:

Color: Color blending mode applies the color from the top layer, using the luminosity (black and white values) from the layer underneath. Color blending mode can often be used to selectively enhance colors.

Luminosity: Luminosity blending mode uses the luminosity information from the top layer and the color information from the layer beneath.

Multiply: Multiply blending mode darkens the image overall, or "burns" specific areas if applied selectively. In small doses, multiply blend can be used to enhance colors.

Screen: Screen blending mode lightens the image overall, or "dodges" specific areas if applied selectively.

Soft light: Soft light blending mode superimposes the pixels in the top layer over those in the bottom layer, with a bias towards lowering the effective contrast in the result.

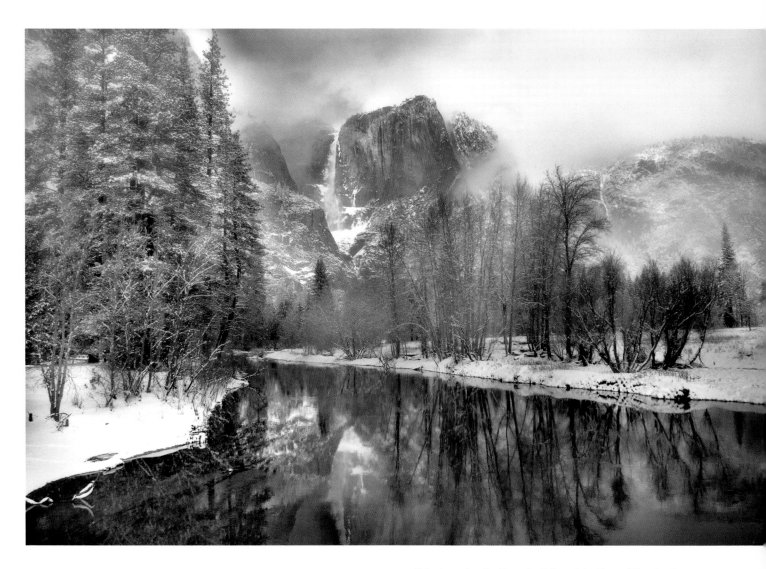

This photo showing Yosemite Falls and the Merced River in winter went through many stages in the digital darkroom.

◀ Top, page 164: I was intrigued by the RAW original as it appeared on my computer monitor, but wanted to lighten it and add color selectively.

◀ Bottom, page 164: Following multi-RAW processing, the photo was partway there.

▲ Above: I used color, luminosity, and multiply blending modes applied selectively to create the color impact I wanted (note particularly the color on the cliff to the right of Yosemite Falls).

All: 18–70mm zoom lens at 18mm, 1/400 of a second at f/11 and ISO 200, hand-held.

At sunset, from the top of Wildcat Peak, I watched the clouds roll in through the Golden Gate.

◄ My original RAW capture seemed awfully washed out to me, but I wanted to see how far I could go with it.

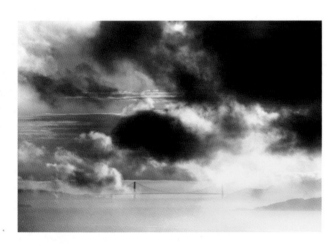

◄ To create this layer, I converted a duplicate to LAB color (see sidebar on page 169). Taking the luminance channel (the L channel in LAB color), I applied an inversion (reversing the levels of blacks and whites). I blended the inversion on top of the original using soft light blending mode.

◄ In order to amplify the blue in the image, still in LAB color, I worked on the B (blue and yellow) channel. To create this layer, I blended the result with amplified blue on top of the original photo in color blending mode.

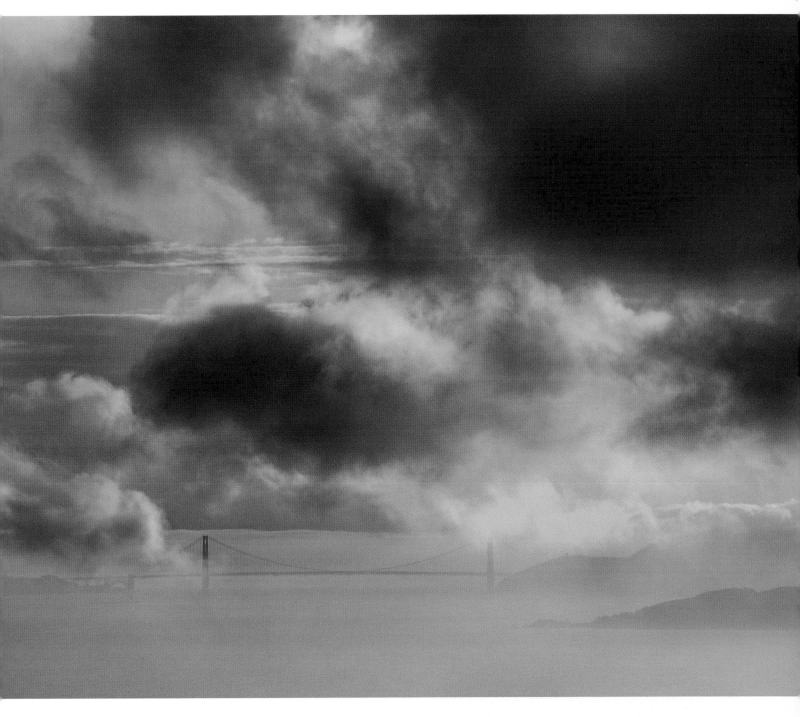

▲ Combining the layers I had created using blending modes and LAB color created a painterly (and somewhat over-the-top) effect.

All: 70–200mm VR zoom lens at 130mm, 1/320 of a second at f/9 and ISO 100, tripod mounted.

Cross Processing

Back in the days of film, cross processing meant to process film (or photo paper) using chemistry intended for another type of film or paper. For example, a typical cross-processing gambit was to process Ektachrome using Kodacolor's C41 chemistry rather than the E6 chemical process intended for Ektachrome. This could be done backwards as well, processing Kodacolor in Ektachrome's intended E6 bath.

Part of the point (and pleasure) of analog cross processing was that you never really knew what you were going to get.

Digital cross processing is not really cross processing at all in any logically rigorous sense. Rather, the idea is to come up with color and light variations that you can layer onto your original photo and apply using blending modes (see sidebar, page 164). So the key elements of an effective approach to digital cross processing are:

- Experiment a great deal. The point of cross processing is to come up with versions that are both different and unexpected.

- Use mechanisms that produce a great deal of variety. You don't have to use everything you come up with, but if you have enough versions to choose from, something may in fact make an interesting enhancement to your photo.

Within Photoshop, the Variations command opens a window that shows thumbnails, each thumbnail representing an exposure or lighting variation from the original photo.

Nik Software markets a special cross processing filter

Understanding Channels

Photos can be represented in a number of different modes (also called color models), depending on your needs and what you plan to do with the photo. For example, RGB mode is used for images that will be displayed on a monitor, using a system that adds the colors while emitting light, and CMYK mode is used for images that will be printed, using a system that subtracts the colors while reflecting light.

Within the RGB mode there are three channels. Each channel is a grayscale representation of color information. This representation is actually a kind of graph showing the distribution of values of the particular color the channel represents.

In RGB, the R channel holds the red information in the photo, the G channel holds the green information, and the B channel holds the blue information.

CMYK channels implement a different color model: C is the cyan channel, M is the magenta channel, Y is the yellow channel, and K is the black channel.

Besides RGB and CMYK, grayscale data and other color models are also implemented using channels. Layer masks (see sidebar on page 163) are an example of a grayscale channel.

you can use within Photoshop, which attempts to simulate both E6-to-C41 and C41-to-E6 cross processing. A number of variations of both effects are provided.

My preferred process for creating cross-processing variations is to convert a duplicate of my photo to LAB color mode (see sidebar).

From the LAB color version, I come up with seven variations as follows:

- I invert the image as a whole. This means transposing each color value in the image for the opposite color.

- I invert the image channel-by-channel, for three more variations.

- I use the Equalize command to amplify the color bias in each of the three channels in turn, for another three variations.

Once I have my variations, I don't have to stay in LAB color. I can go back to "normal" (RGB or CMYK) color, and apply my choice from the variations to parts of all of my photo, using a variety of blending modes, at the opacity I select.

The process of cross processing can go on forever. There's nothing to stop me from repeating channel inversions and equalizations by applying them to one of the existing variations. This generates yet more "cross processing" variations. If one of the variations is interesting, I sometimes save it for future work even if I'm not ready to do anything right away.

◄ Left, page 168: The original version of this Gaillardia flower (shown here already processed from the RAW) seemed attractive enough, if a little bland. I decided to see if I could cross process the image to create a mandala-like effect.

◄ Right, page 168: I converted the photo to LAB color mode (see sidebar), reduced the overall luminance to enhance transparency, and inverted the A and B channels (see text) in separate layers. I applied the inverted colors layers at low levels of opacity to come up with this version.

▼ Left: This version was created using an inversion of the LAB B channel (transposing yellow and blue).

▼ Below: I came up with the black background in this version by completely inverting the photo (transposing black for white data, and vice versa for all the channels).

All: 105mm f/2.8 macro lens, 1.3 seconds at f/36 and ISO 100, tripod mounted.

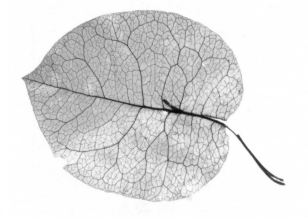

I placed this Bougainvillea petal on a light box to photograph it.

◄ The RAW original photo showed an interesting pattern, but lacked striking colors.

▼ I applied LAB color cross processing (see pages 168–169) to create this version.

► Inverting the luminance channel created this version on a dramatic black background.

200mm f/4 macro lens, 36mm extension tube, 4/5 of a second at f/36 and ISO 100, tripod mounted.

Black and White

The history of photography is largely the history of black and white. Color came into the picture only relatively recently. There are still those who feel that the only truly artistic photo is a black and white photo.

If you fancy your photos as black and white imagery, it's good news that thanks to the digital darkroom color photos can easily be transformed. I've written *transformed* rather than *converted* because you don't want to do just a conversion that simply drops the color data from the digital file.

It's easy to convert the mode of any color image to grayscale in Photoshop, and this does have the effect of simply dropping the data about color to produce a basic black and white version. Unfortunately, at the same time you lose exposure subtleties and the full range of contrast. This information is only included in the complete set of data that includes all the color channels.

Fortunately, there are a number of effective ways of going about converting from color to black and white that do retain the color information necessary for a rich translation (see the example on pages 174–175 for some specifics). Once an image has been converted to monochrome, it's possible to add many interesting effects, such as selective softening, simulated film grain, and simulated palladium or platinum toning (photo, pages 150–151).

It's worth sitting back and thinking about what kinds of photos work well in black and white, because many photos work better in color. It's simply a fact of life that many of today's digital photographers don't shoot with black and white conversion in mind.

If you do have a hankering to make great black and white photos, look for situations with stark, high contrast light. Try to expose the photo for midtones so the darkest areas are truly black and the bright areas don't blow out.

For the most part, compositions that work well in black and white photos are simple and dramatic. In any event, color can't play a crucial role in the photo composition. I think if you start converting your images to black and white that there may be fewer suitable candidates than you initially expect; however, you'll quickly learn which images work, and which ones don't.

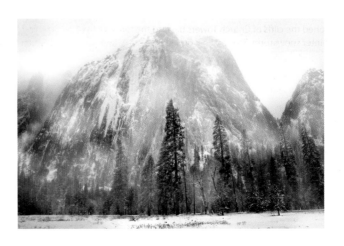

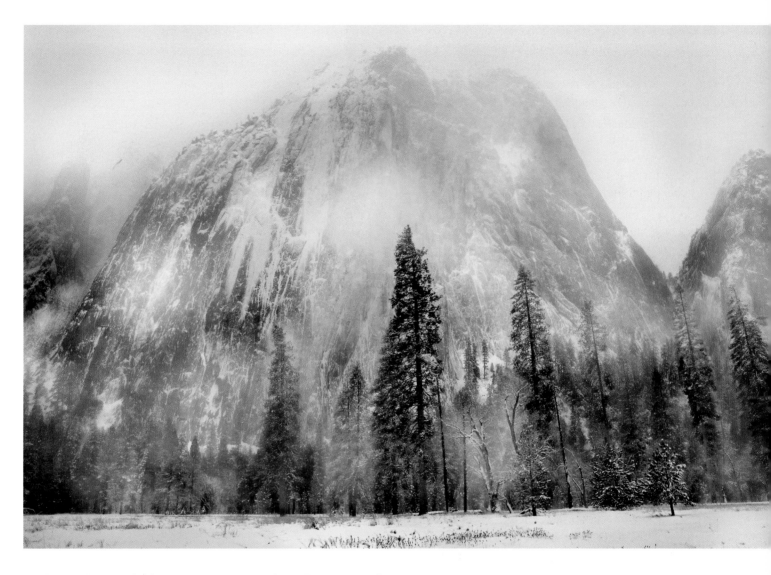

I photographed the cliffs of Church Towers beyond the forest of the Yosemite Valley floor in a winter snowstorm. To me, the world looked stark, and was composed of blacks, whites, and grays.

◄ Top, page 173: The original RAW capture looked almost black and white to start with.

◄ Middle, page 173: I added color and a sense of depth in the RAW conversion process.

◄ Bottom, page 173: I used blending modes and selective effects to enhance the image in Photoshop.

▲ Above: Coming full circle, I converted the enhanced image to black and white, taking care that the subtle color tones were delicately rendered in this version.

For a "toned" version of this black and white image, see pages 150–151.

All: 18–200mm VR zoom lens at 18mm, 1/200 of a second at f/10 and ISO 200, hand-held.

This is a photo of an ancient Bristlecone Pine, one of the oldest living things, found in the mountains on the California–Nevada border.

◄ Here's my color version following the RAW conversion process. I thought this photo, with its dramatic shapes and rather harsh contrast, would work well for a black and white conversion.

◄ I created this version of the Bristlecone Pine by making a new all-black layer and using color blending mode (see page 164) to blend it with the image beneath it.

The conversion method works a little bit better than simply dropping the color data by converting the image to grayscale mode, but doesn't lead to a very dramatic black and white photo.

◄ This version of the Bristlecone Pine shows simulated film grain added to make the photo look more like a "real" black and white print.

▲ Starting the black and white conversion process over again, I used a more sophisticated process to get results that better utilize the data residing in the colored pixels.

To achieve the result, I mixed up a new monochromatic channel made up of 70 percent of the red pixels, 50 percent of the green pixels, and –20 percent of the blue pixels.

You can play with the exact percentages of color used to mix the black and white channel, but the total should always equal 100 percent.

It's possible to create even more dramatic black and white effects than shown here by boosting the red and green components of the mixture. (The mixture—160 percent red, 140 percent green, and –200 percent blue—has sometimes been called the "Ansel Adams effect.")

All: 18–70mm zoom lens at 18mm, 1/125 of a second at f/9 and ISO 200, tripod mounted.

Index